Richard Nickel's Chicago

PHOTOGRAPHS OF A LOST CITY

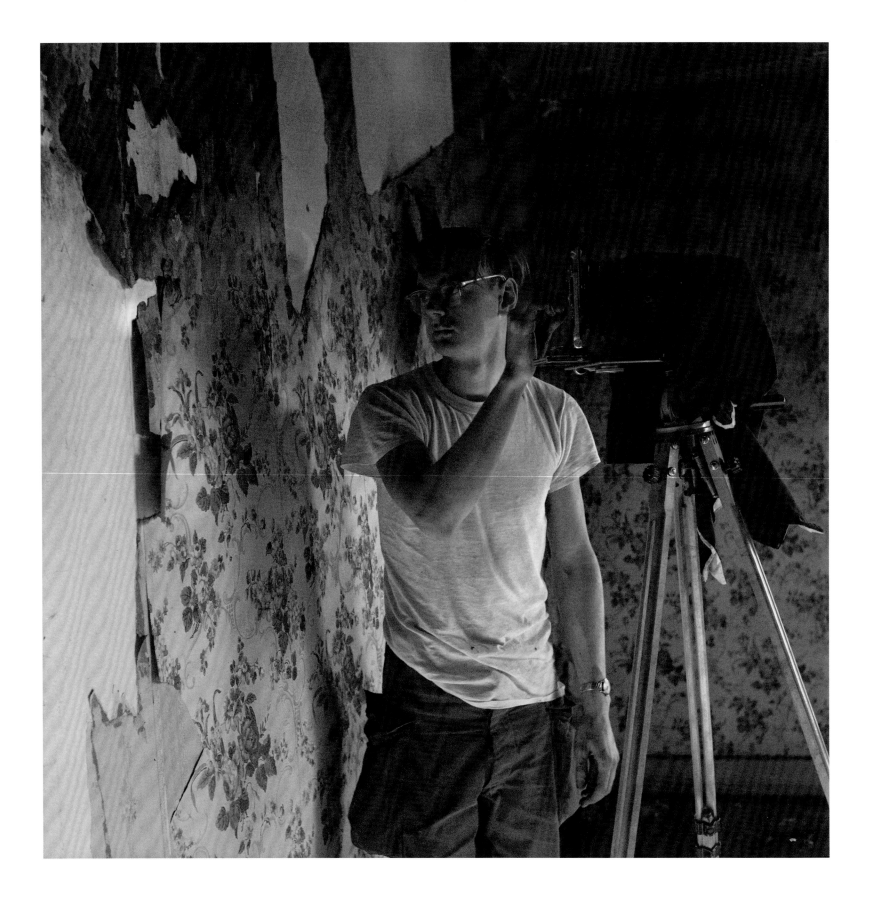

Richard Nickel's Chicago

PHOTOGRAPHS OF A LOST CITY

Richard Cahan and Michael Williams

CHICAGO
CITYFILES PRESS
PUBLISHERS

PUBLISHED BY CITYFILES PRESS, CHICAGO
E-MAIL: CITYFILESPRESS@RCN.COM
WEBSITE: CITYFILESPRESS.COM

NATIONAL EDITION

ISBN: 0978545028

PRINTED IN CANADA BY FRIESENS

FRONTISPIECE: RICHARD NICKEL SELF-PORTRAIT, 1950S

Contents

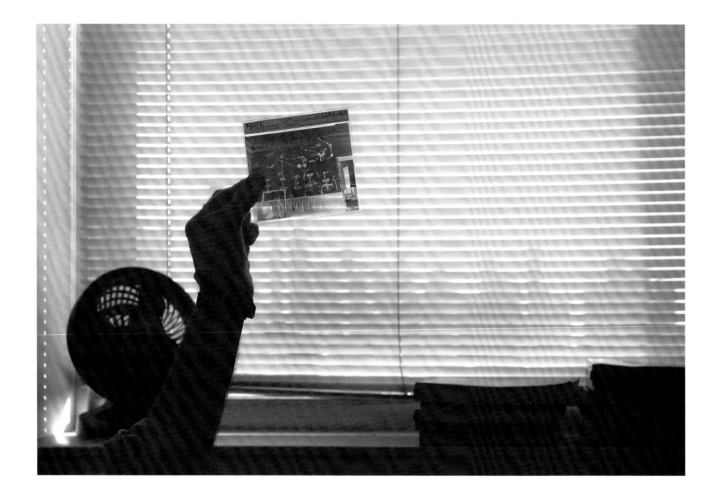

Acknowledgments

The publication of this book could not have been possible without the expressed permission of the Richard Nickel Committee, which serves as custodian of Richard Nickel's work and administers public access to Nickel's architectural and photographic archives. The committee supplied photographs, helped track down important information, and encouraged our work from the start. John Vinci, head of the committee, has preserved and retained the material intact since Nickel's death in 1972. Ward Miller, long associated with the archive and currently its full-time executive director, has kept Nickel's work alive by making the collection available. Miller spent countless hours responding to our requests for photos and research files, and was a remarkable sleuth in figuring out the locations of many pictures. Richard Seidel should also be thanked for organizing Nickel's archive of photographs, files, and written records. Vinci and two other Nickel salvaging colleagues, Tim Samuelson and David Norris, played key roles in providing valuable insight into the work of Nickel and architect Louis Sullivan. Nickel's brother Donald, sister-in-law Harriet, and nieces Susan Brunson and Nancy Nickel have been supportive of our work for decades. Mark Jacob and Tom McNamee provided essential editing help, as did our wives, Karen Burke and Cate Cahan.

This book supplements the 1994 biography *They All Fall Down: Richard Nickel's Struggle to Save America's Architecture*. During the twenty-five years since the start of research on the first book, we have relied on the expertise of many photographers, curators, and Nickel friends to better understand his work.

A NOTE ON THE PHOTOGRAPHS: Only a few of the photos in this book have ever before been published. In fact, only a few have ever before been printed. Nickel made photo contact sheets of much of his work, but printed only a small portion of his archive. He lived a modest life, devoting much of his time to photographing and salvaging the city he loved. He maintained a limited livelihood by working as a freelance photographer for Chicago architecture firms. Architects admired his work, but worried about the honesty Nickel brought to the job and his unwillingness to glorify their buildings. Most of the photos in this book were taken for personal projects. Nickel studiously documented the architectural work of Adler and Sullivan as well as Burnham and Root. He also showed great interest in the city's new architecture.

Nickel primarily used three types of cameras: a view camera that produced 4-by-5-inch negatives, a medium-format camera that produced square 2¼-inch negatives, and a 35mm camera that made 1-by-1½-inch negatives. Because the photographs in this book rarely were cropped, readers will be able to get a sense of what type of camera Nickel used by looking at the shape of each photograph.

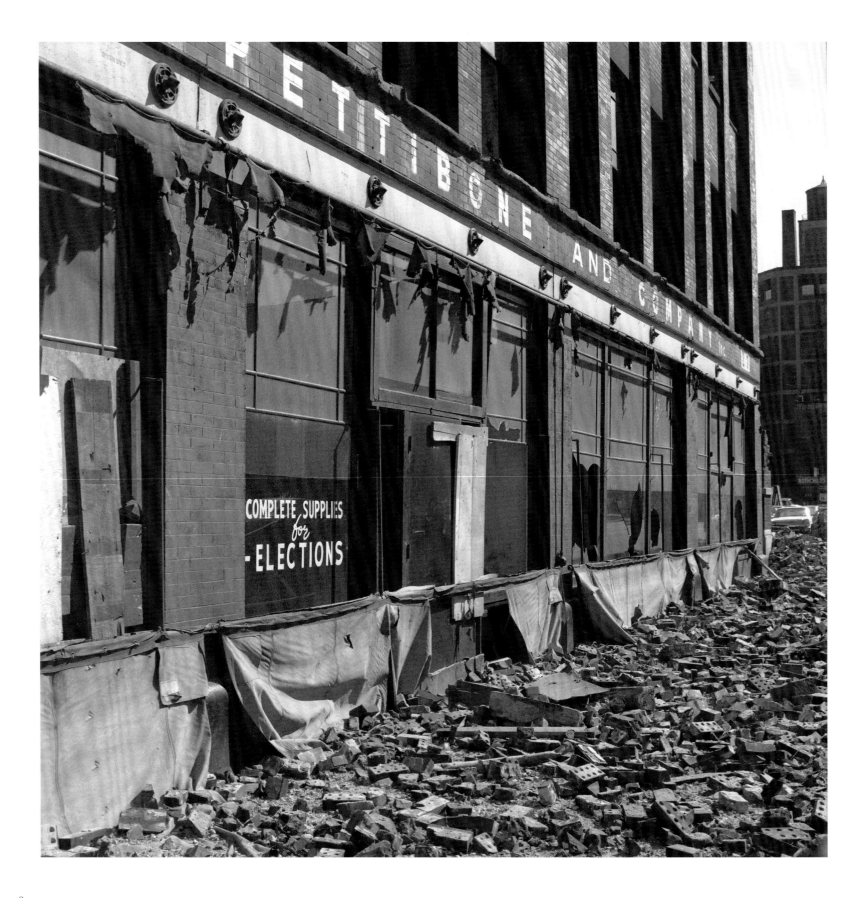

Lost and Found

The city Richard Nickel photographed is mostly gone. Tall weeds grow where Chicago's Grand Central Station once stood. The Garrick Theater was torn down for a parking garage. And the Tunnel of Love at Riverview Amusement Park is but a memory. But the photographs that Nickel took—sober records of a city he fought for—remain. Carefully inventoried, tucked away in plastic sheets, they wait to tell their stories. Of the city he felt passionate about, of its fate, and of the man himself.

Richard Nickel is an urban legend of sorts. He is remembered for his brave and lonely stand to protect Chicago's great architecture, and for his dramatic death in the rubble of the Stock Exchange Building. He is remembered, too, for the photographs he left behind.

Born in 1928 and raised in Polish neighborhoods on Chicago's North and West sides, Nickel attended Catholic grammar and high schools. His father drove a truck and his mother worked in a factory. Young Richard built model airplanes and learned how to develop negatives in his father's makeshift darkroom. "The longer I live, the more I appreciate my idiosyncrasies," Nickel once wrote. "God bless my parents."

He served in the Army in the years right after World War II, and returned to Chicago in 1948, unsure about what he wanted to do with his life. He enrolled at a downtown college named the Institute of Design, tuition-free thanks to the GI Bill, and signed up to learn commercial photography. But this, he would find, was no mere trade school. The Institute of Design was an outgrowth of Germany's radical Bauhaus, where students were taught they could change the world through art. "College was the experience," Nickel wrote. "There I met free minds, people who were active, dynamic. And life opened up."

His early architectural photography showed great promise, and it was clear from the start that he was proficient in the necessary technical and creative skills. But Nickel had another skill—taking pictures of people. While many young photographers struggle to find the confidence to do "street" work, he produced bold photos on the sidewalks of downtown Chicago. Outside the Marshall Field's store, he looked for "significant masks," such as the furs, makeup and hats of women passing by, or their "significant attitudes," he wrote. His talent was obvious, ready to be shaped by two masters of photography—Harry Callahan and Aaron Siskind—who would change his life forever.

Callahan taught Nickel about greyscale, Dektol developer, gloss and matte paper, and an artist's existence. Most every day, Callahan would go out and photograph Chicago—often with his wife, Eleanor, and young daughter, Barbara—in search of the perfect negative. He pushed the shy Nickel out into the city, and urged him to zero in on serious subjects. Callahan showed Nickel that a photographer's life was built around a lifetime of work rather than a single photograph.

LEFT: "I LOOK FORWARD TO THE DAY WHEN I NEVER HAVE TO ENTER A WET, CHARRED, SMOKY BUILDING AGAIN," RICHARD NICKEL WROTE AFTER REMOVING DISCARDED ARCHITECTURAL ORNAMENT FROM ADLER AND SULLIVAN'S PETTIBONE PRINTING COMPANY WAREHOUSE AT 27-33 NORTH DESPLAINES STREET IN 1970.

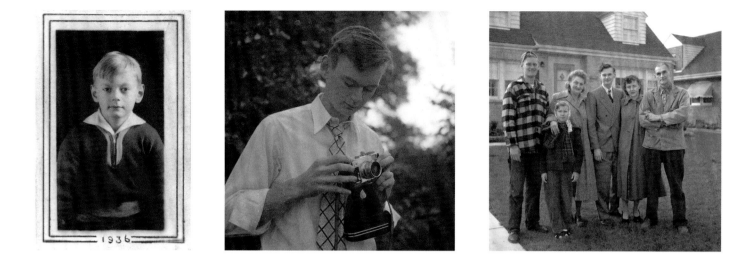

Siskind, who years before documented Harlem and the Bowery in New York City, stressed the importance of creating a series of photographs. He taught Nickel how to see the world anew through the ground glass of a view camera. He showed Nickel how the world becomes an abstract flat plane in the camera lens. First, Siskind had the young photographer take photographs of crumbling wallpaper and other decaying, abstract surfaces. Then it was billboards. And finally it was the city itself. Express yourself, he told Nickel. Look for emotion. Make something altogether new.

After a second tour of duty in the Army and a short marriage, Nickel joined Siskind's class photographing the architecture of Louis Sullivan. Now famous for his observation that "form follows function," Sullivan was one of Chicago's most outstanding architects during the late nineteenth century, a man who considered buildings to be poetic expressions of mankind's desire to live in nature. Siskind assigned his Institute of Design students to photograph all of the 100 or so known Sullivan-designed buildings. Nickel was put in charge of the project primarily because he was the only draft-exempt student. He coordinated an Institute of Design exhibition on Sullivan in 1954, and was assigned to help create a book on Sullivan and partner Dankmar Adler called *The Complete Architecture of Adler and Sullivan.*

Nickel used a large-format camera atop a tripod. Its bellows moved and tilted so he could control convergence and alter depth-of-field. Working under his camera's dark cloth, he strove for complete honesty. His photographs, Siskind once said, were "simple and correct and quite beautiful." Nickel took the assignment seriously, and he gave up photographing people. He re-photographed Adler and Sullivan's buildings in Chicago, took cross-country trips to photograph the firm's buildings outside the city, and scrutinized architectural periodicals and newspapers to turn up unknown commissions. Sullivan, considered by many as the father of modern architecture, had fallen upon hard times during the last decades of his life. After he broke with Adler in 1895, Sullivan designed about twenty buildings on his own, and died in 1924, leaving no complete record of his work. "Now I wasn't very well read at that point, but I never had run across a personality like that, one that was so involved in life," Nickel wrote about Sullivan.

Nickel rediscovered thirty-eight unknown Adler and Sullivan buildings and commissions, and watched as the firm's structures—houses on the South Side as well as factories and skyscrapers in the Loop—were razed for new construction. Appalled by what he was witnessing, Nickel took his first instinctive steps into a second vocation—historic preservation. As Sullivan's lush terra cotta and stone

FROM LEFT: NICKEL AT AGE 8; LEARNING TO USE A CAMERA, AND STANDING CENTER IN FRONT OF HIS FAMILY'S NEW SUBURBAN PARK RIDGE HOME WITH BROTHER DONALD, COUSIN CAROL BOGNAR, MOTHER AGNES, WIFE ADRIENNE, AND FATHER STANLEY IN THE LATE 1940S.

ornament fell at his feet, Nickel scooped it up and created an exceptional collection. And in 1960, Nickel stood up to stop the the demolition of Adler and Sullivan's Garrick Theater Building. He was one of the first people in America to protest the razing of a building solely because of its architectural significance. "Talk about embarrassment," he later wrote. "Someone came up to me, and said 'What the hell do you think you are doing?' All I could say was that I didn't want the building wrecked."

Nickel was transfixed by Sullivan, and overwhelmed by a sense of responsibility to understand, document, salvage and save Sullivan's architecture. But it was not only Adler and Sullivan's work that Nickel cared about. He created a record of Chicago that includes its most famous landmark buildings and new architecture. He watched and photographed the demolition of Henry Ives Cobb's Federal Building and Burnham and Root's First Regimental Infantry, and photographed such new structures as Ludwig Mies van der Rohe's Federal Office Building. Nickel did not dislike modern architecture, but wondered why it so often replaced the city's best old buildings. "In a city of slums, why must the quality buildings be doomed?" he asked in a letter just six months before his death.

This portfolio documents the two decades when Nickel opened his eyes to Chicago, recorded what he saw, and met his death while salvaging items in the wreckage of Adler and Sullivan's Stock Exchange Building. His death on April 13, 1972, was properly ruled accidental. But, as these pictures show, his death was not a total accident. He understood the risk. He returned to the Stock Exchange for the same reason he returned to dozens of other buildings. He couldn't stay away.

Nickel was a documentarian, but his photographs go beyond mere objective documentation. "I prefer to be completely left out as the maker or interpreter," he wrote, "and I don't care whether this is creative photography or not." But he knew that every photographer creeps into every photograph. By deciding what to photograph and how to photograph, he fused an extra level of meaning to his pictures. His feelings and passions came through. He saw his work as a last stand.

Nickel was there to take the final photographs. Somehow, in the midst of the chaotic frenzy of Chicago in the fifties and sixties, he was able to brace himself like he braced his camera, and take intimate photographs that were organized and calm. His photographs of the final moments of Chicago's most significant buildings may look effortless, but they must have been torture. Not only did he have to brave dangerous working conditions, he also had to set aside his anger, frustration and sadness in an effort to

FROM LEFT: IN SOUTH KOREA WITH THE ARMY IN 1951; AT HOME AFTER SALVAGING ORNAMENT FROM AN ADLER AND SULLIVAN HOUSE IN 1968, AND PAUSING WITH HIS FIANCÉ, CAROL SUTTER, FOR A SNAPSHOT TAKEN A FEW DAYS BEFORE HIS DEATH AT THE STOCK EXCHANGE BUILDING IN APRIL 1972.

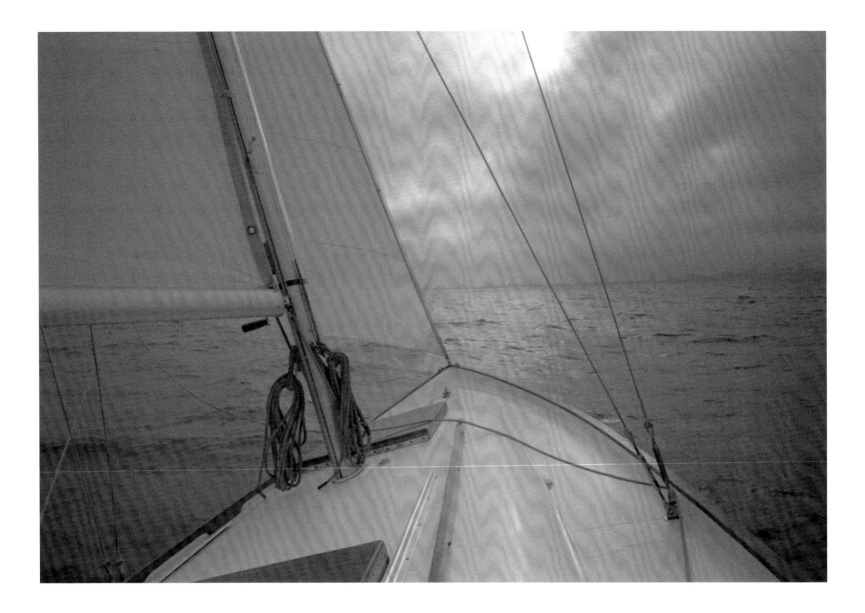

find a few moments of beauty amidst the rubble. Even after a building had been knocked over or cut in two, he still could find insight into Sullivan's genius and celebrate the buildings he loved. His photos are resolute and steeled—like the man who took them.

Significantly, Nickel's work is never nostalgic. He did not fancify the city or the times. For every photo of Marshall Field's on North State Street, he took a picture of seedy South State Street. For every photo of the lacy Rookery Building, he took a picture of the web-like scaffolding that surrounded and marked a building for demolition. Nickel showed clothes hanging on a line, water tanks, smokestacks, freight rail yards, and all the urban bric-a-brac that most people want to avoid, hide, or tear down. His best pictures were dramatic and perfect, taken in the right light at the right time. They didn't come easily.

"I would like to use your plant roof as a viewpoint for a photograph of a building located at 2147 West Lake Street," he wrote officials at the Western Rust-proof Company in July 1957 as he

NICKEL LOVED TO SAIL IN LAKE MICHIGAN OFF CHICAGO DUR-ING THE 1960S AND 1970S. HE WROTE OF HIS BOAT: "I'VE NAMED HER GARDEN CITY AFTER ALL THE IDEALISTS OF EARLY CHICAGO ART HISTORY, AND AFTER CHICAGO'S UNREALIZED POTENTIAL."

planned his photographs of the Richard Knisely Store and Flats. "I spoke to the watchman on Sunday and he said it was simply a matter of getting a note from your office. The important thing that I would like to stress is that I would need access to the roof both early some morning (6-7 a.m.) and/or late some evening 7-8 p.m. Another thing that is difficult is to preselect the day I am very anxious to get this photo made as the sun rises and sets at its northernmost points in June and July." He ended up making the photograph, shown on page 68, from the roof in May 1958.

This is a book about a lost city. Not lost like mythological Atlantis, swept away instantly by the raging sea. But lost in time, slowly changing. Nickel's Chicago was torn down one by one. Some of the buildings he photographed wore away. Others were taken down by would-be urban visionaries who were convinced—so often wrongly—that all this old stuff had to go to make room for a newer, better city.

Some of Nickel's Chicago remains. Kids at play still roam the South Side neighborhoods, and the Polish Constitution Day Parade still marks the changing seasons. Frank Lloyd Wright's masterful Robie House stands proudly in Hyde Park, surviving an attempt in the late fifties to tear it down. But there is a new city now, which rode in with the John Hancock Center and the Civic Center and Marina City. Nickel saw the coming of modern Chicago, and documented that, too.

This is also a book about one man's relationship with his city. Chicago is where Nickel was born and raised—a city of wonder and a city of sadness. He could see it all, and in that he was ahead of his time. He saw richness where others saw barrenness. He saw beauty where others saw decay. His photographs help us see that now—what we failed to see and now so miss—and they remind us what we still possess.

The pace of destruction, like a drumbeat, continued during the 1950s and 1960s, making life increasingly more difficult for Nickel. "Things happen fast now, and if you wait, you're lost," he wrote in 1965. "Real estate deals especially are secretive until they break, then the bulldozers move fast."

While others in Chicago celebrated the building boom that promised to revitalize the aging city, Nickel soldiered on in the trenches of preservation and memory. Nickel ran counter to his culture. He held on to the old, rather than embrace the new. And because of this, he suffered. In 1969, tired and bitter and beat, Nickel told a reporter that he would not continue his fight to document and save the city's architecture. But he returned over and over again. After taking apart, mostly by hand, the facade of the doomed Albert Sullivan residence on the city's South Side, he wrote: "There's nobody in the world who knows what that effort involved."

And then, in early 1972, Nickel's life took a happy turn. He fell in love. Her name was Carol Sutter. He promised her that he would step back from his dangerous obsession, finish his book and get on with his life. They exchanged intimate letters, and made plans to be married. For a time, Nickel seemed to move in another direction. But he returned to the Stock Exchange one more time. It was a glorious work of art that he could not abandon.

Told to stay away, he defied the wreckers that spring day and snuck inside to pick up a cast-off piece of metal and Sullivan ironwork he had squirreled away. Nobody knows exactly what happened. But the floors of the buildings were structurally weak as Nickel headed to the long-abandoned Trading Room. The wreckers didn't know he was there. His body was found beneath the room twenty-eight days later.

Nickel is remembered as a martyr and as an artist. But he was also a philosopher, as his words at the start of each section of this book show.

His long-forgotten photographs are a gift to the city. They speak for him to this day.

Value art. Value life. Don't take them lightly.

Messages as clear as the pictures themselves.

Richard Nickel's Chicago

THE PASSING SCENE

"IN A SENSE, I BELIEVE I WAS UNCONSCIOUSLY TRYING TO
KNOW PEOPLE, TO FIND SOMETHING STRONG AND UNIVERSAL
ABOUT THEM."

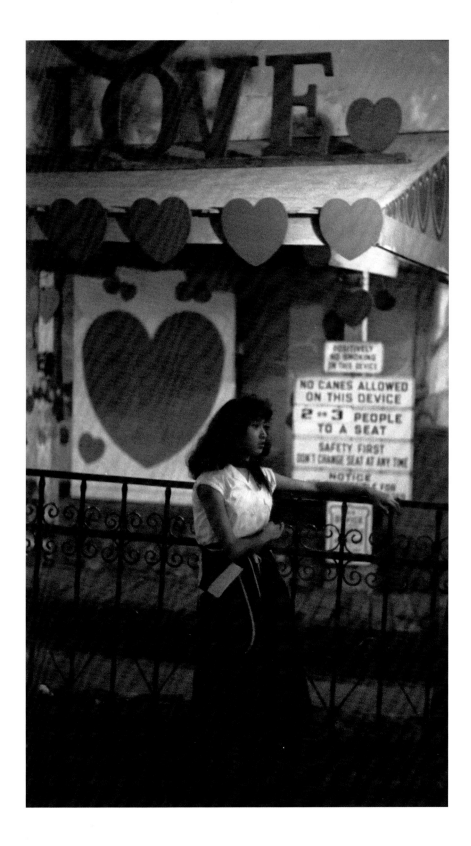

RIVERVIEW PARK, NEAR BELMONT AND WESTERN AVENUES, 1952.

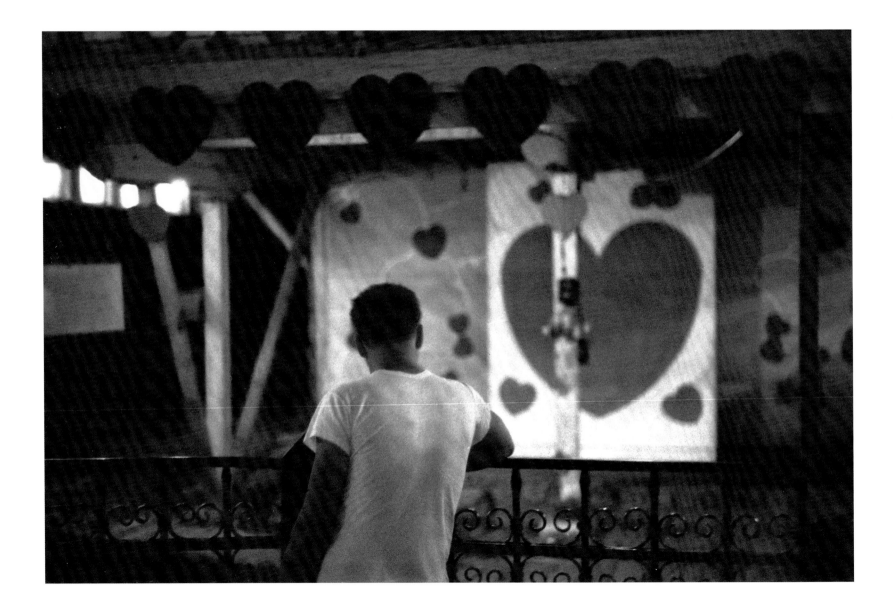

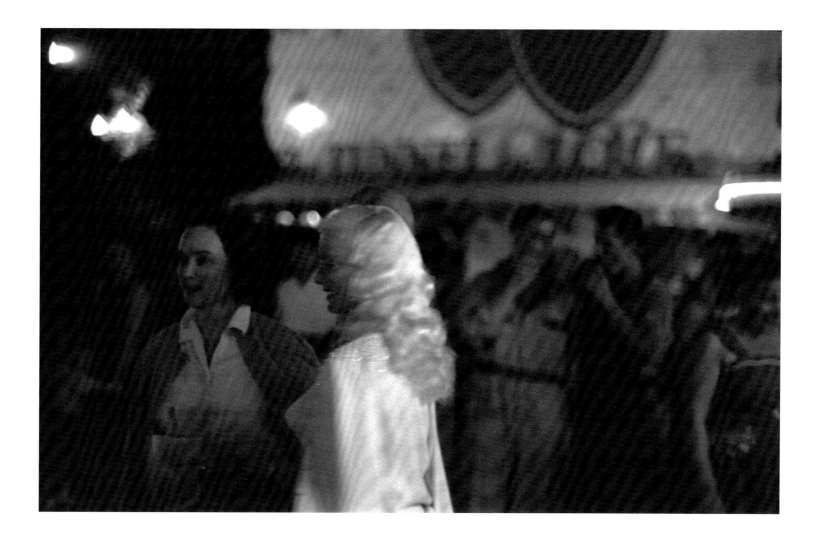

NICKEL PHOTOGRAPHED RIVERVIEW SEVERAL TIMES IN THE 1950S AND 1960. THE PARK WAS
CLOSED IN 1967, AND DEMOLISHED SOON AFTER.

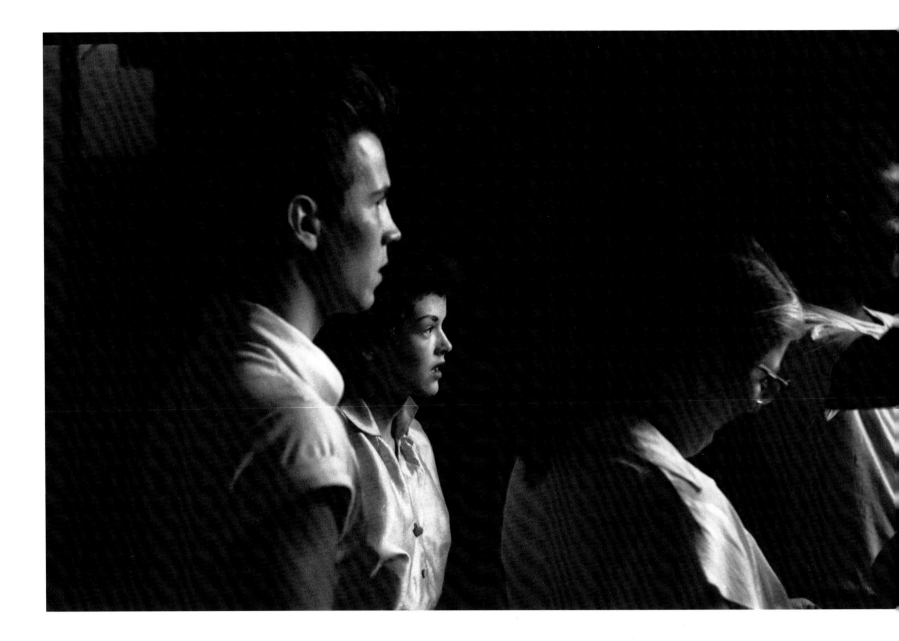

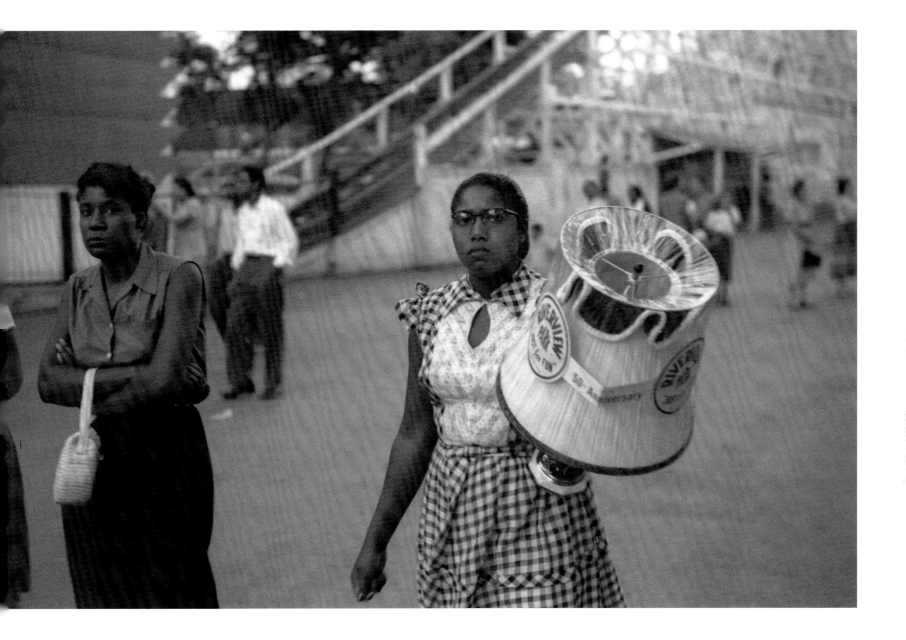

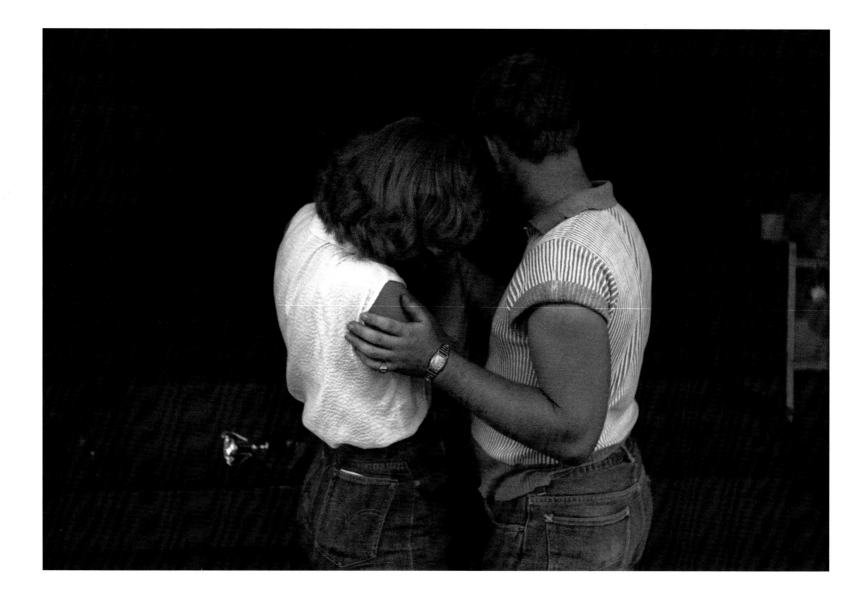

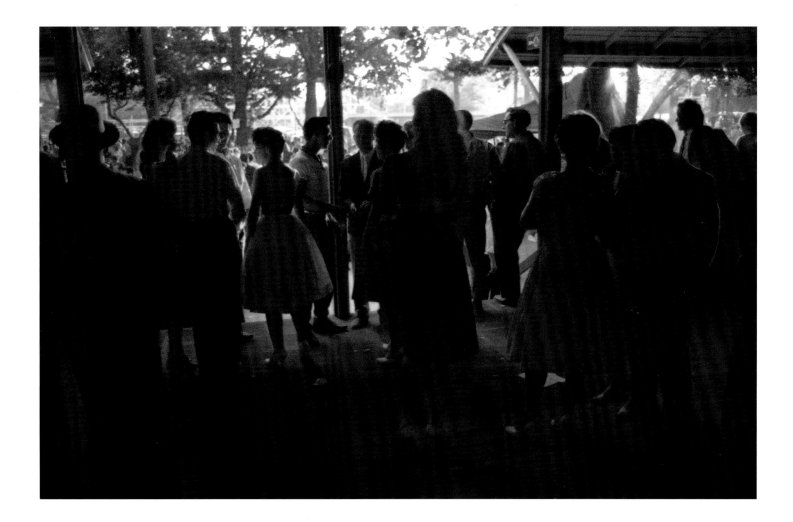

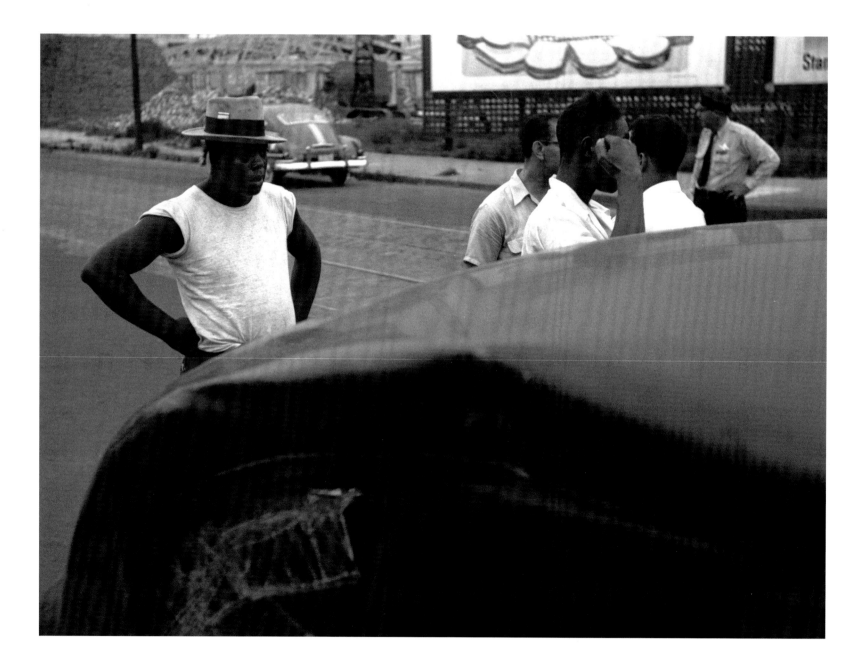

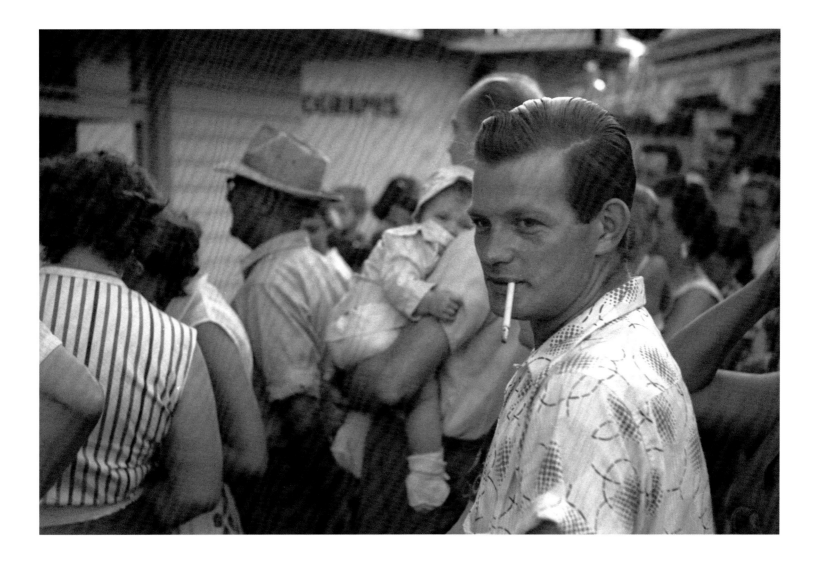

ARLINGTON PARK RACETRACK, 1953. LEFT: AUTOMOBILE ACCIDENT. NICKEL WAS TAUGHT AT THE INSTITUTE OF DESIGN THAT PHOTOGRAPHY IS A MEANS OF EXPRESSION—NOT MERELY A RECORDING DEVICE—TO PERSUADE AND CONVINCE.

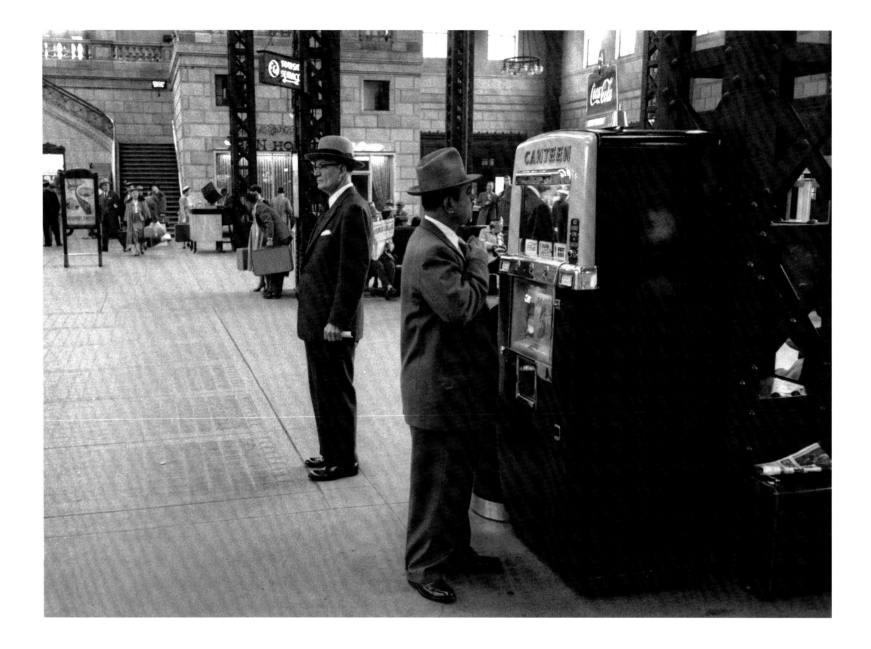

UNION STATION'S PASSENGER CONCOURSE IN 1957. NICKEL WAS COMMISSIONED BY THE UNITED
STATES INFORMATION AGENCY TO DO A PICTURE STORY ABOUT THE TRAVELERS AID SOCIETY. THIS
SECTION OF THE STATION, JUST WEST OF THE CHICAGO RIVER BETWEEN ADAMS AND JACKSON
STREETS, WAS RAZED IN 1969 FOR OFFICE TOWERS.

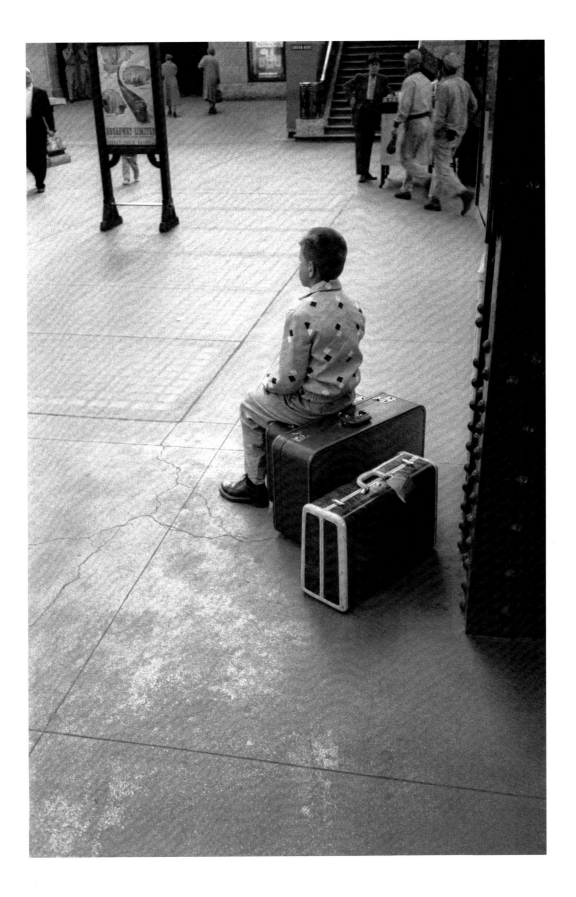

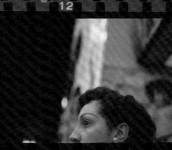

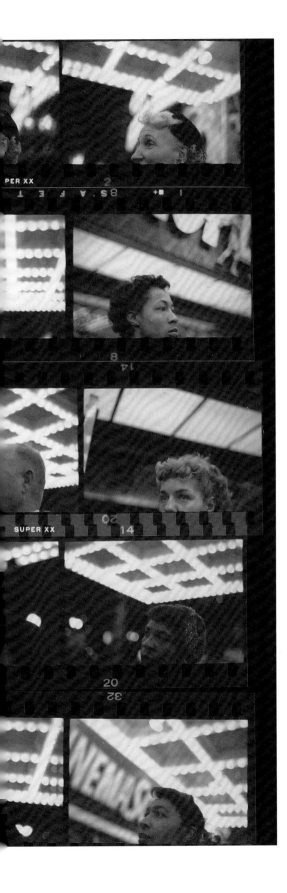

MEN AND WOMEN PASS UNDER THE MARQUEE OF THE STATE-LAKE
THEATER AT 190 NORTH STATE STREET IN 1953. NICKEL WAS
PLEASED WITH THE RESULTS ON THIS PHOTO CONTACT SHEET. HE
LATER WROTE: "WHEN YOU MAKE A DOCUMENT, YOU HAVE TO HOLD
TO THE FACTS."

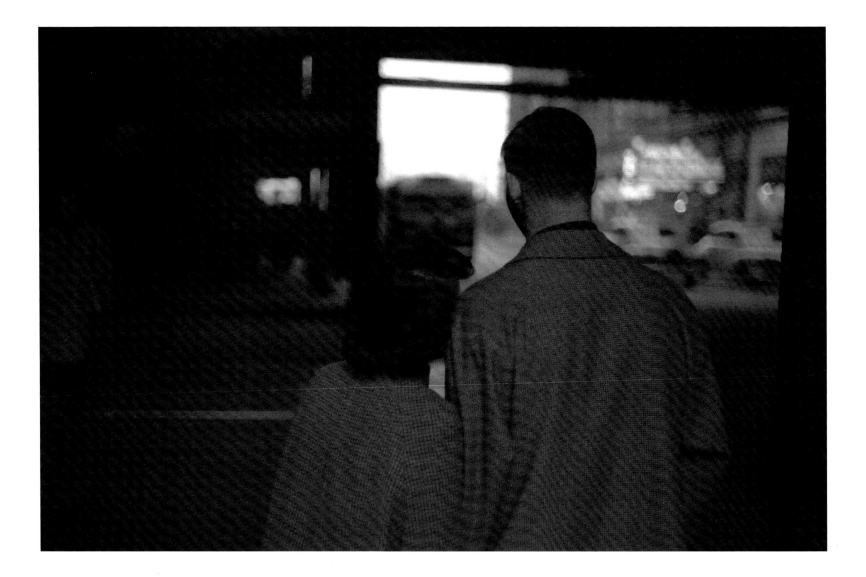

STREET PHOTOGRAPHY IN THE LOOP. ABOVE: A COUPLE UNDER THE WABASH ELEVATED TRACKS AT WASHINGTON STREET. RIGHT: ON SOUTH STATE STREET. NEXT PAGES: OUTSIDE THE MARSHALL FIELD'S STORE. THE PHOTOS ARE REMINISCENT OF THE WORK OF HARRY CALLAHAN, NICKEL'S PHOTO INSTRUCTOR.

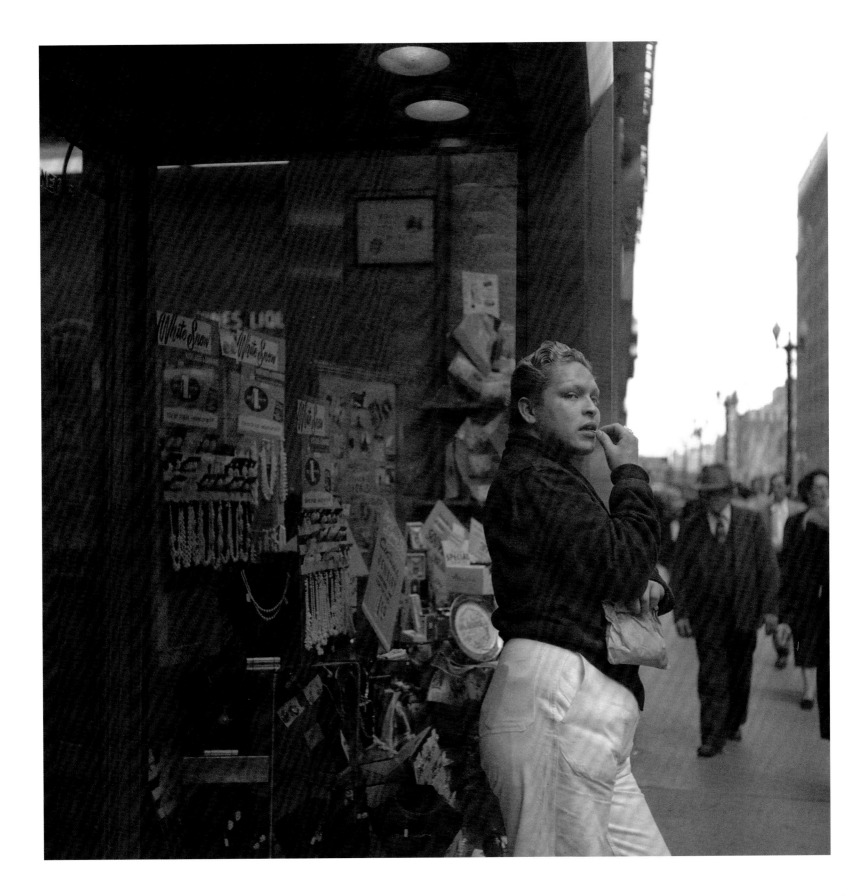

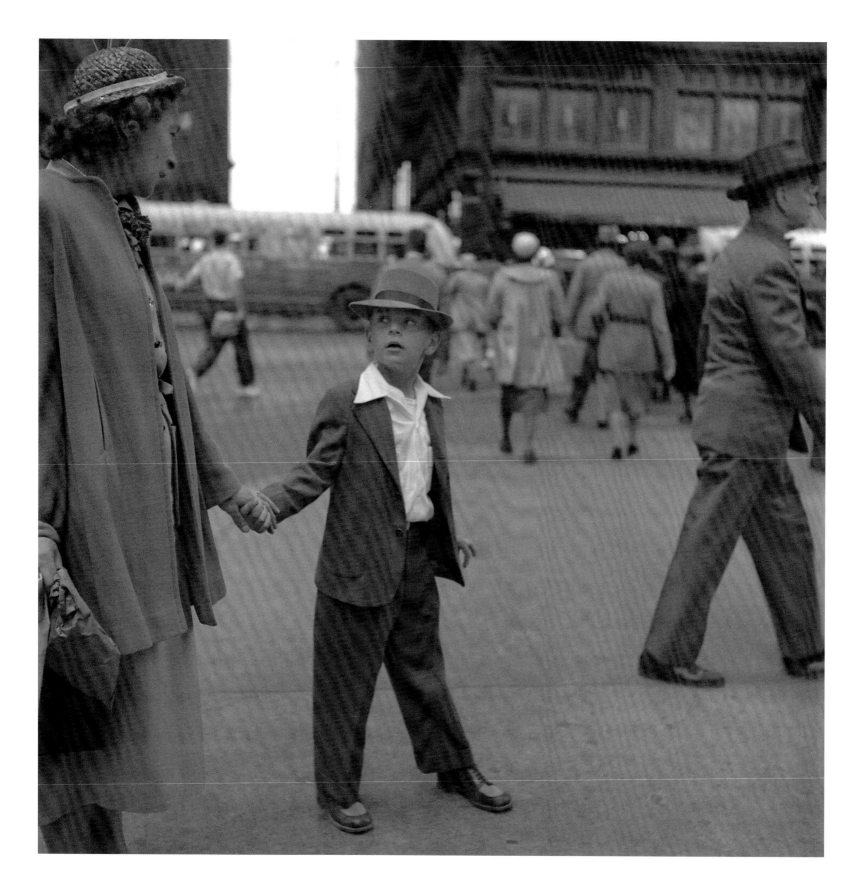

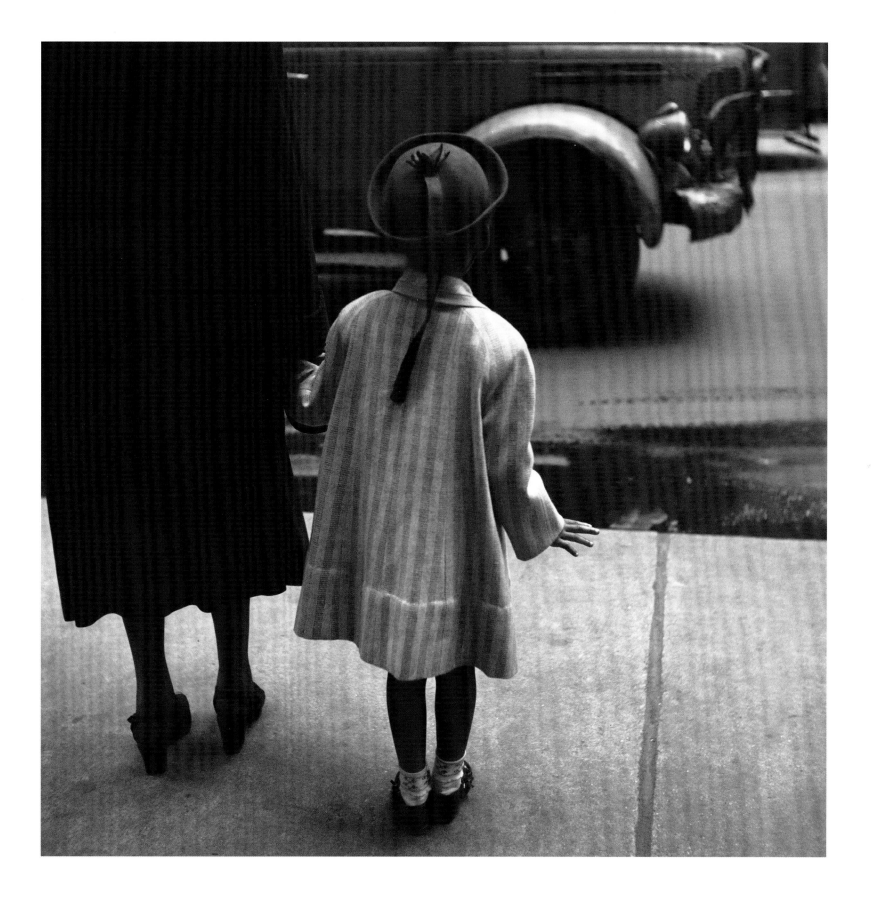

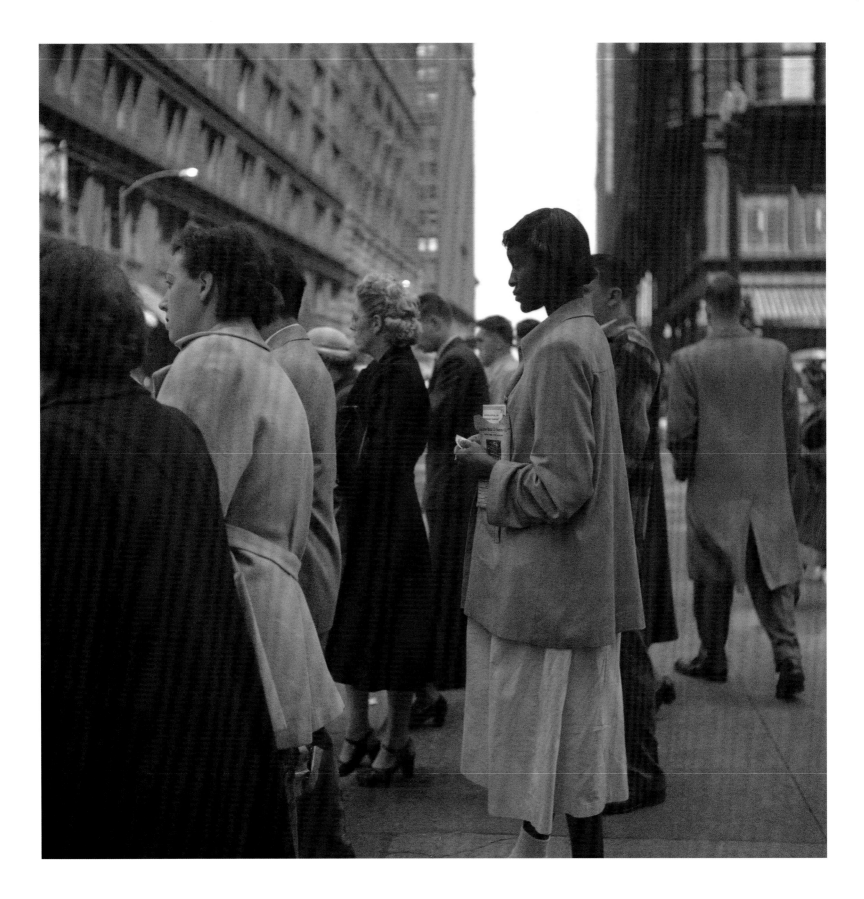

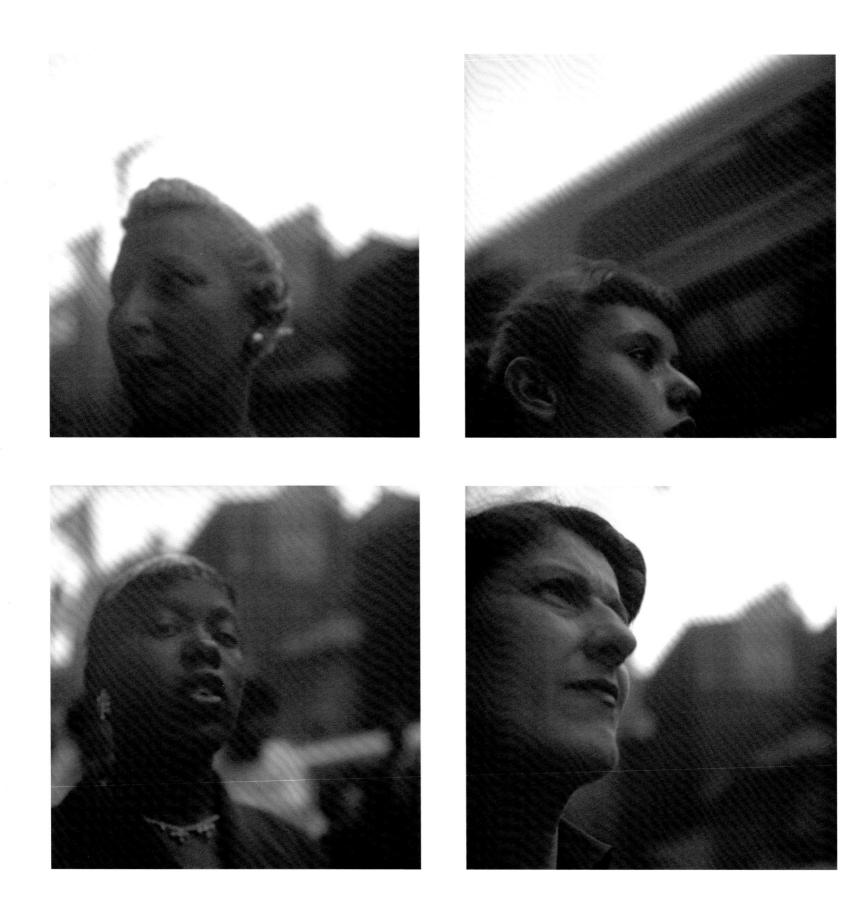

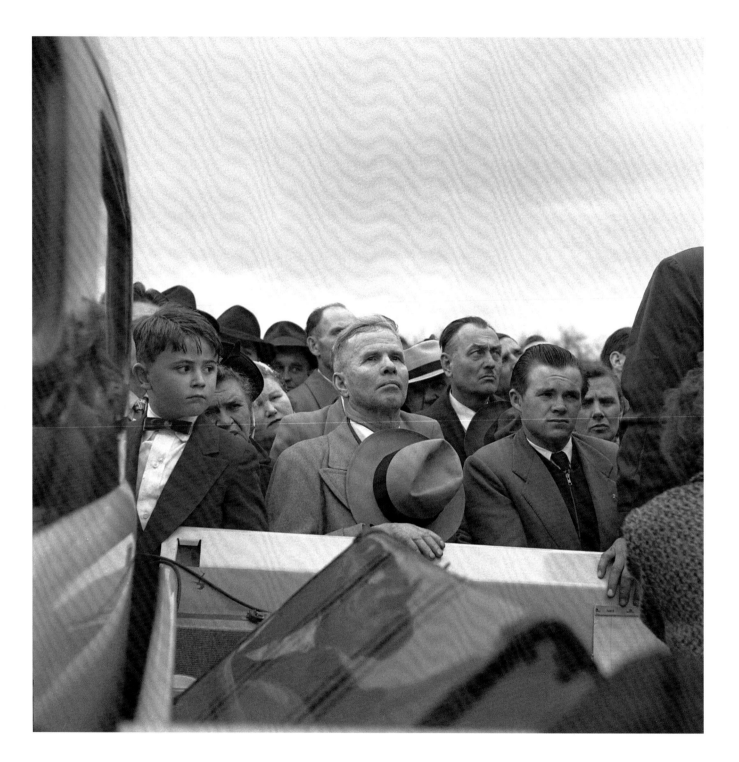

THE POLISH CONSTITUTION DAY PARADE IN 1953. THE MARCH STARTED AT HOLY TRINITY POLISH CHURCH IN THE HEART OF CHICAGO'S POLISH-AMERICAN COMMUNITY, AND CONCLUDED AT HUMBOLDT PARK ON THE CITY'S NORTHWEST SIDE. NICKEL GREW UP IN THIS AREA.

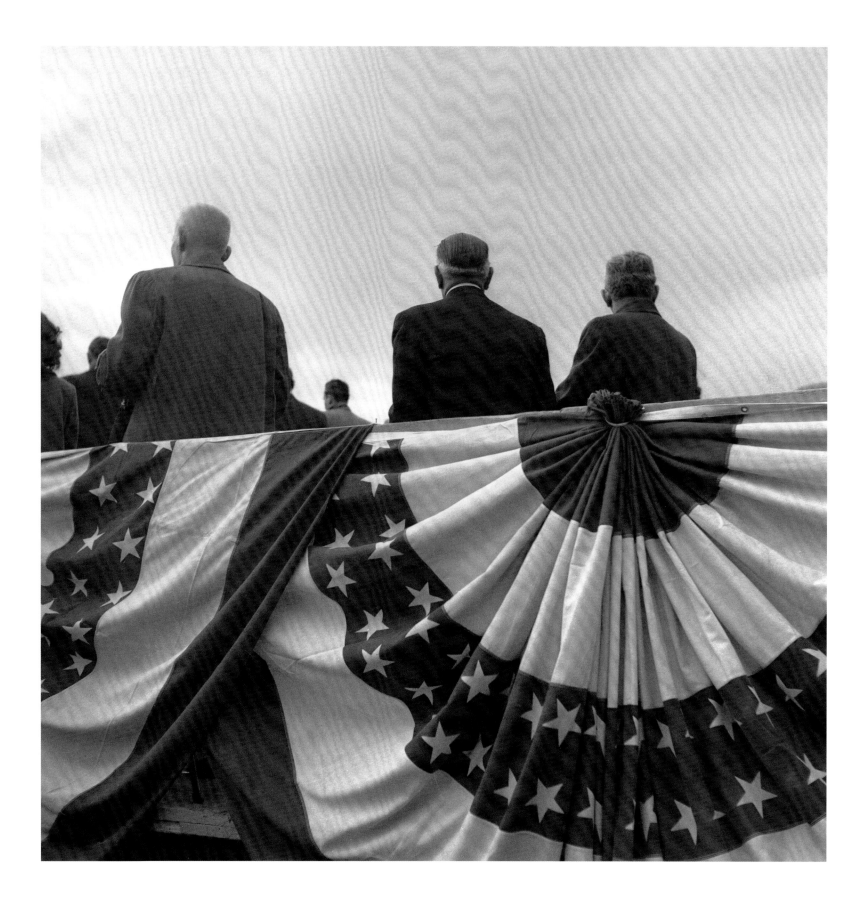

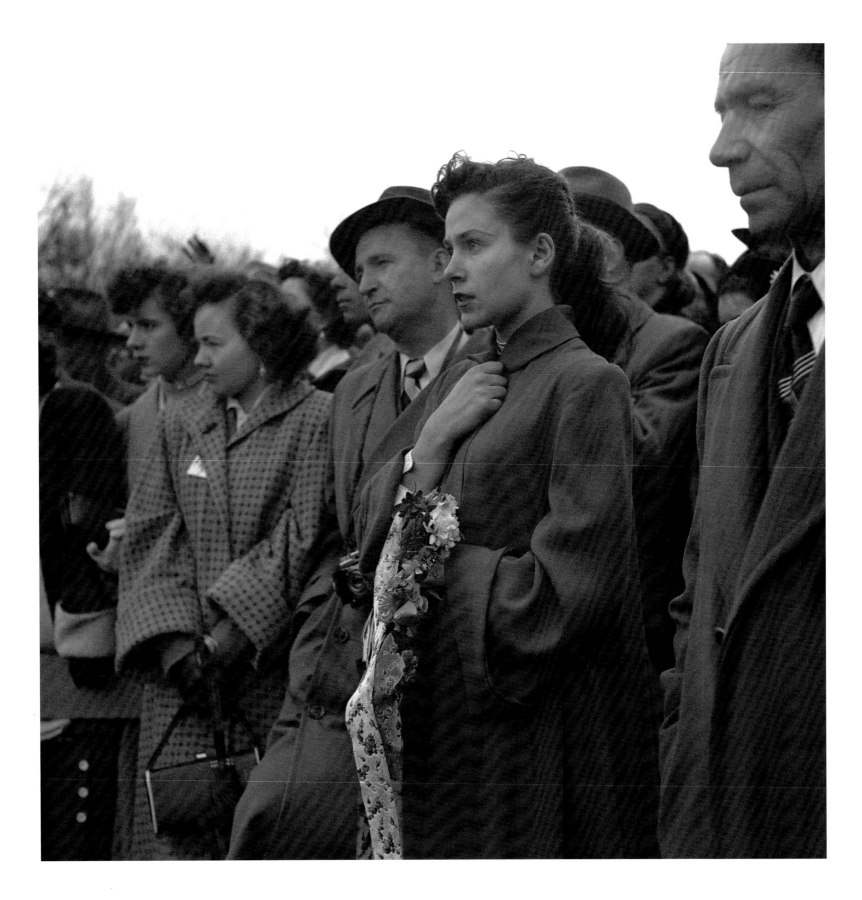

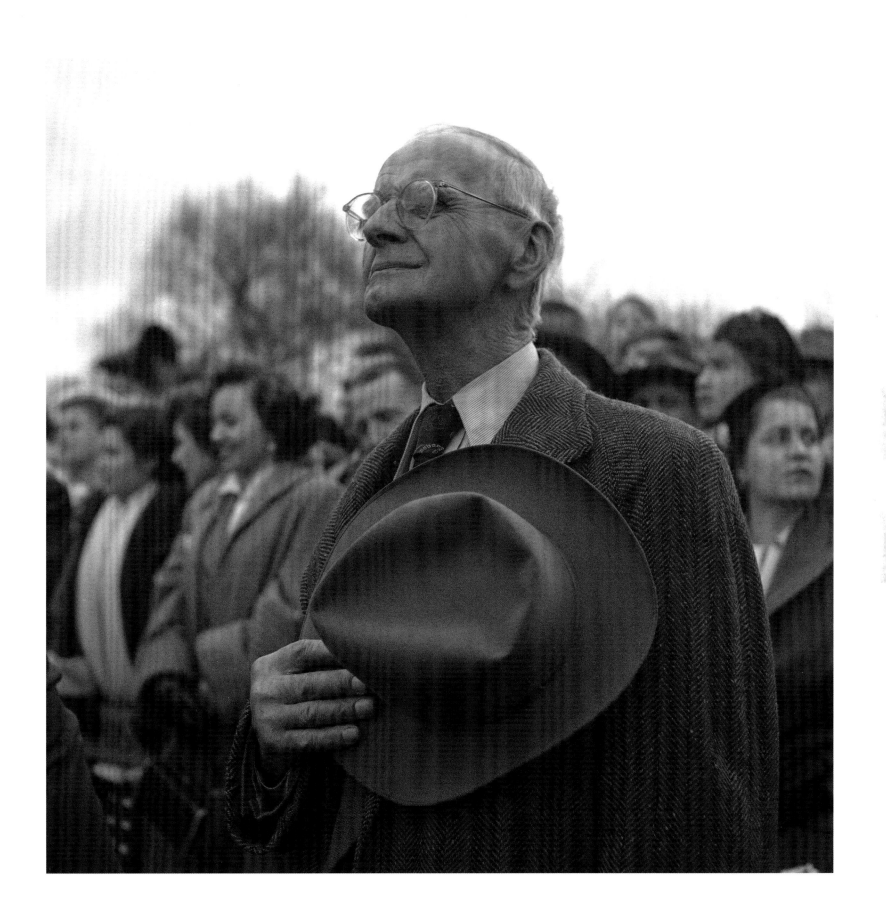

THE CITY BECKONS

"AT THE START, I DIDN'T HAVE THE PROPER EQUIPMENT, AND HAD NEVER GIVEN ARCHITECTURE A SERIOUS THOUGHT."

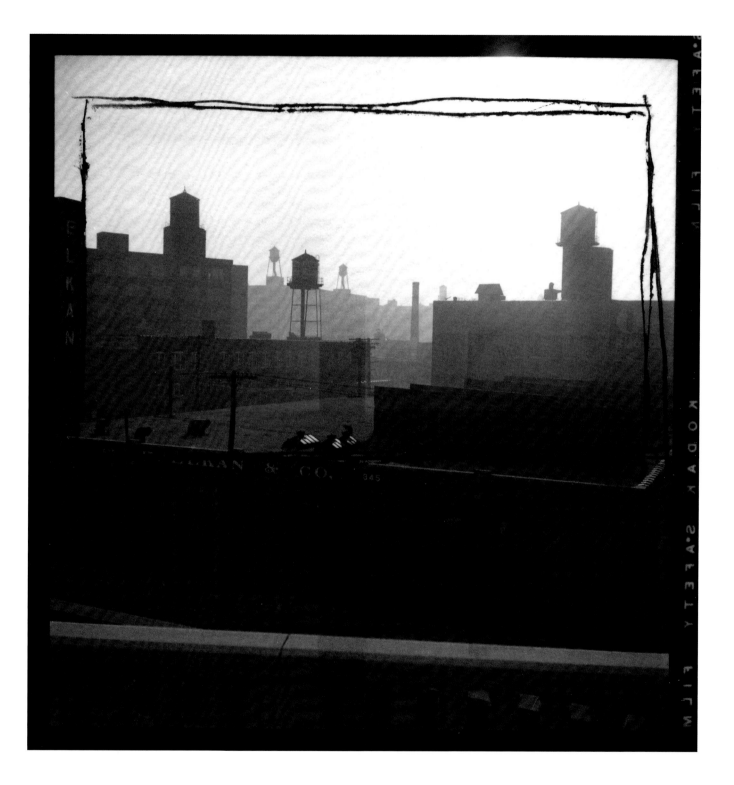

MANY OF NICKEL'S EARLY PHOTOS OF CHICAGO ARCHITECTURE EXIST ONLY ON PHOTO CONTACT
SHEETS, SOME OF THEM MARKED FOR CROPPING PURPOSES. THIS IS THE NORTH SIDE INDUSTRIAL
DISTRICT LOOKING FROM THE ELKAN TANNERY AT 833 WEST HAINES STREET IN 1953.

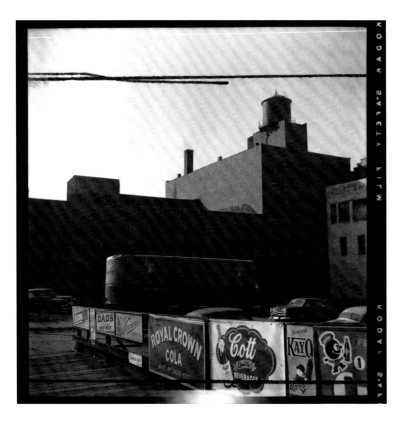

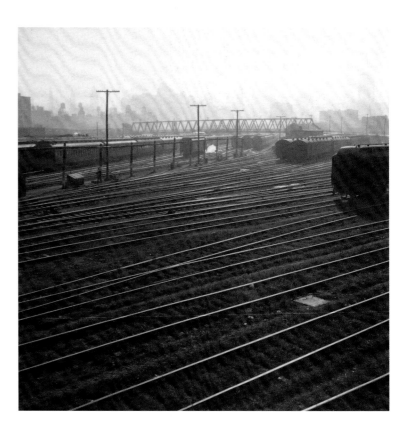

48

NICKEL'S IDEA OF "BEAUTY IN CHICAGO." STREAKING LIGHTS OF CARS ON NORTH LAKE SHORE DRIVE. BOTTOM RIGHT ON LEFT PAGE: THE MILWAUKEE ROAD RAILROAD PASSENGER CAR YARD NEAR WEST GRAND AVENUE. NICKEL WROTE THAT HE ATTEMPTED TO CAPTURE THE MOOD OF THE CITY'S NORTH SIDE RATHER THAN SIMPLY RECORD ITS BEAUTY.

CARS PASS BENEATH THE NORTH AVENUE BRIDGE ALONG LAKE SHORE DRIVE. BOTTOM RIGHT: MIES VAN DER ROHE'S COMMONWEALTH PROMENADE APARTMENT BUILDINGS, COMPLETED IN 1956.

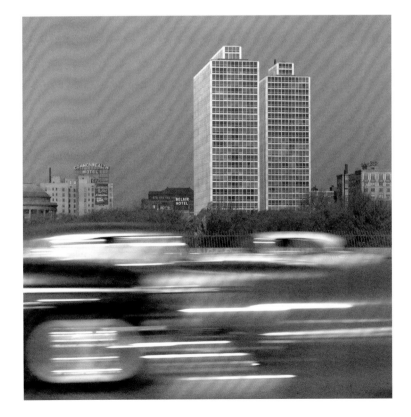

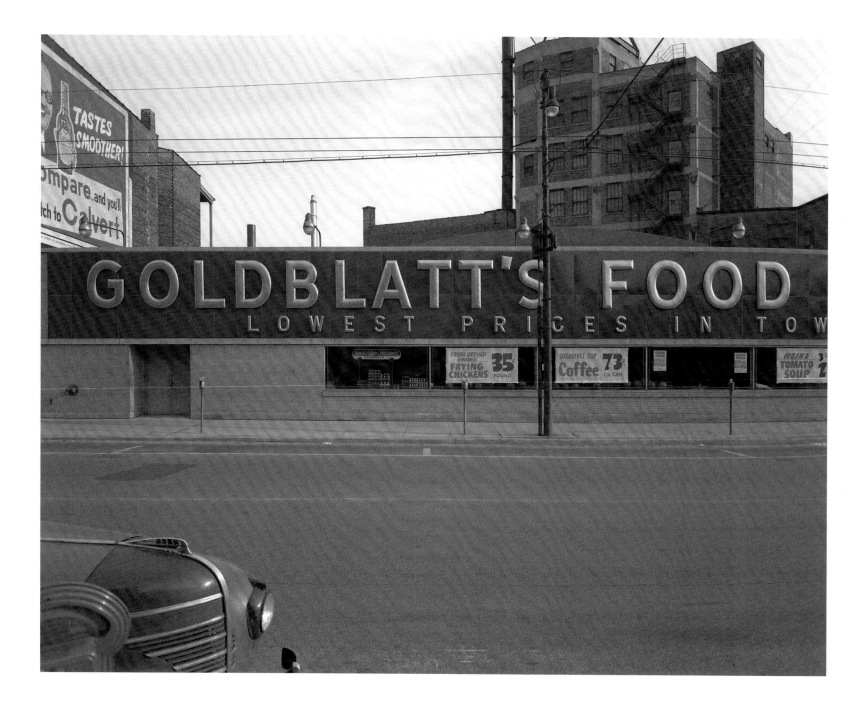

CHICAGO'S NORTH SIDE: ON BELMONT AVENUE JUST EAST OF LINCOLN AVENUE. RIGHT: THE FINKL STEEL FACTORY AT THE CHICAGO RIVER NEAR ARMITAGE AVENUE. "IT'S A VERY SIMPLE MATTER. PHOTOGRAPHY IS MADE UP OF MANY STEPS, AND THINGS OFTEN GO WRONG. ONE DAY YOU DO GOOD, AND THE NEXT DAY YOU DON'T," NICKEL WROTE.

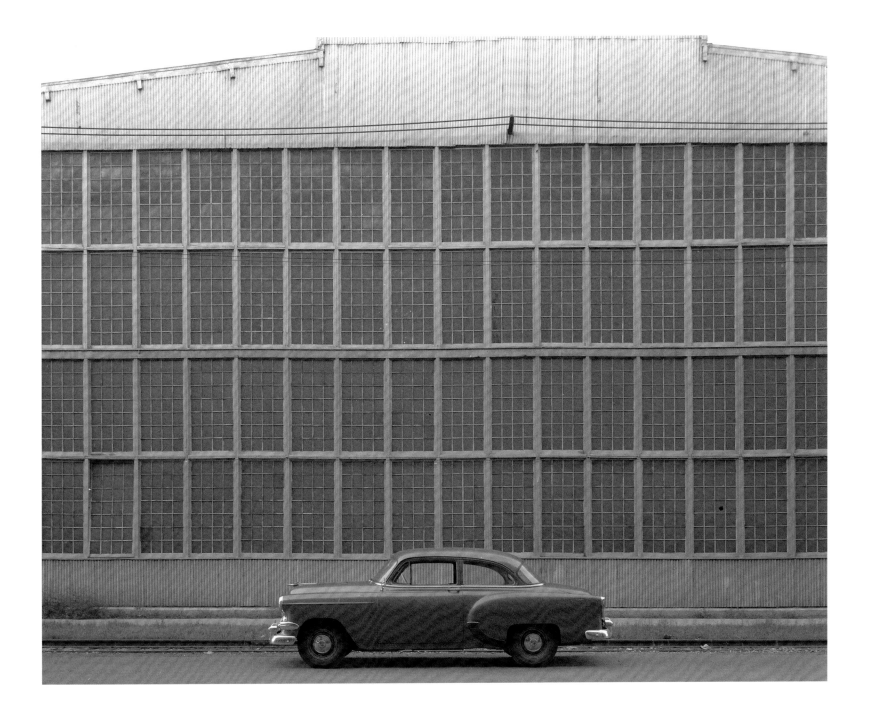

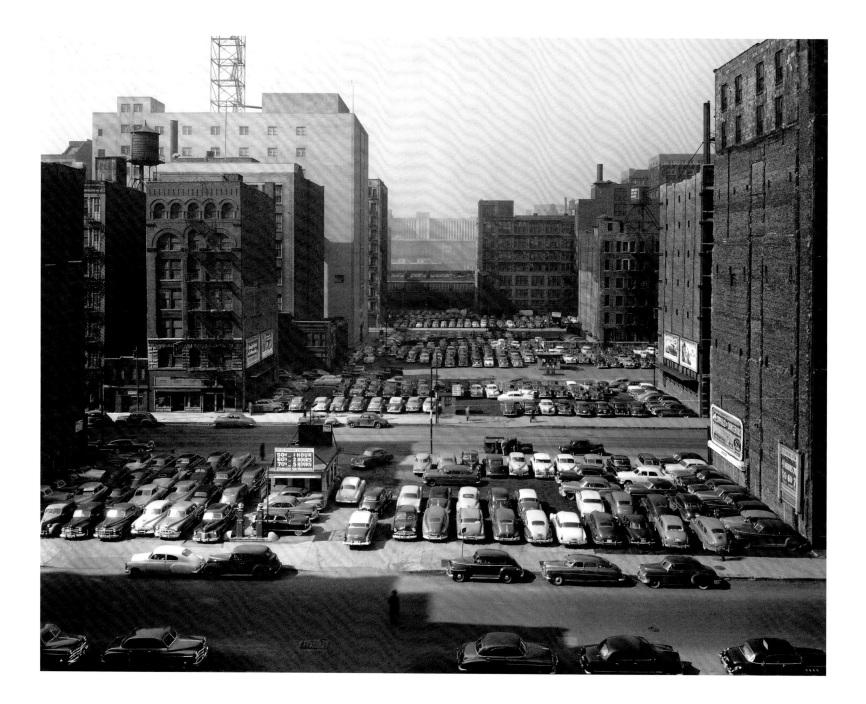

THE LOOP LOOKING WEST TOWARD THE MAIN POST OFFICE FROM STATE STREET IN 1951, BEFORE THE CONGRESS STREET EXPRESSWAY WAS BUILT. RIGHT: BILLBOARD NEAR THE LAKE SHORE DRIVE S-CURVE EAST OF THE LOOP. MONROE HARBOR IS IN THE BACKGROUND. NEXT PAGES: BILLBOARDS, 1953.

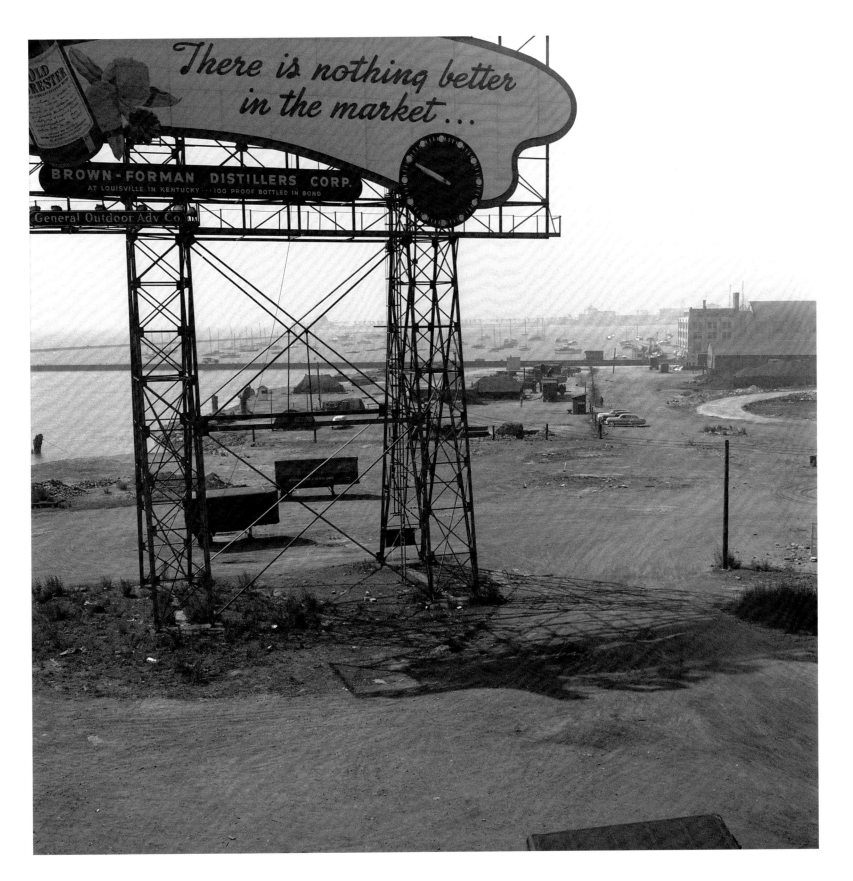

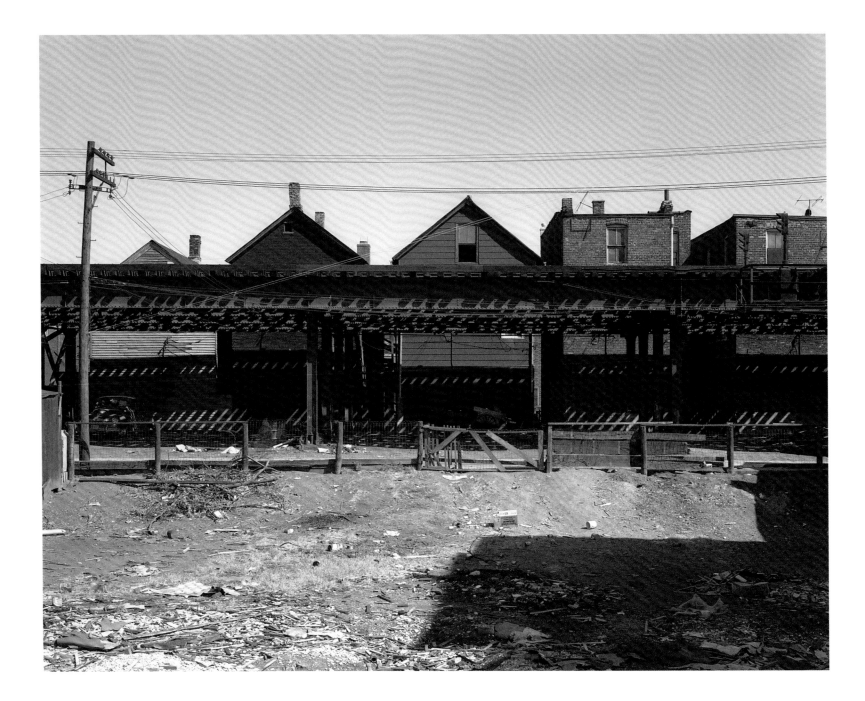

THE RAVENSWOOD ELEVATED TRACKS NEAR CLYBOURN AVENUE ON THE NORTHWEST SIDE.
RIGHT: ALADDIN'S CASTLE, AS SEEN FROM BEHIND, AT RIVERVIEW PARK.

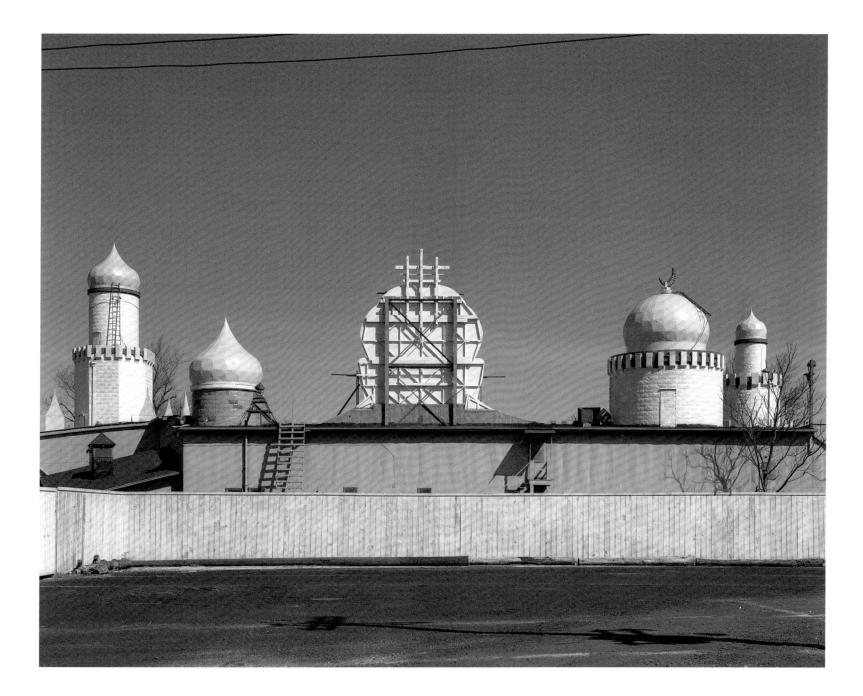

MASTER PIECES

"IN EFFECT, WE FEEL THAT THE HISTORY OF ARCHITECTURE AND THE FORCE WHICH LOUIS SULLIVAN HAD ON THAT ARCHITECTURE WILL NOT BE COMPLETELY REALIZED UNTIL OUR SELF-ASSIGNED WORK IS COMPLETED."

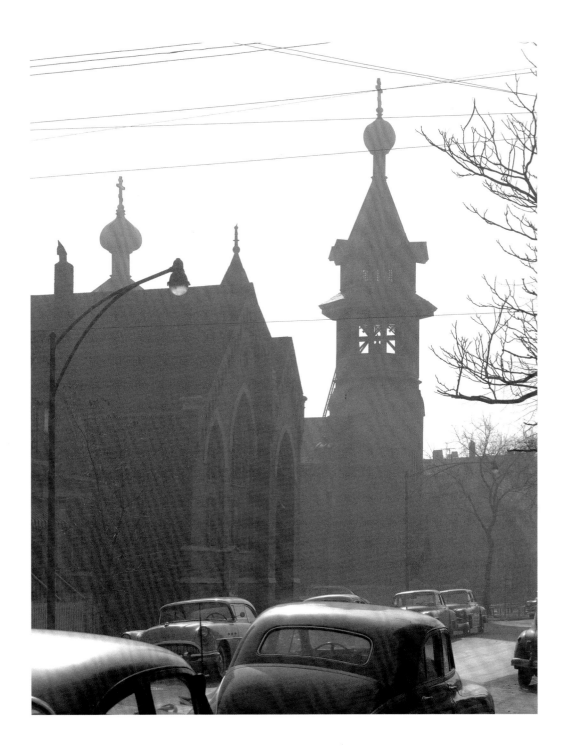

ARCHITECT LOUIS SULLIVAN'S HOLY TRINITY ORTHODOX CHURCH AND RECTORY AT 1121
NORTH LEAVITT STREET. NICKEL BEGAN WORK ON AN ASSIGNMENT IN 1952 TO PHOTOGRAPH
THE ARCHITECTURE OF SULLIVAN AND PARTNER DANKMAR ADLER. THE ASSIGNMENT WOULD
CONSUME THE REST OF HIS LIFE.

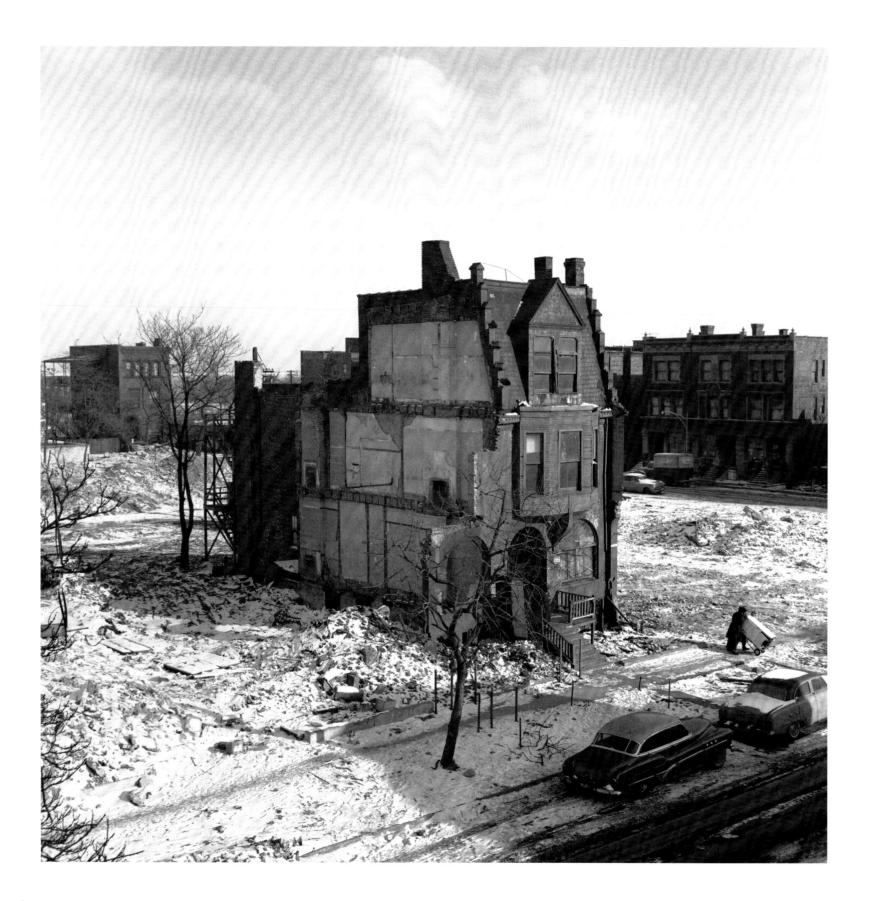

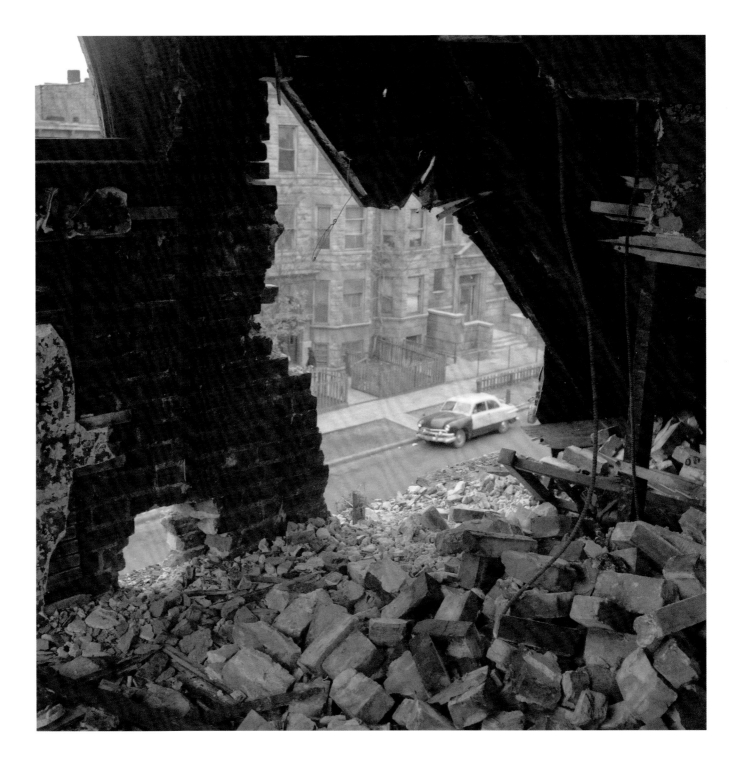

NICKEL SAW MANY BUILDINGS DESTROYED. ABOVE: NICKEL PUNCHED HOLES THROUGH A THIRD-FLOOR WALL OF THE FIRE-RAVAGED MARTIN BARBE RESIDENCE AT 3157 SOUTH PRAIRIE AVENUE TO REMOVE SULLIVAN'S EXTERIOR ORNAMENT. LEFT: METAL SCAVENGERS LEAVE A ROW HOUSE THAT DANKMAR ADLER BUILT FOR HIS FAMILY AT 3543 SOUTH ELLIS AVENUE IN 1961. THE HOUSE WAS TORN DOWN THREE DAYS LATER.

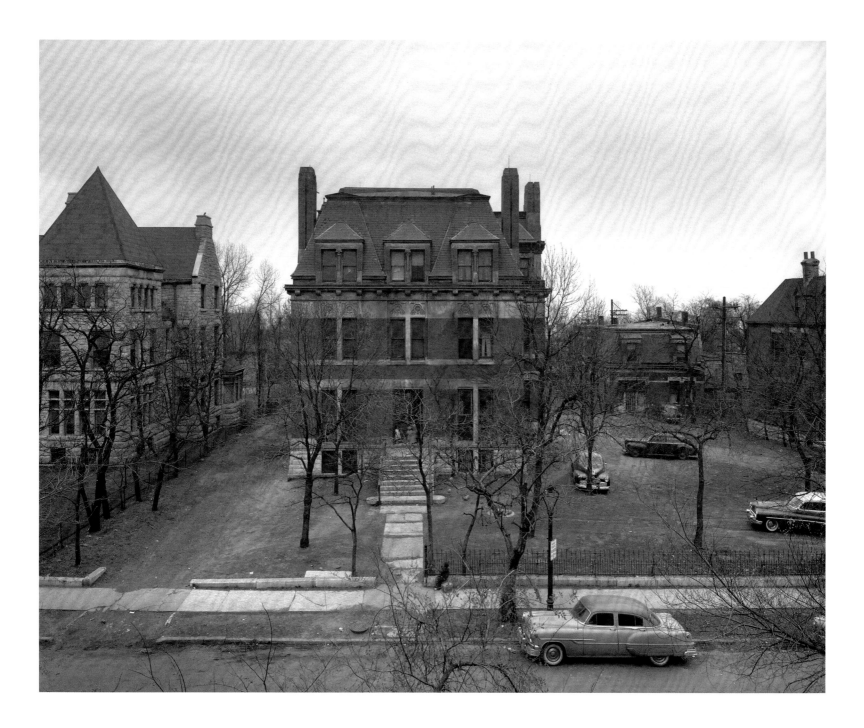

THE JOHN BORDEN RESIDENCE, ADLER AND SULLIVAN'S FIRST CHICAGO HOUSE, WAS BUILT IN 1880 AT 3949 SOUTH LAKE PARK AVENUE. NICKEL PHOTOGRAPHED IT BEFORE IT WAS TORN DOWN IN 1954. RIGHT: THE NEXT YEAR, NICKEL PHOTOGRAPHED THE INTERIOR OF THE CYRUS MCCORMICK MANSION AT 675 NORTH RUSH STREET. JUST BEFORE IT WAS RAZED, ARTISTS HELD A PARTY THERE AND VANDALIZED THE SULLIVAN-DESIGNED INTERIOR.

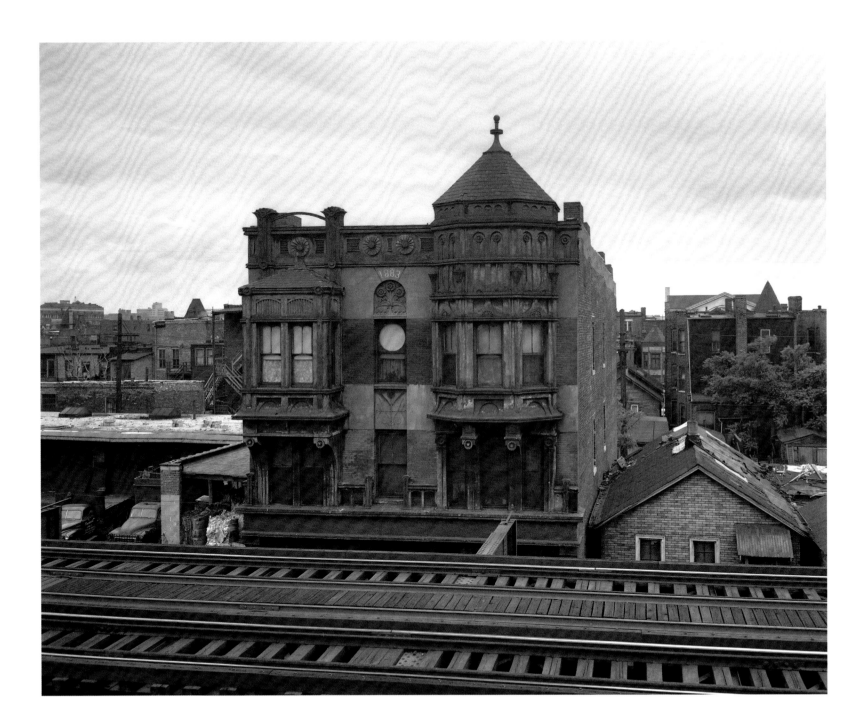

NICKEL USED A PUBLISHED LIST OF ADLER AND SULLIVAN BUILDINGS TO LOCATE THE FIRM'S WORK,
BUT SOON LEARNED THAT THE LIST WAS FAR FROM COMPLETE. IN 1954, NICKEL DROVE ALONG
THE WEST SIDE LOOKING FOR A BUILDING MENTIONED IN A SULLIVAN BIOGRAPHY, AND FOUND
SULLIVAN'S CHARACTERISTIC ORNAMENT ON THIS BUILDING AT 2147 WEST LAKE STREET.

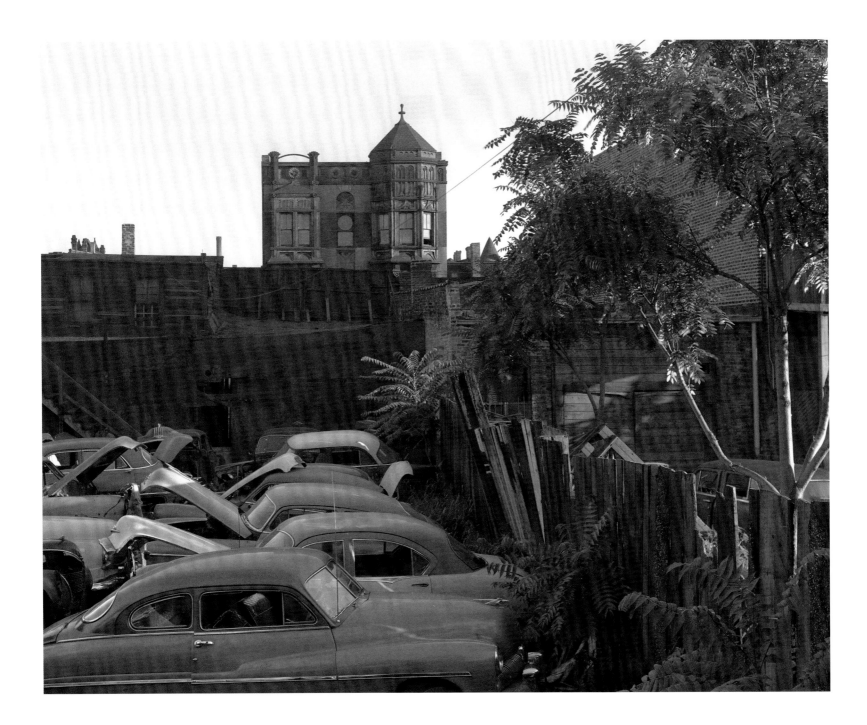

CITY RECORDS CONFIRMED THAT THE STRUCTURE WAS DESIGNED BY ADLER AND SULLIVAN. THE RICHARD KNISELY STORE AND FLAT WAS TORN DOWN IN 1958. "I SUFFERED A GREATER DISAPPOINTMENT ON THAT BUILDING BECAUSE THEY FAILED TO LET ME KNOW WHEN THE WRECKING WOULD START. WHEN I ARRIVED ON THE SCENE ONE DAY, THE BUILDING WAS HALF DOWN YOU CAN IMAGINE HOW I FELT AT THAT MOMENT," NICKEL WROTE.

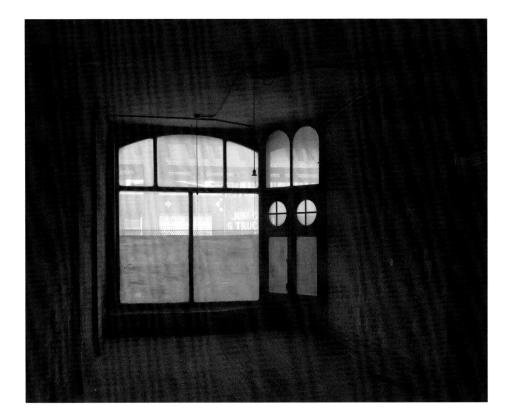

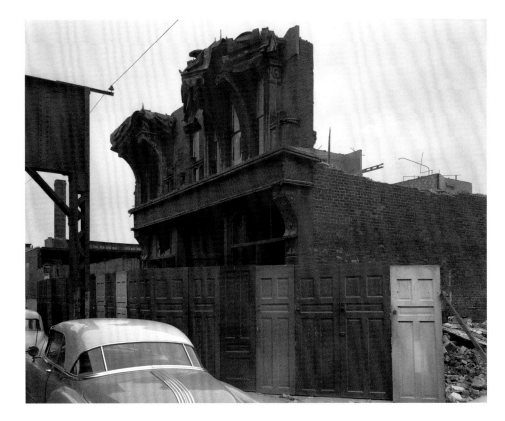

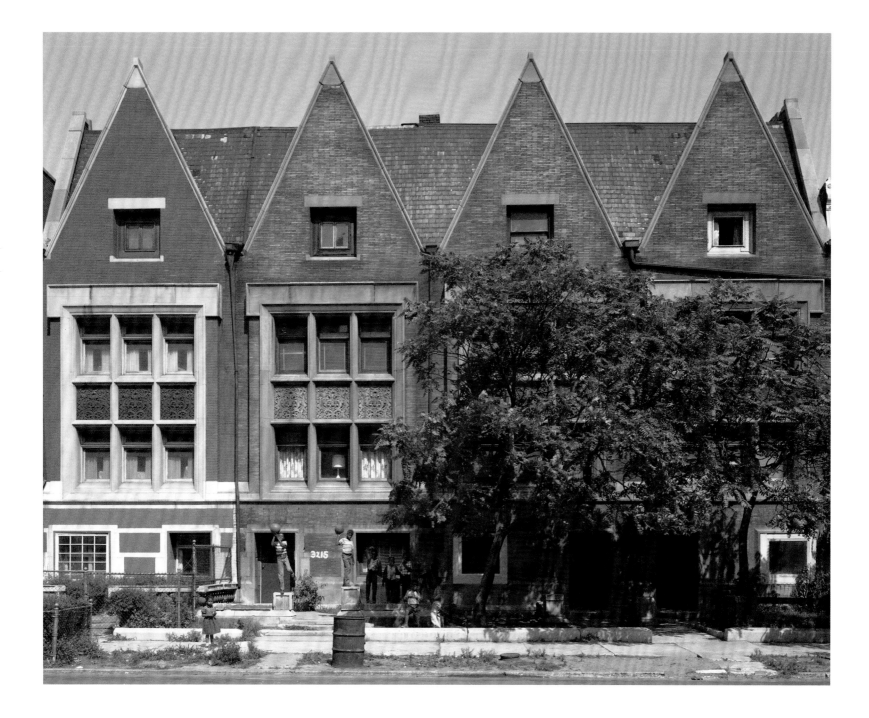

THE ROLOSON HOUSES AT 3213-19 SOUTH CALUMET AVENUE WERE DESIGNED BY FRANK LLOYD
WRIGHT IN 1894, JUST AFTER HE LEFT THE FIRM OF ADLER AND SULLIVAN. RIGHT: ONE OF THREE
MAX M. ROTHSCHILD HOUSES, DESIGNED BY ADLER AND SULLIVAN IN 1884 AT THE SOUTHWEST
CORNER OF INDIANA AND 32ND STREET. THE HOUSES WERE DESTROYED BY FIRE IN 1966.

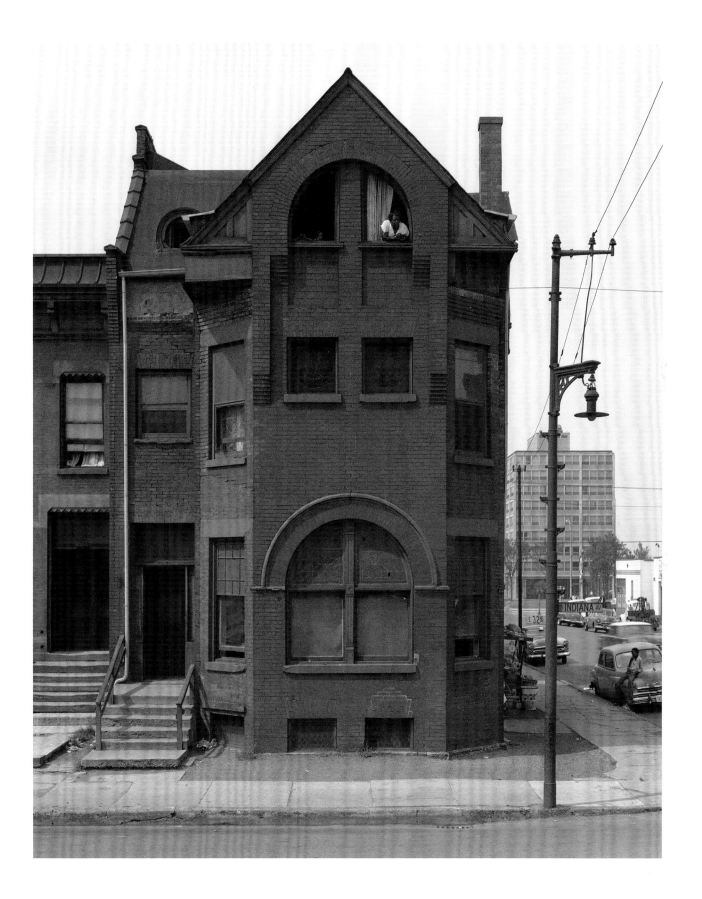

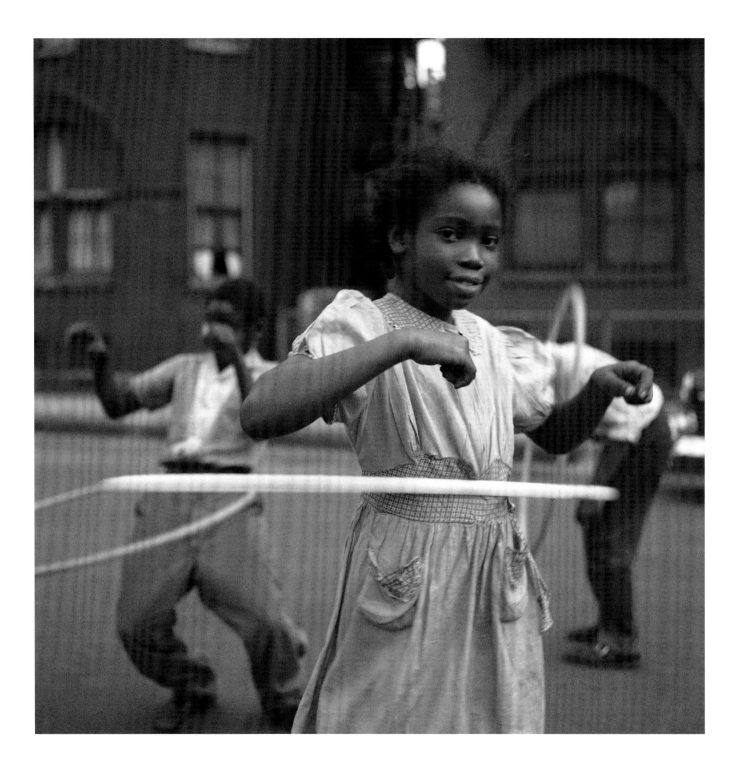

CHILDREN POSED FOR NICKEL AND WONDERED WHY HE SPENT SO MUCH TIME IN THEIR NEIGHBORHOODS. THESE PHOTOS WERE TAKEN IN FRONT OF THE ROTHSCHILD HOUSES.

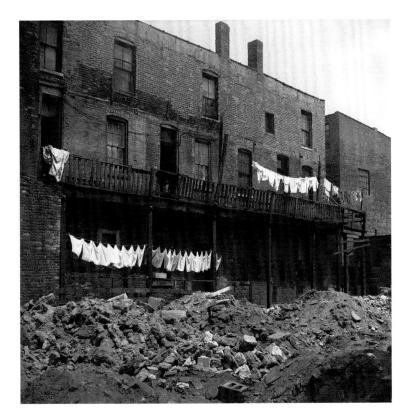

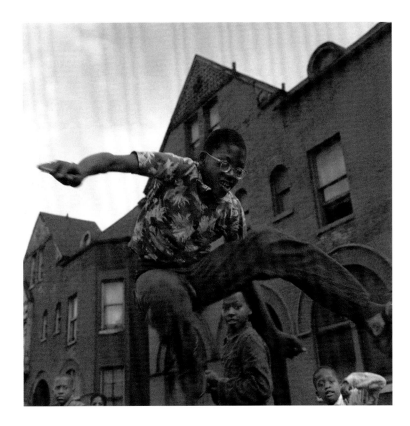

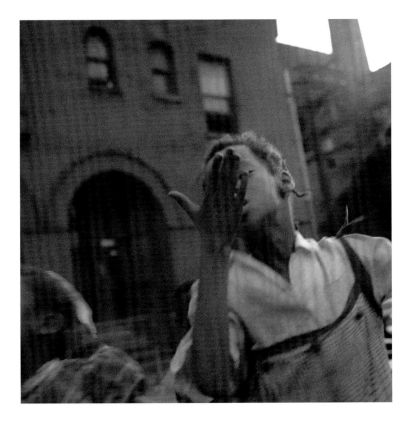

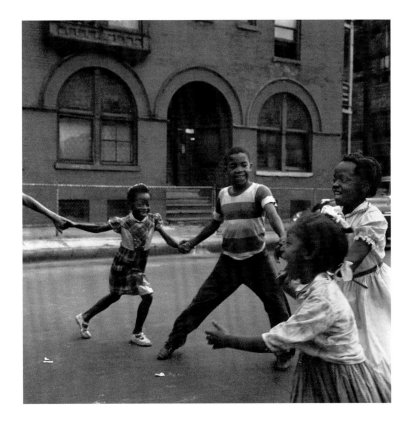

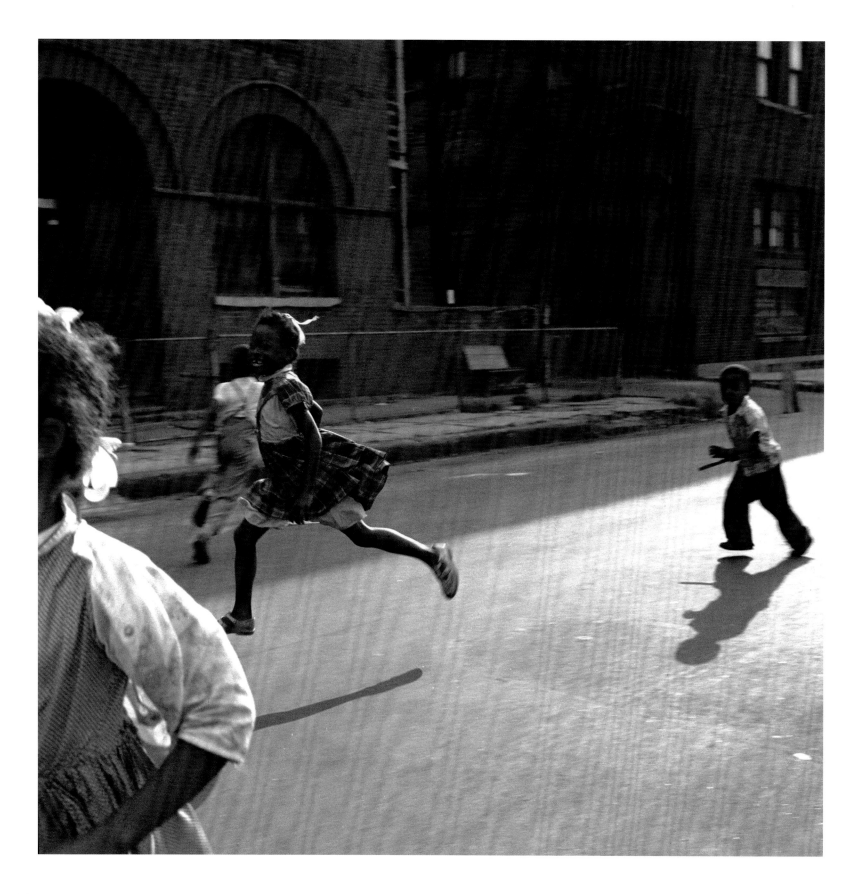

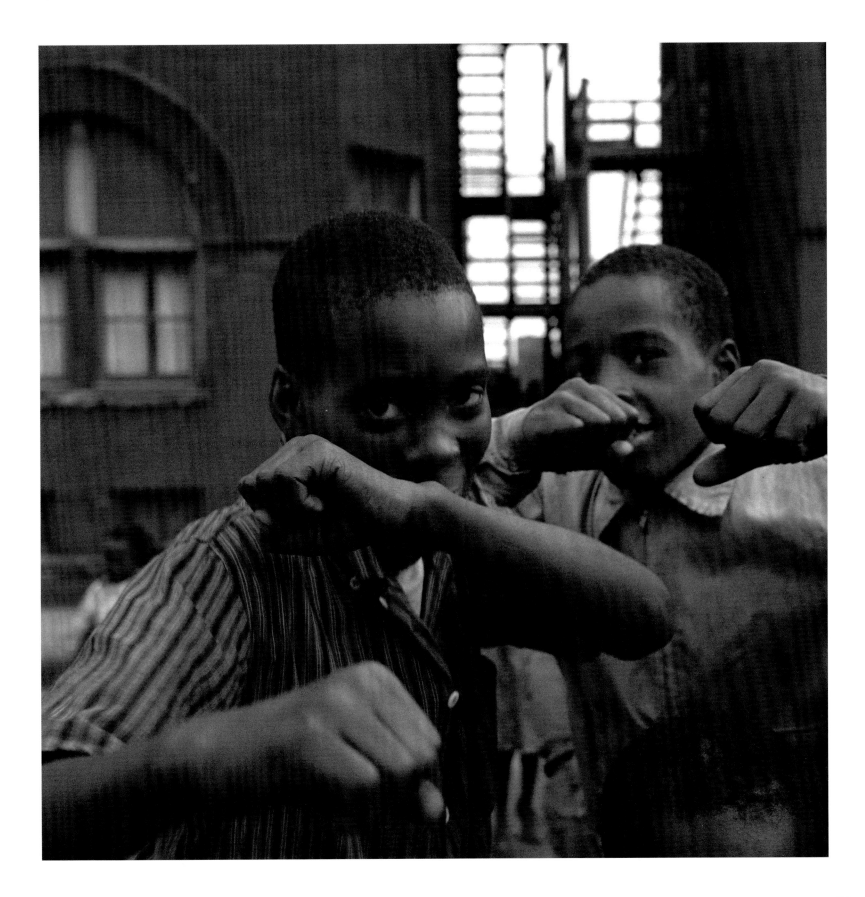

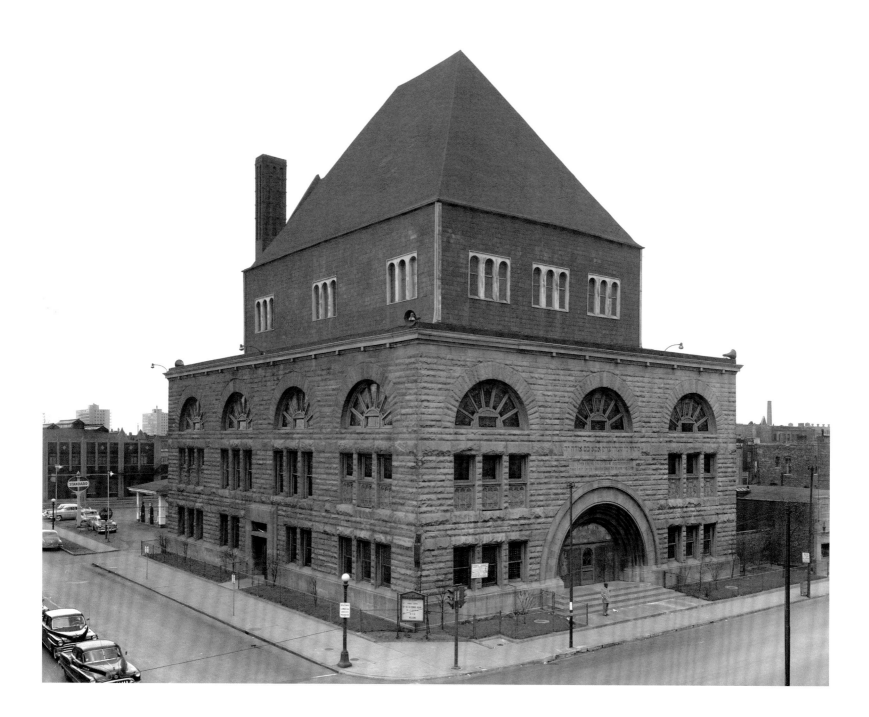

THE FRONT AND BACK OF ADLER AND SULLIVAN'S 1890 PILGRIM BAPTIST CHURCH AT THE
SOUTHEAST CORNER OF 33RD STREET AND INDIANA AVENUE. "WE WERE INTERESTED IN GEN-
ERAL OVERALL SHARPNESS, AND IN A SIMPLE AND DIRECT POINT OF VIEW," NICKEL WROTE. THE
CHURCH, CONSIDERED THE BIRTHPLACE OF GOSPEL MUSIC, WAS BUILT AS THE KEHILATH ANSHE
MA'ARIV SYNAGOGUE. THE STRUCTURE WAS GUTTED BY FIRE IN 2006.

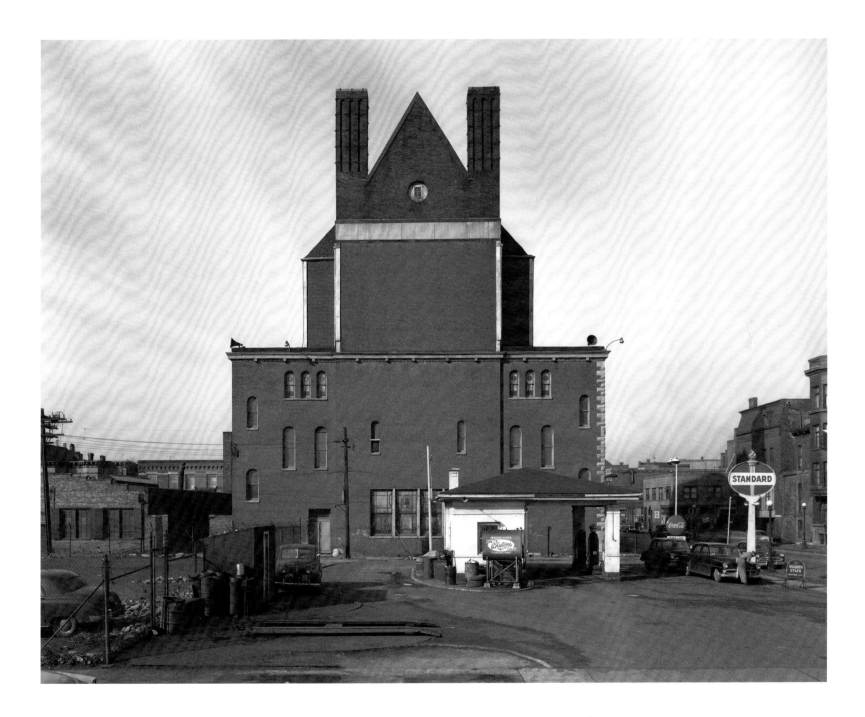

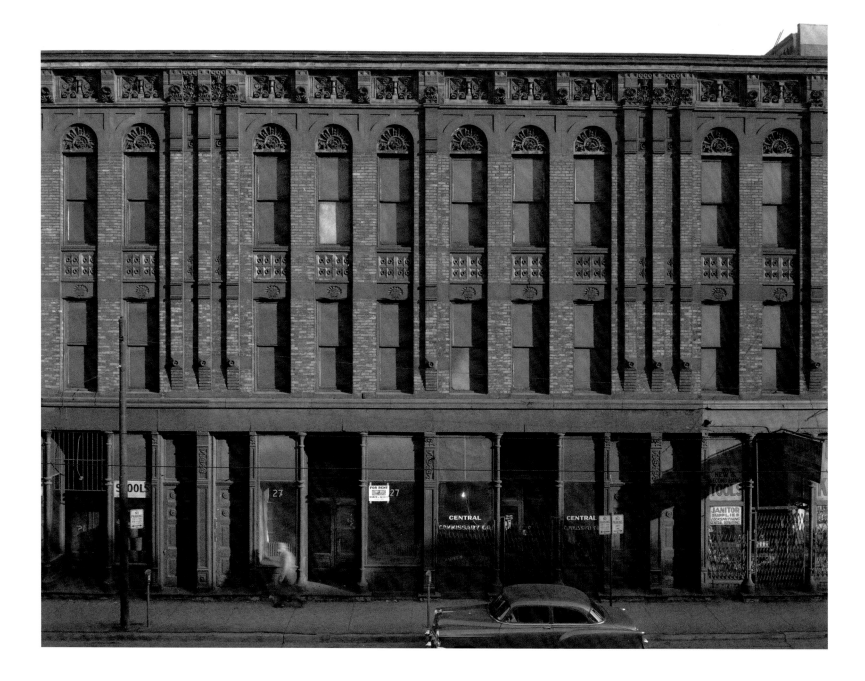

ADLER AND SULLIVAN'S LEVI ROSENFELD BUILDING AT THE SOUTHEAST CORNER OF WASHINGTON BOULEVARD AND HALSTED STREET. "WHILE DOING FINAL RESEARCH ON THE BUILDING, ON OCTOBER 24, 1958, WHICH IS UNDERGOING DEMOLITION, I WAS ON THE ROOF OF THE 1881 STORE-APARTMENT SECTION," NICKEL WROTE. "A STRONG WIND PULLED MY ROSENFELD NOTES INTO THE AIR." HE SAVED MOST OF THEM.

ADJACENT ADLER AND SULLIVAN FACTORIES: THE SCOVILLE BUILDING (FOREGROUND) AND THE PETTIBONE PRINTING COMPANY WAREHOUSE IN THE WEST LOOP. BOTH WERE DEMOLISHED IN THE 1970S AND REPLACED BY THE SOCIAL SECURITY ADMINISTRATION BUILDING. RIGHT: THE EUSTON AND COMPANY LINSEED OIL AND LINOLEUM PLANT, ALONG THE NORTH BRANCH OF THE CHICAGO RIVER ON KINGSBURY STREET BETWEEN BLACKHAWK AND EASTMAN STREETS. A SMALL SECTION OF THE FACTORY REMAINS.

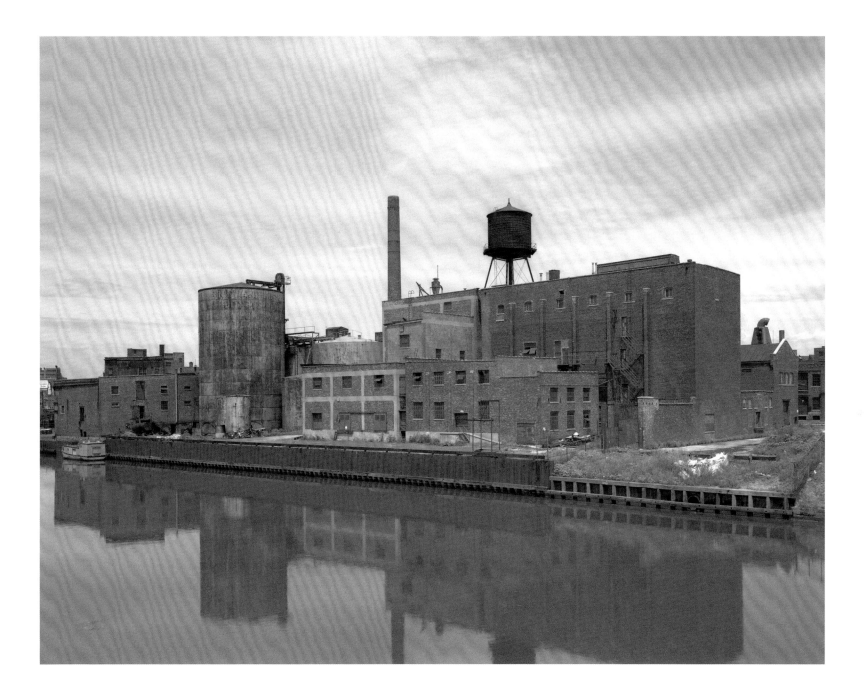

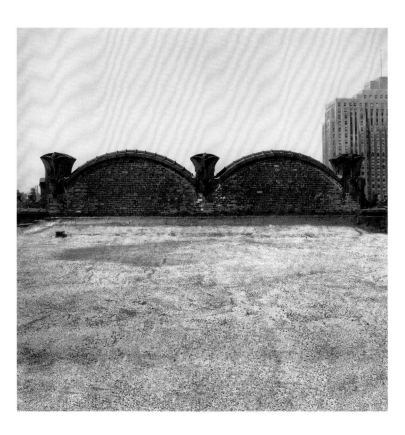

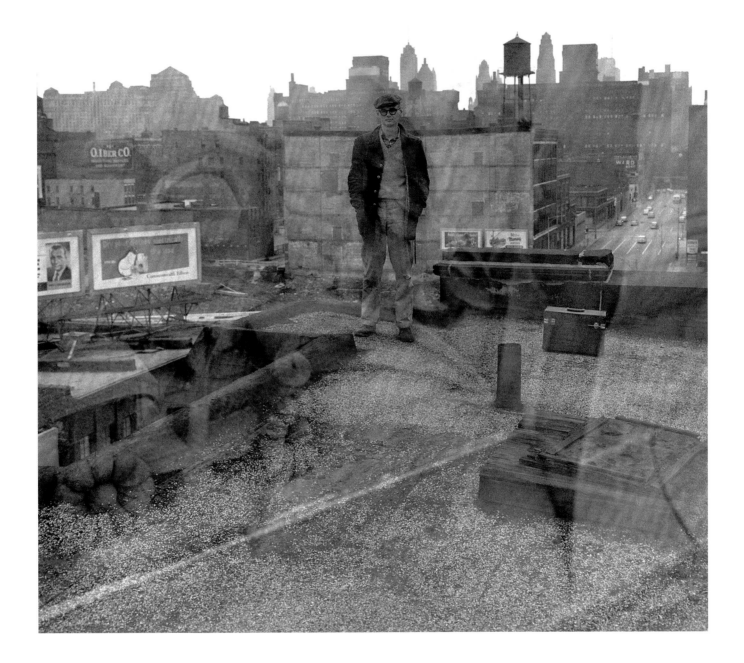

THIS DOUBLE-EXPOSURE OF NICKEL ATOP THE ROSENFELD BUILDING IS OVERLAID BY ORNAMENT FROM THE BUILDING. LEFT PAGE, CLOCKWISE FROM TOP LEFT: A LOOP VIEW OF THE BOSTON STORE; ATOP THE ROSENFELD BUILDING; ADLER AND SULLIVAN'S TROESCHER BUILDING IN THE WEST LOOP, AND THE FIRM'S LINDAUER RESIDENCE ON THE SOUTH SIDE.

MONUMENTS

"THE PROBLEM WITH LANDMARKS—THE BASIC PROBLEM—IS THAT
MATERIAL THINGS ARE SHORT-LIVED, EASILY REPLACEABLE IN
THE USA."

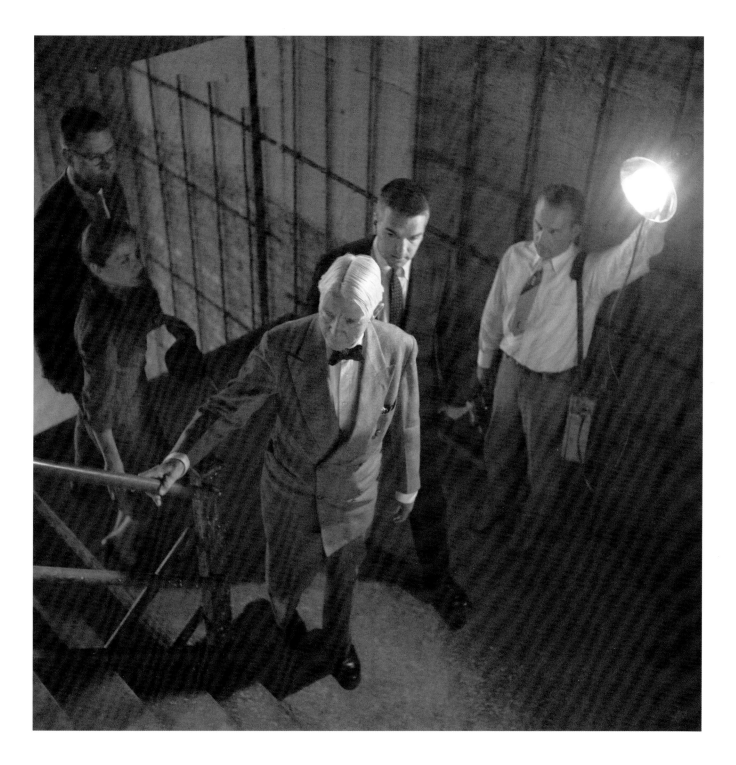

CARL SANDBURG TOURED CHICAGO FOR THREE DAYS IN 1957 TO GATHER MATERIAL TO UPDATE HIS FAMOUS "CHICAGO" POEM. HERE HE IS GUIDED THROUGH THE MUTUAL TRUST LIFE INSURANCE COMPANY BUILDING AT 110 NORTH WACKER DRIVE BY ARCHITECT GEORGE DANFORTH.

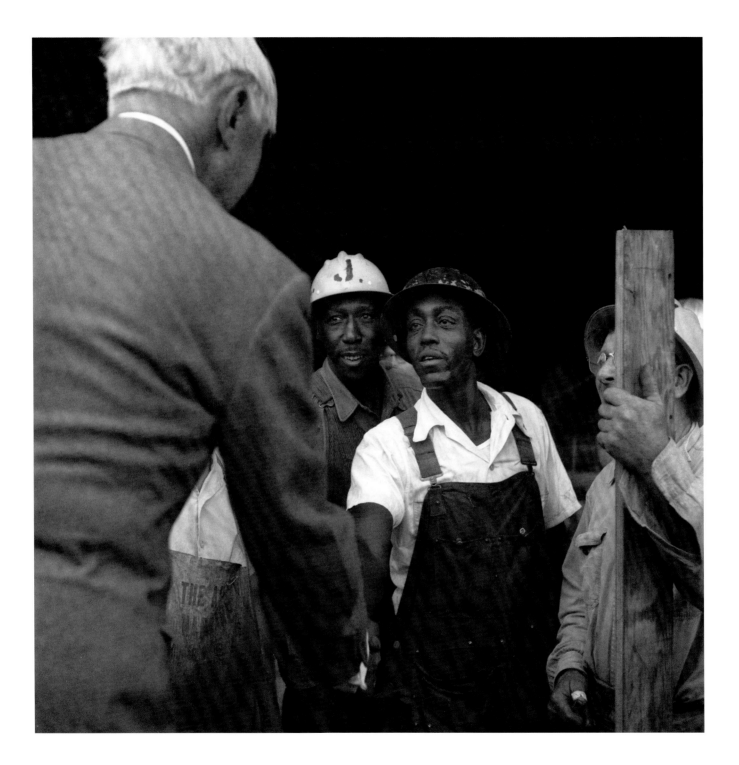

SANDBURG, WHO LIVED IN CHICAGO FROM 1912 TO 1928, MET WITH CONSTRUCTION WORK-
ERS AND CITY OFFICIALS INCLUDING MAYOR RICHARD J. DALEY, AND TOOK A CRUISE DOWN
THE CHICAGO RIVER. "BEING PROBABLY THE YOUNGEST PERSON TO FOLLOW HIM ABOUT, MR.
SANDBURG ADOPTED ME AS THE 'MASCOT' OF THE GROUP," NICKEL WROTE.

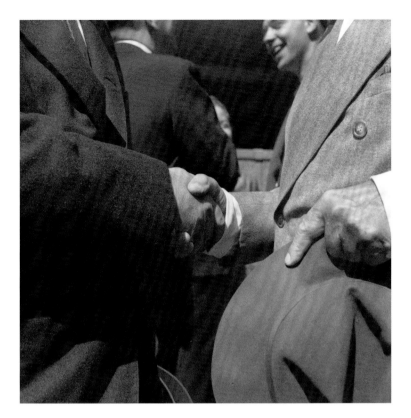

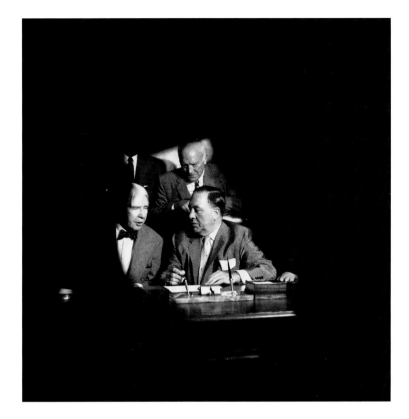

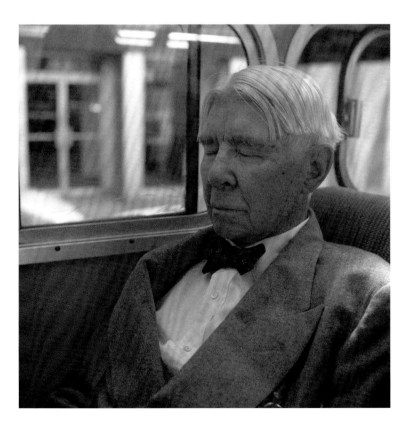

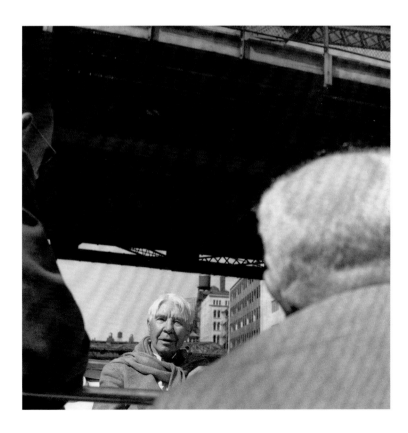

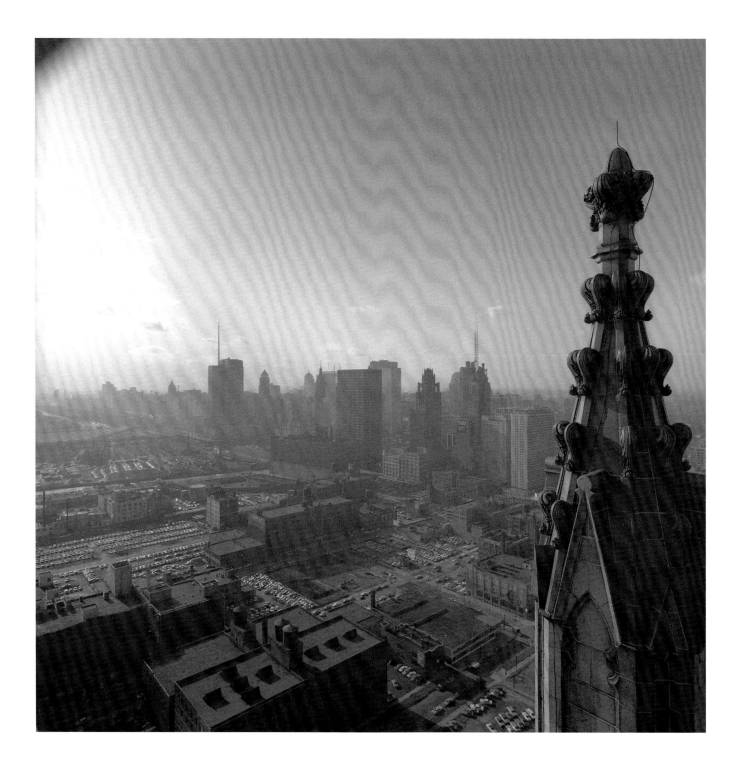

NICKEL'S ARCHITECTURAL INTEREST EXTENDED FAR BEYOND SULLIVAN. NICKEL'S MILIEU WAS CHI-
CAGO. ABOVE: DOWNTOWN SEEN FROM THE THIRTY-STORY AMERICAN FURNITURE MART TOWER, AT
LAKE SHORE DRIVE AND ERIE STREET. RIGHT: A PHOTO THAT NICKEL CALLED "CHICAGO CHEESECAKE,"
TAKEN ATOP THE NINETEEN-STORY NORTH AMERICAN BUILDING AT 36 SOUTH STATE STREET.

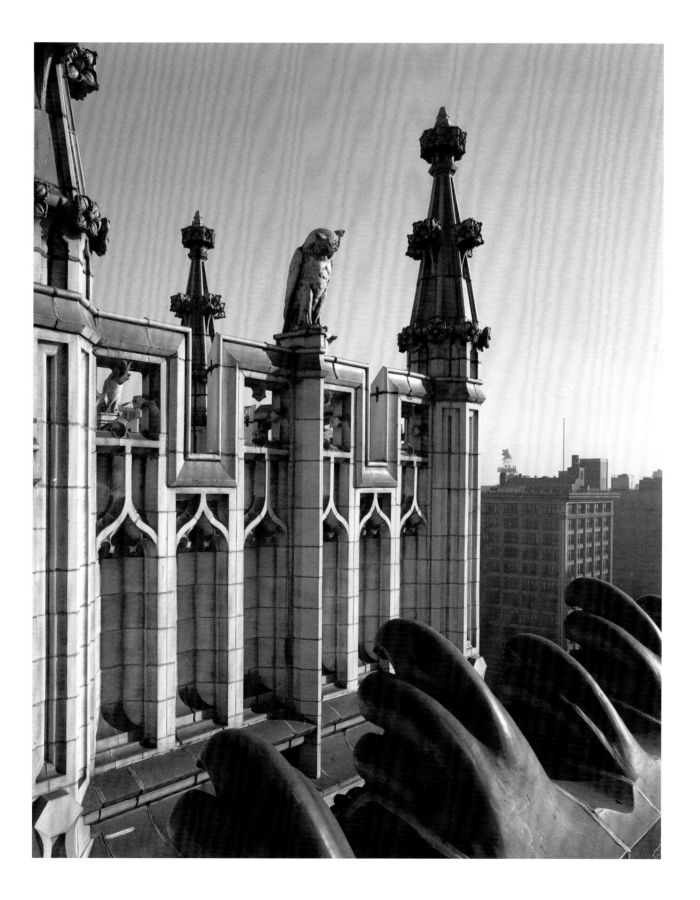

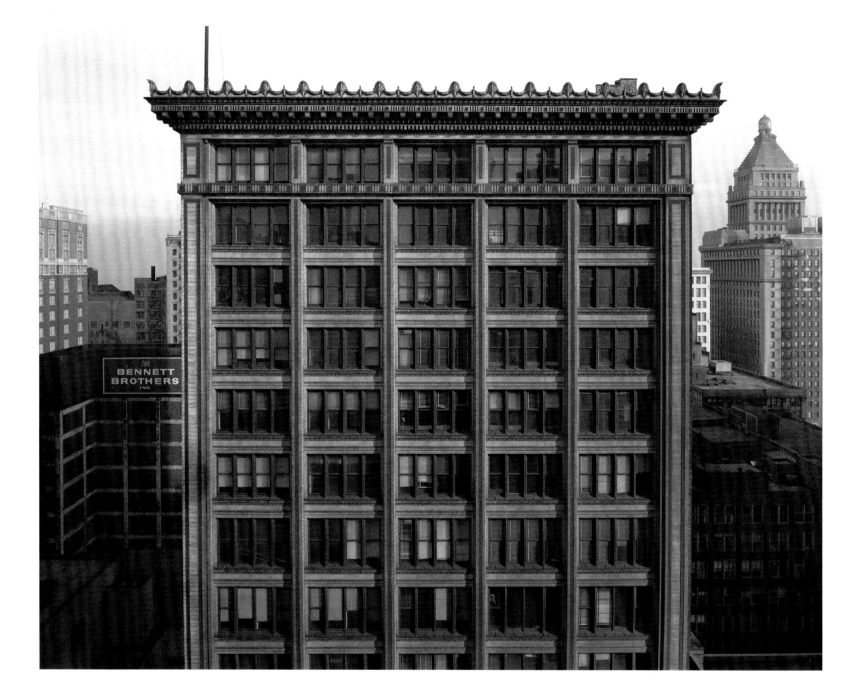

THE GLORIOUS REPUBLIC BUILDING, DESIGNED BY HOLABIRD AND ROCHE, WAS ONE OF NICKEL'S FAVORITE SKYSCRAPERS. "THE REPUBLIC HAS A TIMELESS INTEGRITY WHICH THIS 'NEW ARCHITECTURE' BARELY EQUALS," HE WROTE. THE BUILDING AT 209 SOUTH STATE STREET, WAS TORN DOWN IN 1960 FOR THE HOME FEDERAL SAVINGS AND LOAN BUILDING. RIGHT: TWO STORES AT 160-166 WEST LAKE STREET ARE OVERSHADOWED BY THE TWENTY-SIX STORY BUILDERS BUILDING.

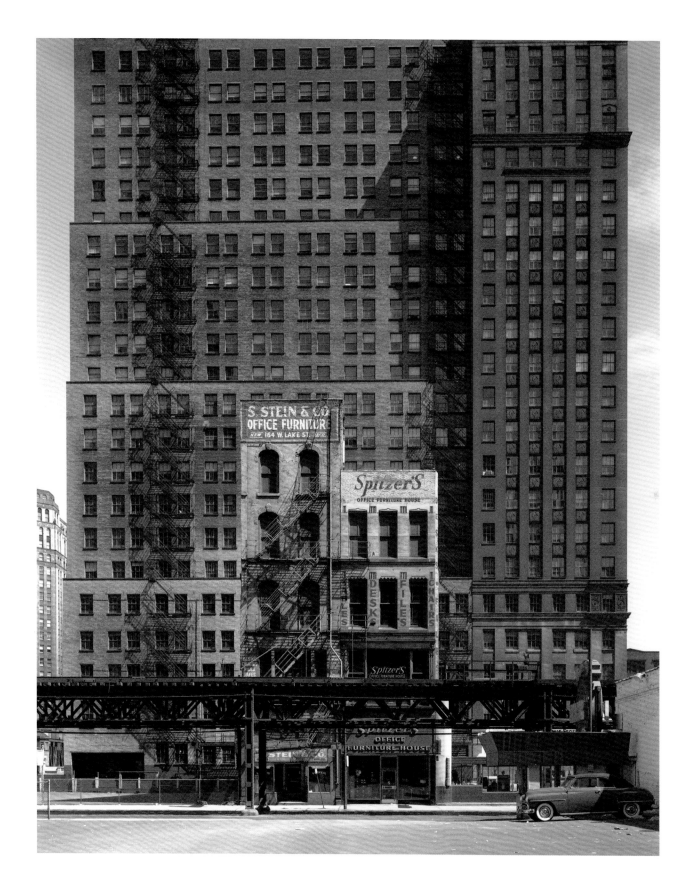

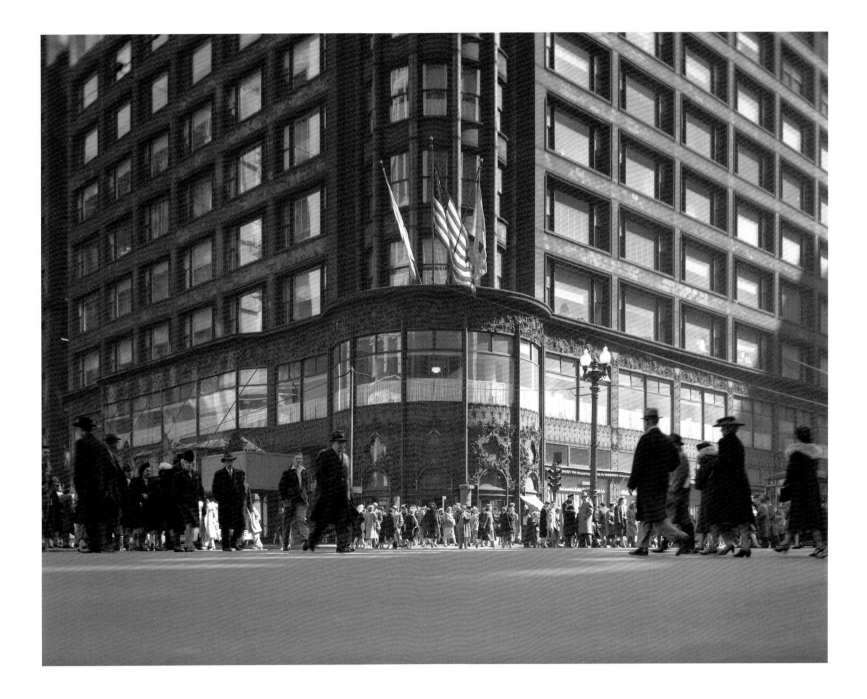

"IF THE CARSON PIRIE SCOTT STORE WAS ERECTED TODAY JUST AS SULLIVAN DID IT IN 1902, WE WOULD ALL BE AMAZED," NICKEL WROTE. "FOR TRANSPARENCY (LOTS OF GLASS AREA), RICH-NESS OF MATERIALS, FUNCTIONALISM, BEAUTY, AND SO FORTH, THE BUILDING WAS A HIGH POINT." RIGHT: THE WORLD'S FIRST GLASS-AND-STEEL SKYSCRAPER, THE 1890s RELIANCE BUILDING, BY THE FIRM OF BURNHAM AND ROOT.

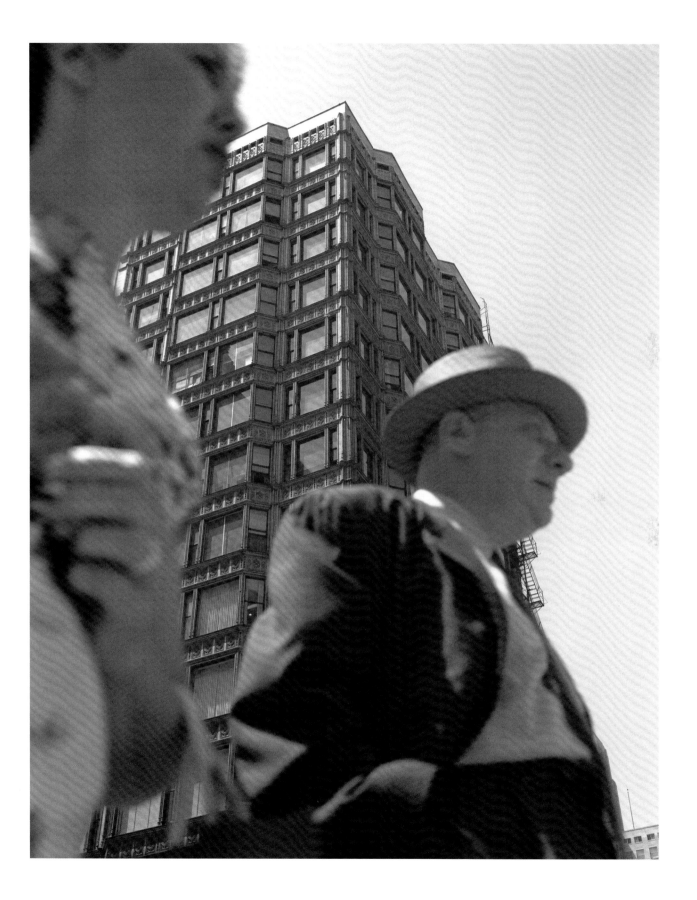

LOOKING DOWN WASHINGTON STREET FROM THE RELIANCE BUILDING EASTWARD TOWARD MARSHALL FIELD'S. RIGHT: THE VIEW FROM A SIXTH-FLOOR CORNER OFFICE OF THE 1880S WILLOUGHBY BUILDING, AT THE NORTHWEST CORNER OF JACKSON BOULEVARD AND FRANKLIN STREET. NICKEL WROTE HIS "USUAL EMOTIONAL LETTER" PROTESTING THE DEMOLITION OF THE WILLOUGHBY IN 1964.

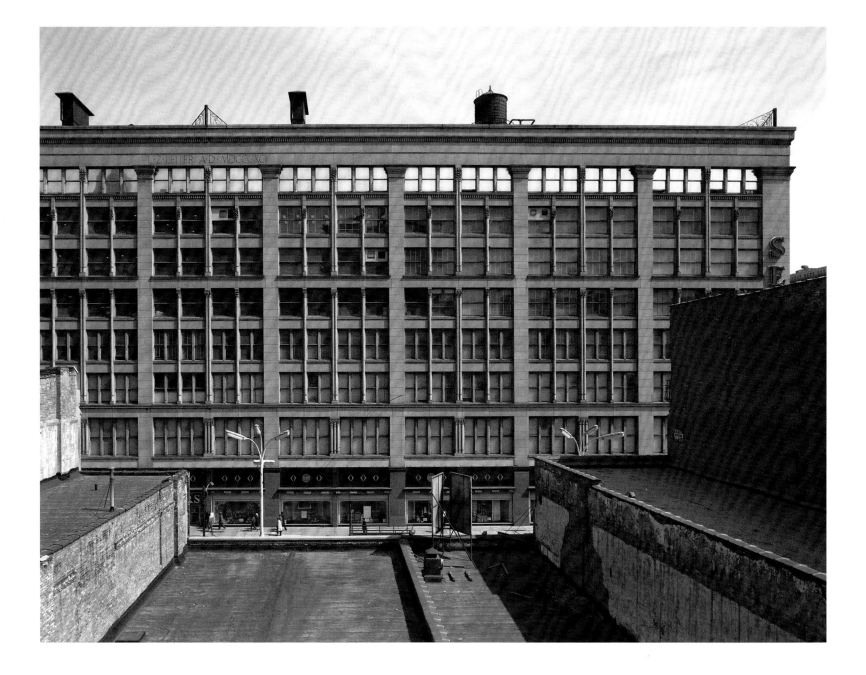

WILLIAM LE BARON JENNEY'S 1891 SECOND LEITER BUILDING AT 403 SOUTH STATE STREET, ONE OF THE WORLD'S FIRST SKYSCRAPERS WITH A METAL SKELETAL FRAME. RIGHT: "PERHAPS IT'S THE SIMPLICITY AND THE MASSIVE STRUCTURE WHICH PROTECTS THE MONADNOCK FROM CHANGE," NICKEL WROTE. "IT IS RATHER UNCHANGEABLE, LIKE THE PYRAMIDS." THIS VIEW OF BURNHAM AND ROOT'S SKYSCRAPER WILL LIKELY NEVER BE REPEATED. NICKEL TOOK IT AFTER THE NEIGHBORING FEDERAL COURTHOUSE WAS RAZED IN 1965, AND BEFORE THE KLUCZYNSKI FEDERAL BUILDING WAS PUT IN ITS PLACE.

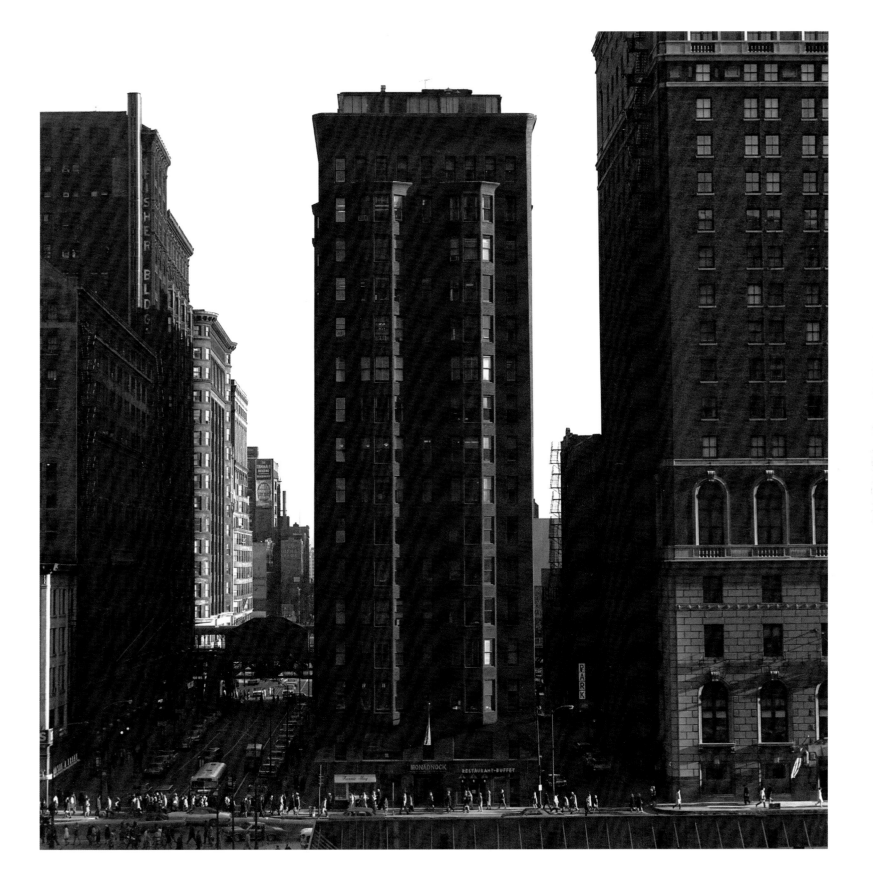

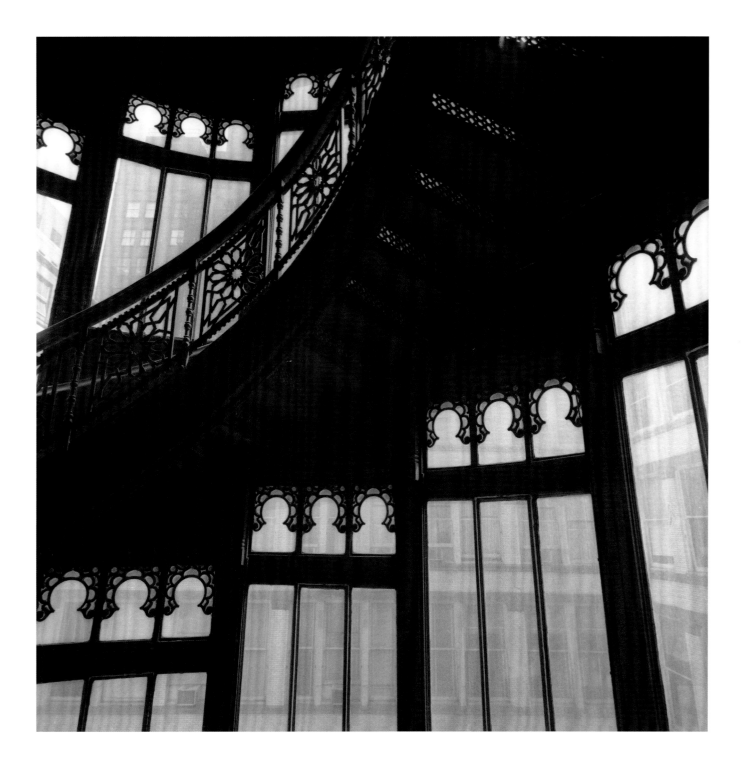

THE ROOKERY, BURNHAM AND ROOT'S MASTERPIECE AT 209 SOUTH LASALLE STREET. ABOVE: THE STAIRCASE AND LIGHT COURT. LEFT: CAST-IRON STOREFRONTS ALONG THE BUILDING'S QUINCY STREET SIDE. NICKEL STARTED METHODICALLY PHOTOGRAPHING BURNHAM AND ROOT BUILDINGS IN THE MID-1960S. HE CONSIDERED THE FIRM ALMOST AN EQUAL TO ADLER AND SULLIVAN.

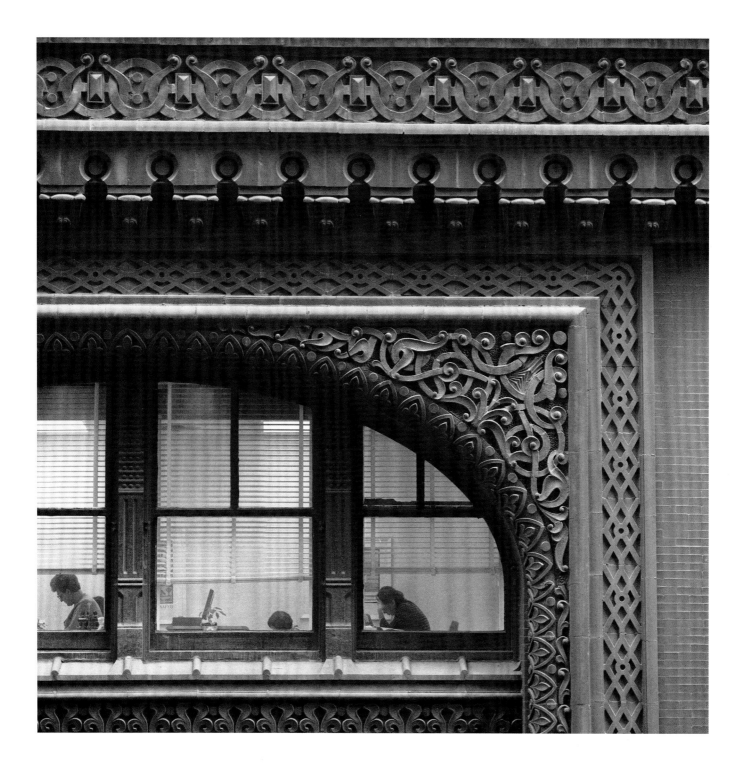

LOOKING IN AT THE TENTH-FLOOR OFFICES OF THE ROOKERY BUILDING. RIGHT: SULLIVAN'S FESTOONS TOP THE GAGE BUILDING AT 18 SOUTH MICHIGAN AVENUE. THE ART INSTITUTE OF CHICAGO AND GRANT PARK ARE IN THE BACKGROUND.

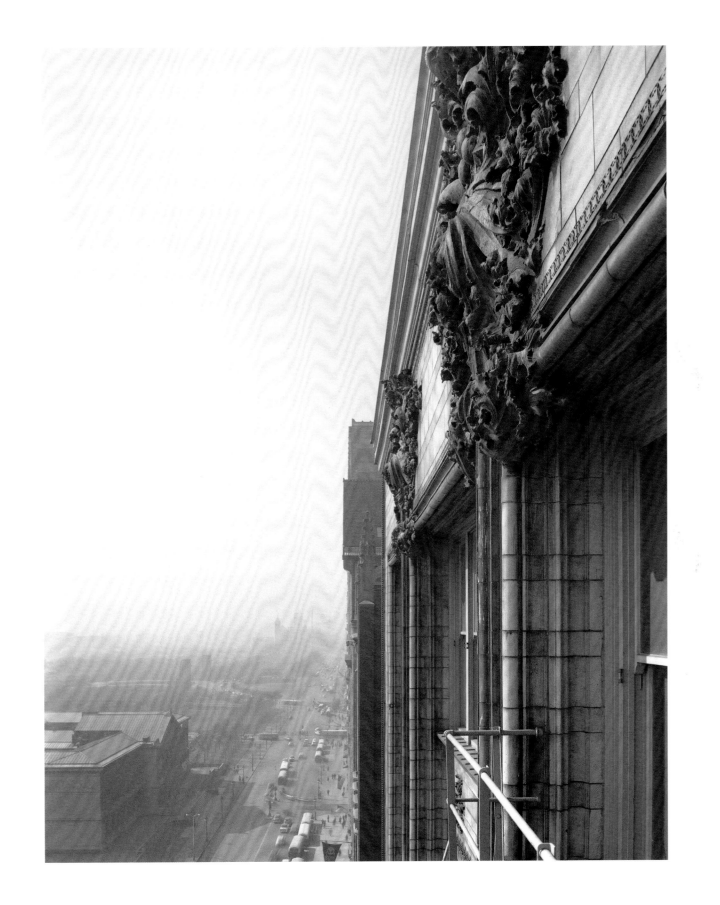

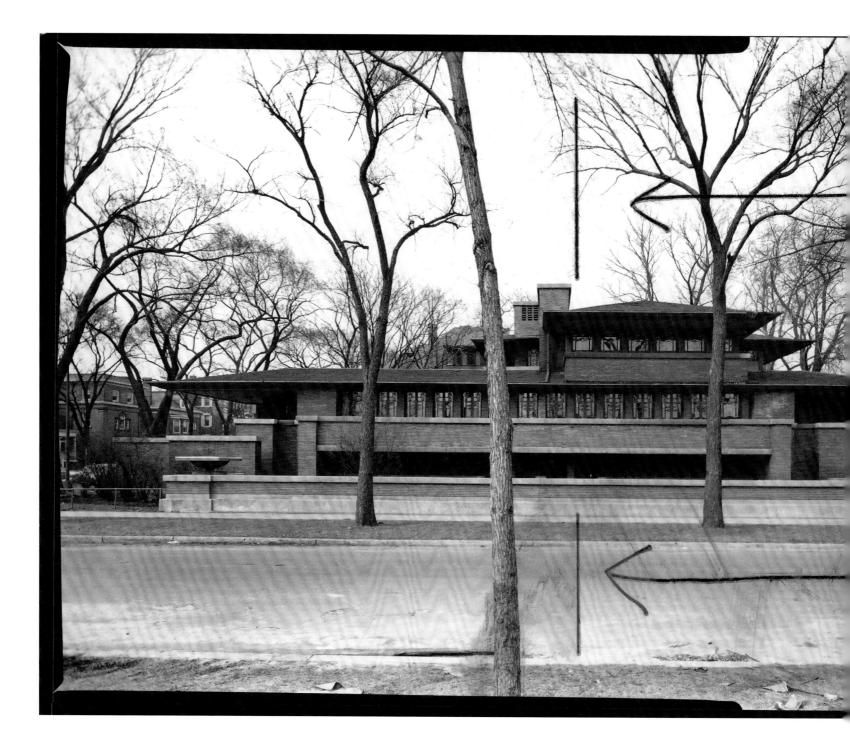

ONE OF NICKEL'S MOST FAMOUS PHOTOGRAPHS SHOWS THE ENTIRE SOUTH FACADE OF FRANK LLOYD WRIGHT'S ROBIE HOUSE AT 5757 SOUTH WOODLAWN AVENUE. IT IS ACTUALLY A COMBINATION OF TWO PHOTOS THAT NICKEL AND AARON SISKIND TOOK ON A "DASTARDLY NOVEMBER DAY" IN THE 1950S. THEY TOOK TURNS RUNNING OUT OF A WARM CAR TO PRESS THE SHUTTER OF NICKEL'S CAMERA ON A TRIPOD. THIS WORK PRINT SHOWS HOW NICKEL SPLICED THE PHOTOS TOGETHER TO MAKE ONE LONG IMAGE.

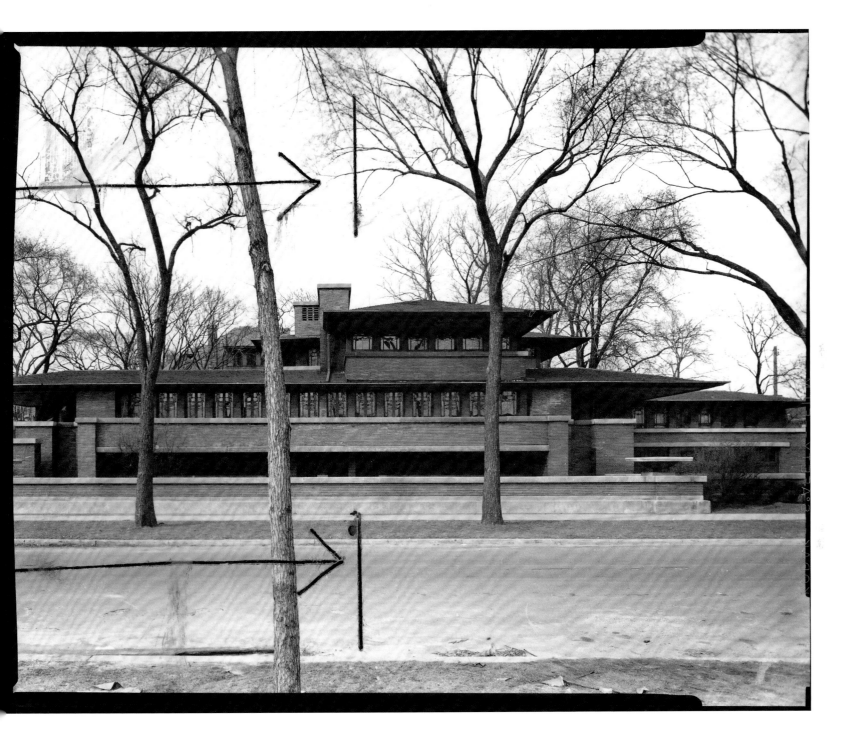

STANDING TALL

"OH WELL, GUESS IT IS TIME TO GET OUT THE OLD PICK AXE AGAIN."

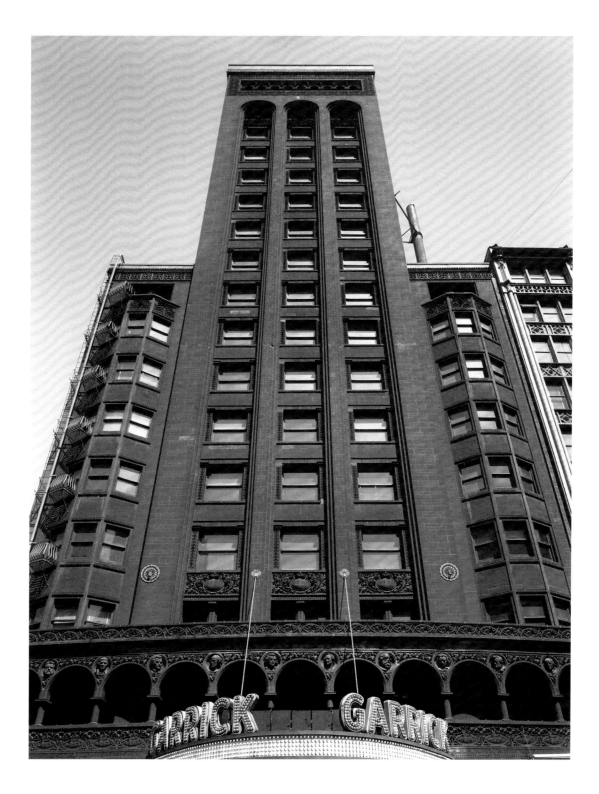

"THE GARRICK IS ADLER AND SULLIVAN'S TALLEST BUILDING (SEVENTEEN STORIES)," NICKEL WROTE. "WHAT WOULD THE WORLD SAY WERE WE TO DESTROY THIS ACCOMPLISHMENT OF THE MAN WHO GAVE ESTHETIC EXPRESSION TO THE TALL BUILDING?"

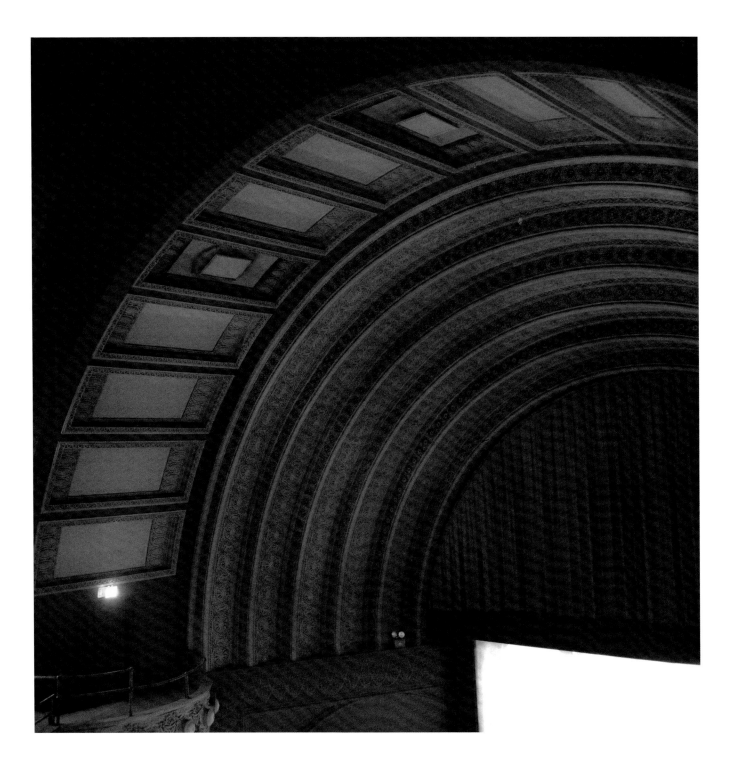

AFTER NICKEL LEARNED THAT THE GARRICK THEATER BUILDING AT 64 WEST RANDOLPH STREET
WAS SLATED FOR DEMOLITION, HE STARTED MAKING AN EXTENSIVE ARCHIVE OF THE INTERIOR.
TO TAKE PHOTOS OF THE GREAT THEATER SPACE, HE WOULD ARRIVE DURING THE LAST SHOW-
ING OF MOVIES AND STAY UNTIL DAWN.

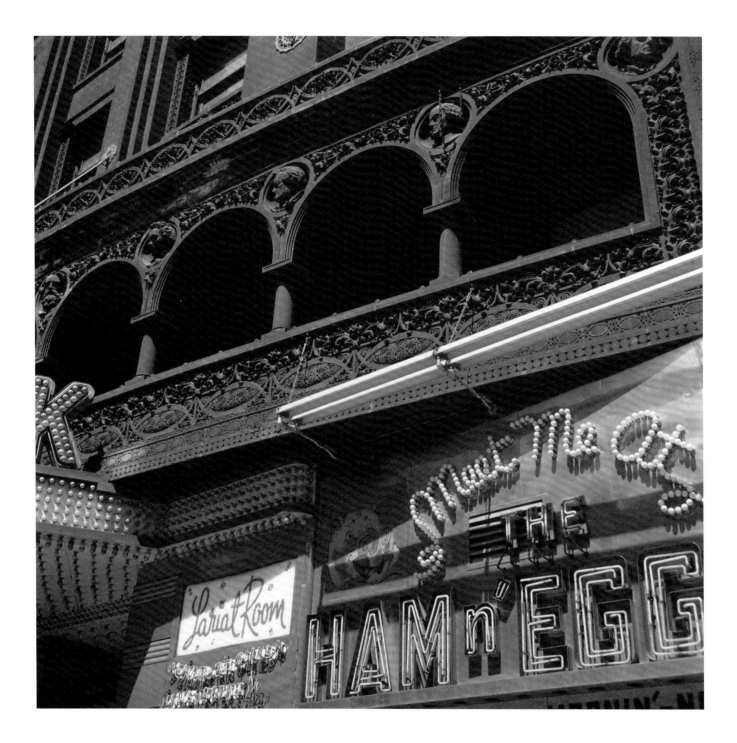

NICKEL TOOK ABOUT 2,000 PHOTOGRAPHS OF THE GARRICK THEATER, DOCUMENTING THE BUILDING FROM TOP TO BOTTOM. "I ONLY HOPE THOSE WHO CONDEMN THE BUILDING CAN JUSTIFY ITS LOSS," HE WROTE.

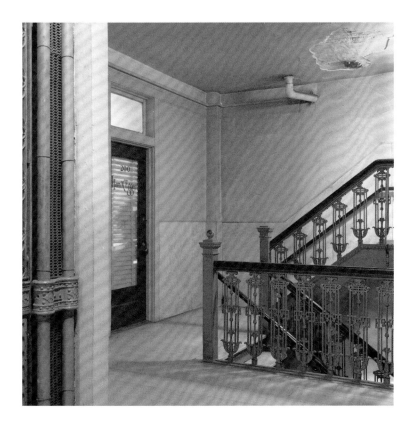

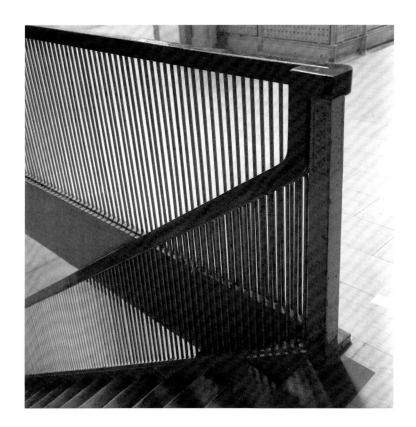

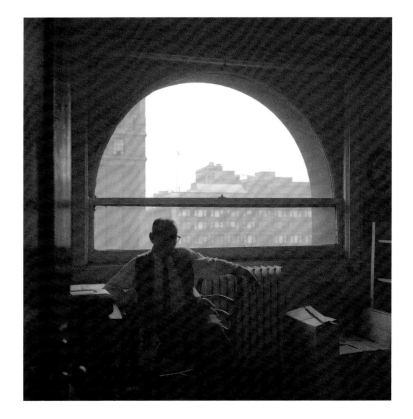

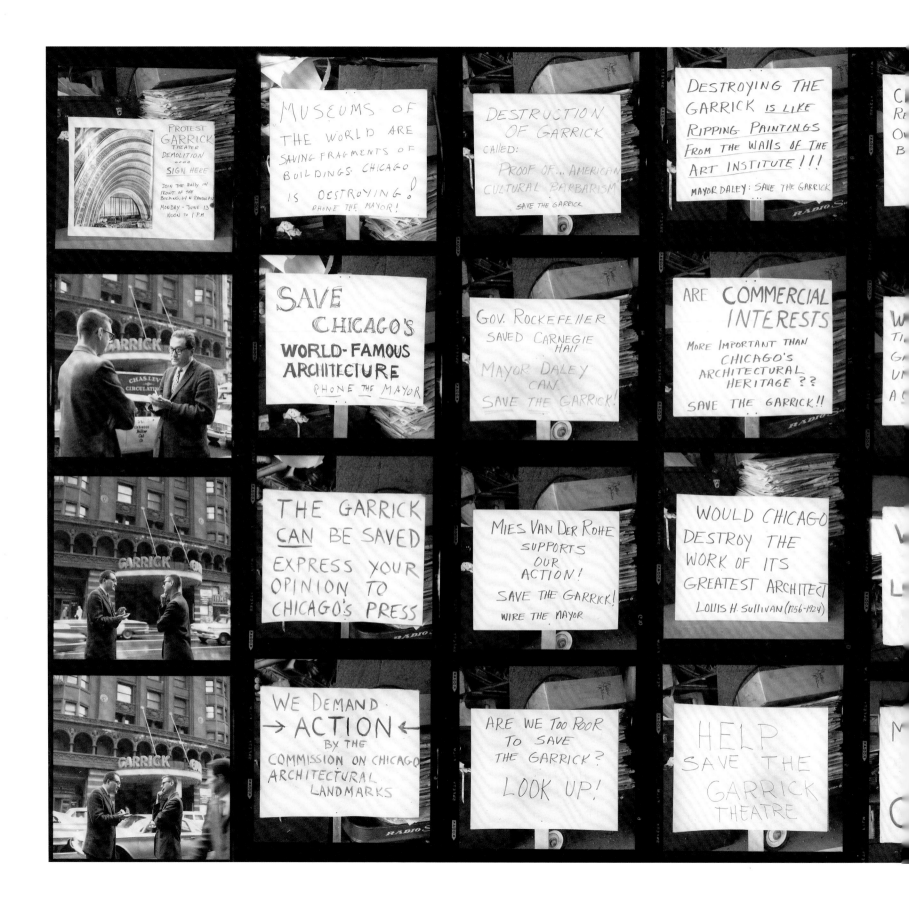

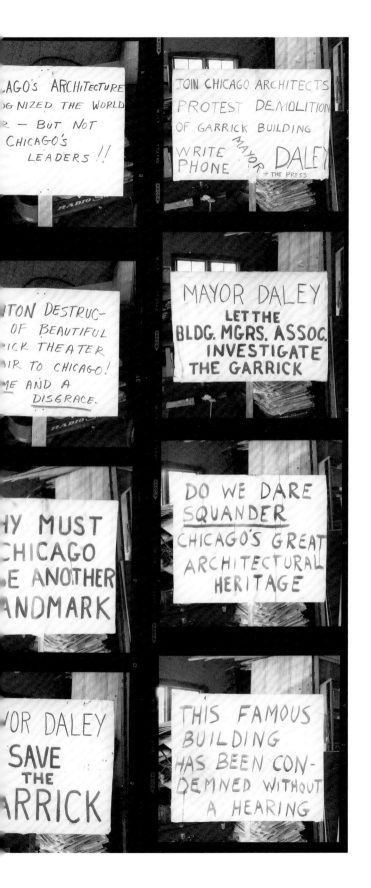

NICKEL WORKED WITH THOMAS STAUFFER, WHO HAD HELPED CRAFT THE CITY'S FIRST LANDMARK LAW, IN FORMING A PROTEST MOVEMENT AGAINST THE DEMOLITION OF THE GARRICK. THE TWO ORGANIZED FOUR DAYS OF PICKETING IN FRONT OF THE BUILDING, AND GATHERED 3,300 SIGNATURES. "AT THIS MOMENT WE ARE VERY HOPEFUL, BUT THERE IS ALWAYS THE POSSIBILITY THAT IT IS ALL POLITICALLY PREDETERMINED," NICKEL WROTE IN SEPTEMBER 1960.

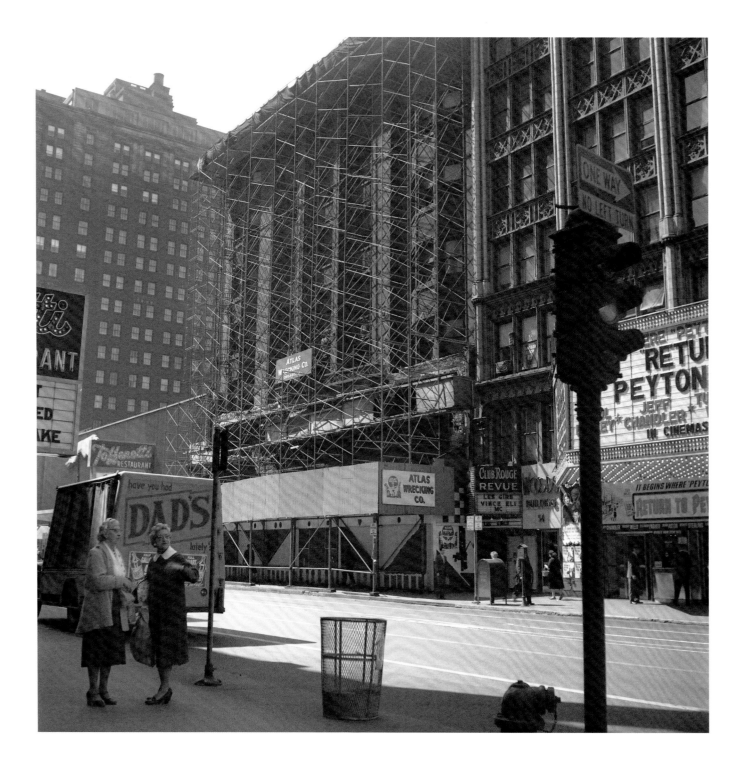

A FEW MONTHS LATER, NICKEL LOST HIS BATTLE. SCAFFOLDING WAS INSTALLED TO DEMOLISH THE GARRICK THEATER BUILDING IN 1961. RIGHT: WORKERS REMOVE THE SECOND-FLOOR LOGGIA. PART OF THIS OPEN GALLERY WAS USED AS THE ENTRANCE TO THE NEW SECOND CITY THEATRE AT 1616 NORTH WELLS STREET.

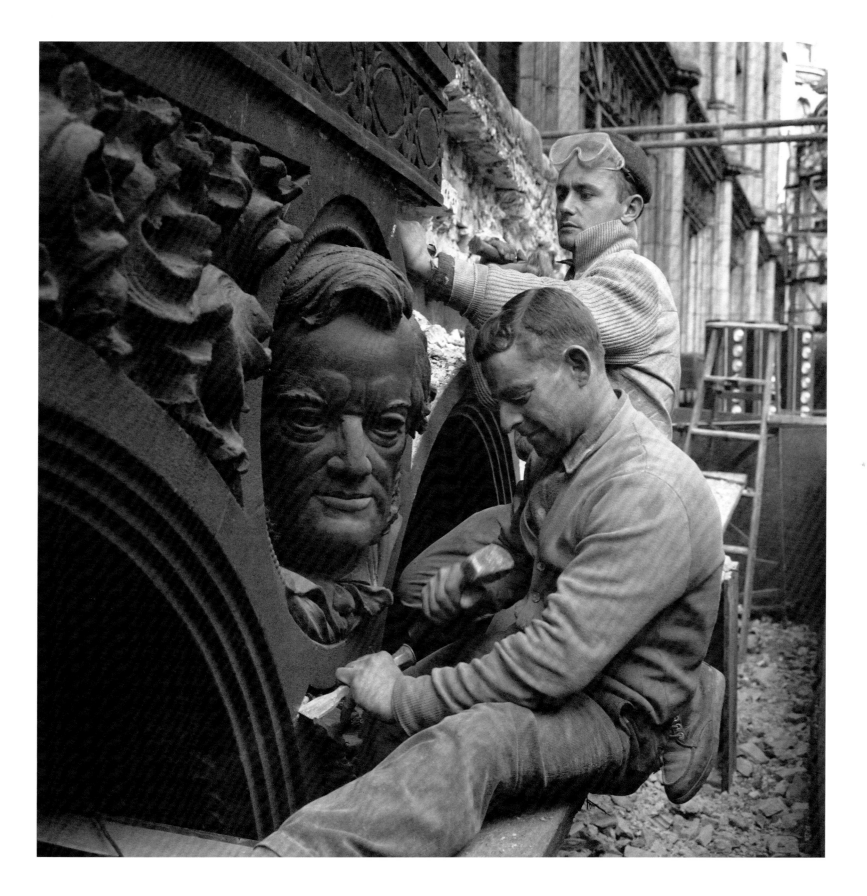

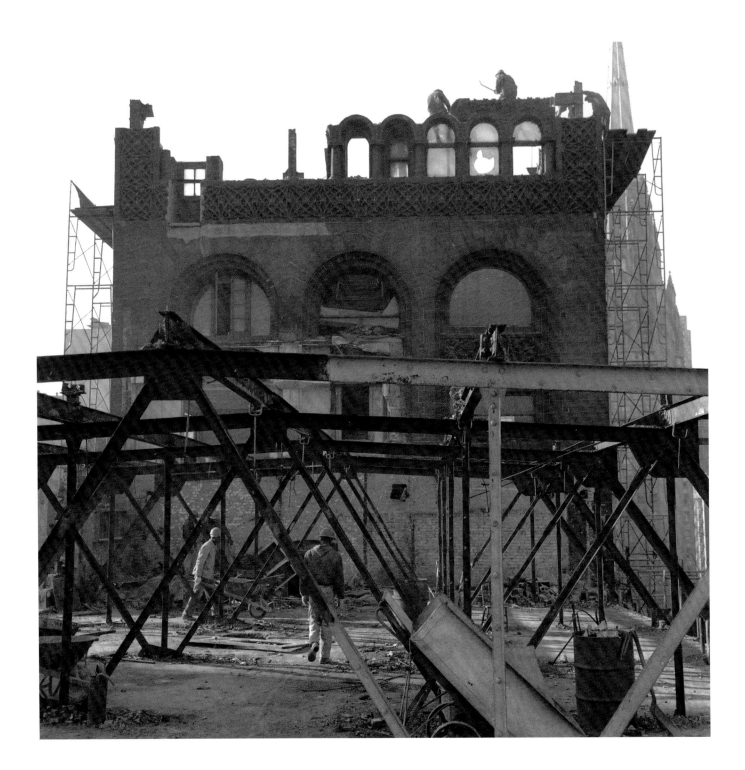

DEMOLITION CREWS DISMANTLE THE GARRICK'S TOWER AND THE TOP FLOOR OF THE BUILD-
ING'S NORTH WING. "THROUGH EXPOSURE, ONE GETS THE FEELING THAT THE ORNAMENT IS
THE BUILDING, AND THE BUILDING CONFIRMS THE ORNAMENT," NICKEL WROTE. "HEREIN LIES
SULLIVAN'S SIGNIFICANCE."

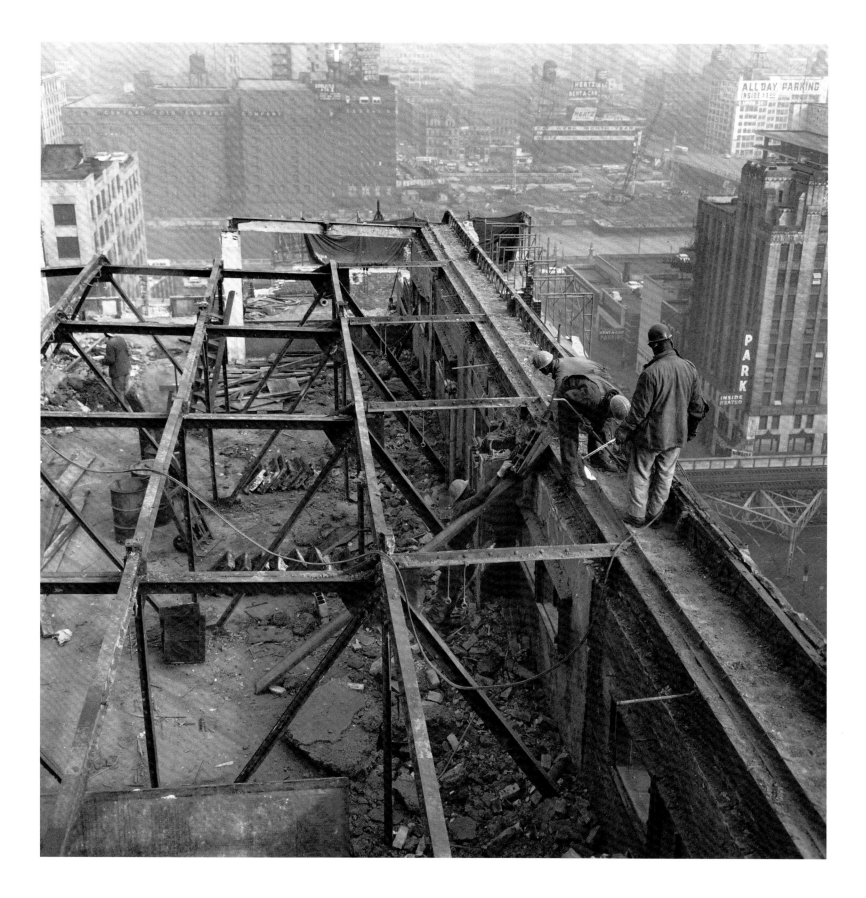

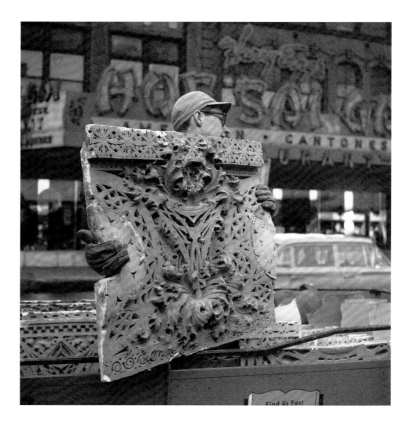

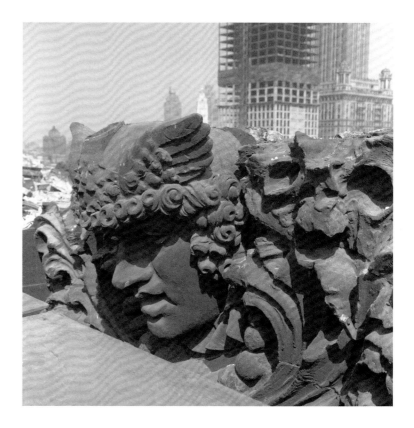

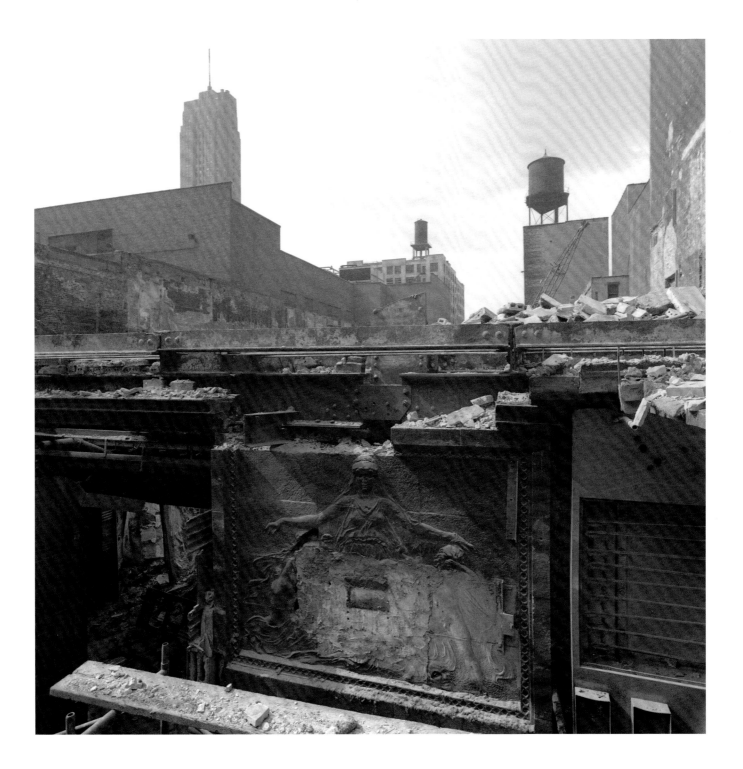

NICKEL WAS APPOINTED IN 1961 TO LEAD A CITY EFFORT TO SAVE TONS OF GARRICK ORNAMENT.
ABOVE: AN IRON BAS-RELIEF WAS DISCOVERED WHEN THE THEATER MARQUEE WAS REMOVED. LEFT
PAGE, CLOCKWISE FROM TOP LEFT: WORKERS REMOVE SECOND-FLOOR STATUARY; SALVAGER DAVID
NORRIS TRANSPORTS PLASTER FROM THE THEATER, AND UPPER-LEVEL ORNAMENT IS REMOVED.

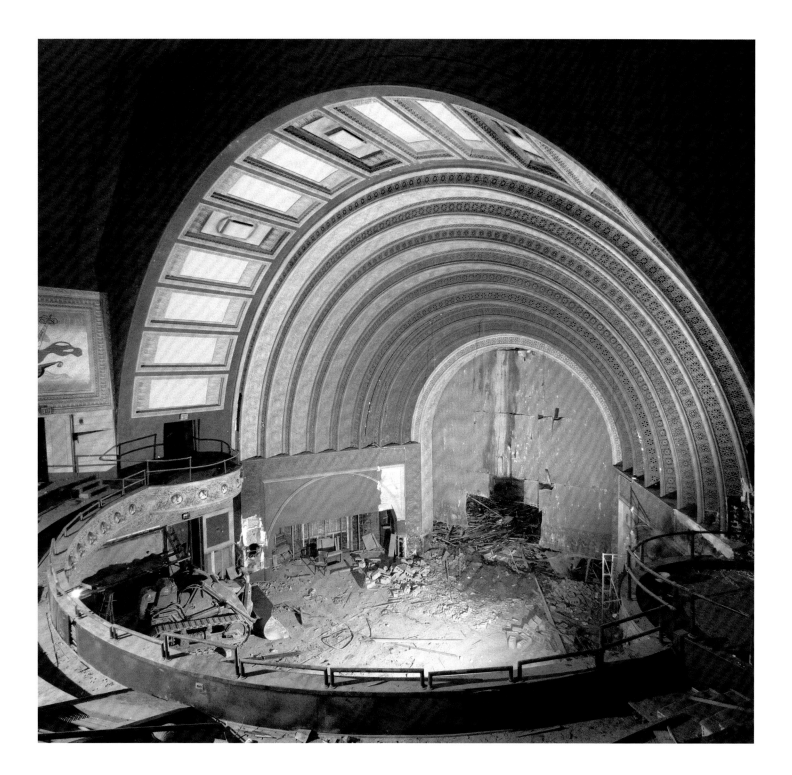

"EVEN IN ITS FINAL STATE, THE PROSCENIUM VAULT WAS EQUAL AND MAYBE GREATER THAN ANY
GOTHIC CATHEDRAL I'VE SEEN," NICKEL WROTE.

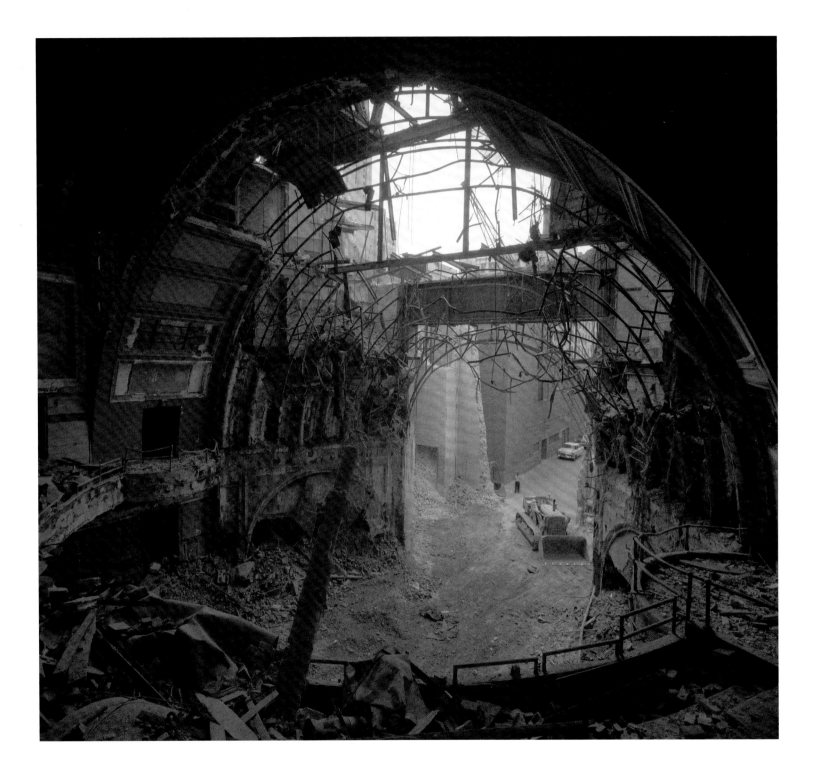

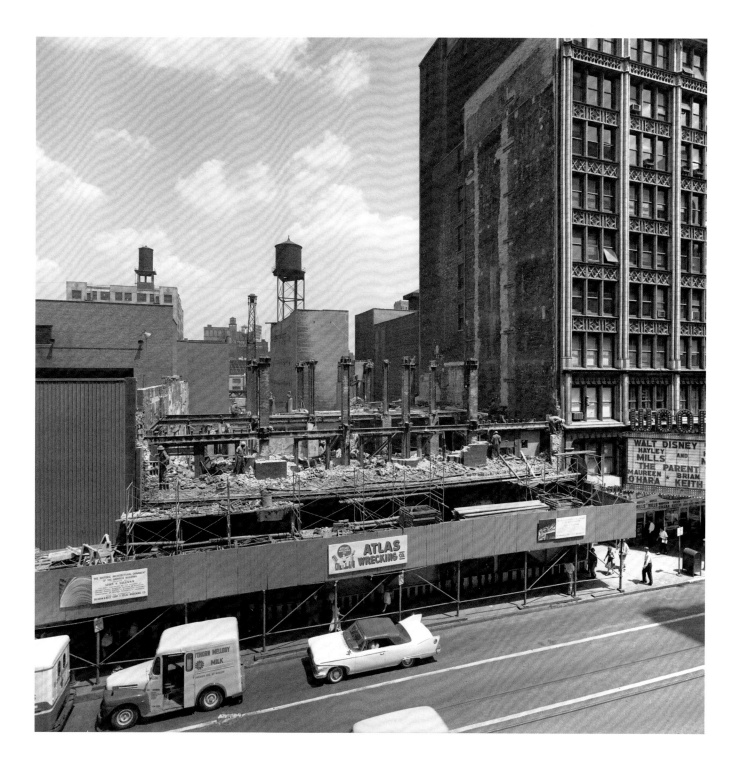

THE WRECKING ALMOST COMPLETE. RIGHT: NICKEL'S COLLEAGUE JOHN VINCI LIES FOR OUR SINS AMONG TERRA-COTTA ORNAMENT REMOVED FROM NEAR THE TOP OF THE GARRICK. A PARKING LOT REPLACED THE SKYSCRAPER. IT IS NOW THE SITE OF THE GOODMAN THEATRE.

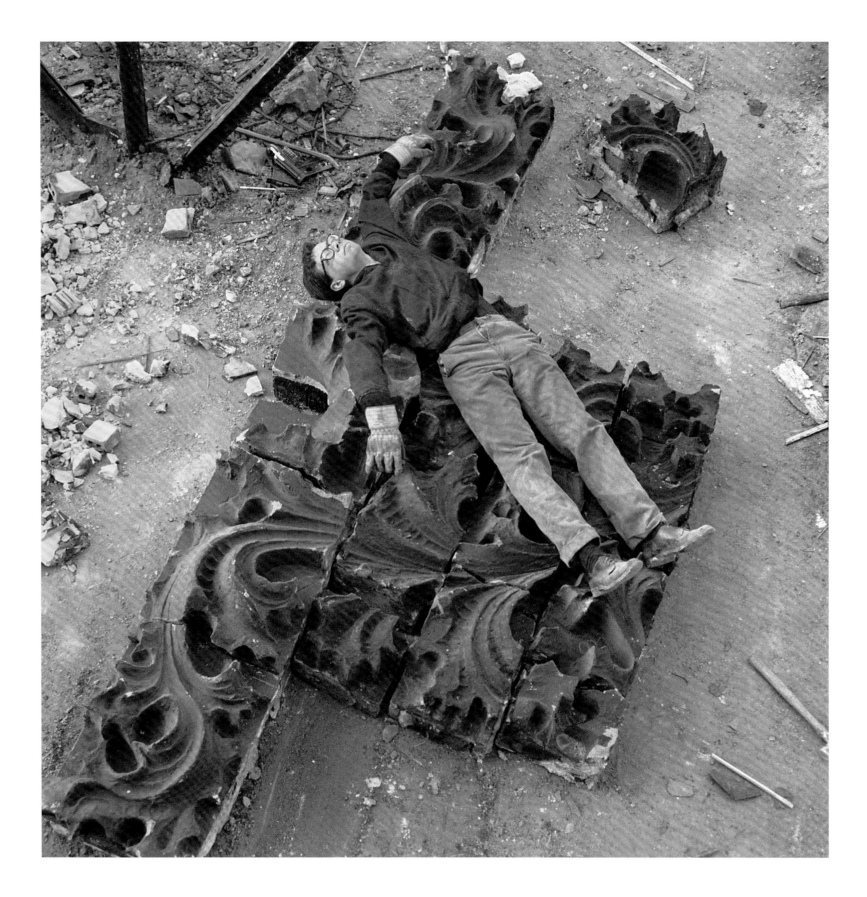

REMNANTS

"I OFTEN THINK IT [SALVAGE WORK] IS THE MOST IMPORTANT THING I AM DOING. IT IS NOT AN INTELLECTUAL ACCOMPLISHMENT, BUT SIMPLY A RECOGNITION OF THE IMPORTANCE AND GREAT BEAUTY OF SULLIVAN'S WORK HONESTLY, I'M MORE AT HOME IN A WRECKERS ENVIRONMENT: DIRTY CLOTHES, USING ROPE AND PINCH BAR, MOVING WEIGHTS OUT IN THE AIR AND WIND. VERY EXHILARATING, ESPECIALLY WHEN YOU GET A CHOICE PIECE OF THE BUILDING UP HIGH AND THEN TAKE IT HOME AND LOOK AT IT EVERY DAY IN VARIOUS KINDS OF LIGHT. AH, SULLIVAN!"

NICKEL IN THE BEDROOM OF HIS PARK RIDGE HOME, WHICH HE SHARED WITH HIS PARENTS. HE
IS HOLDING A PIECE OF SULLIVAN'S METAL ORNAMENT FROM THE KNISELY STORE AND FLATS.

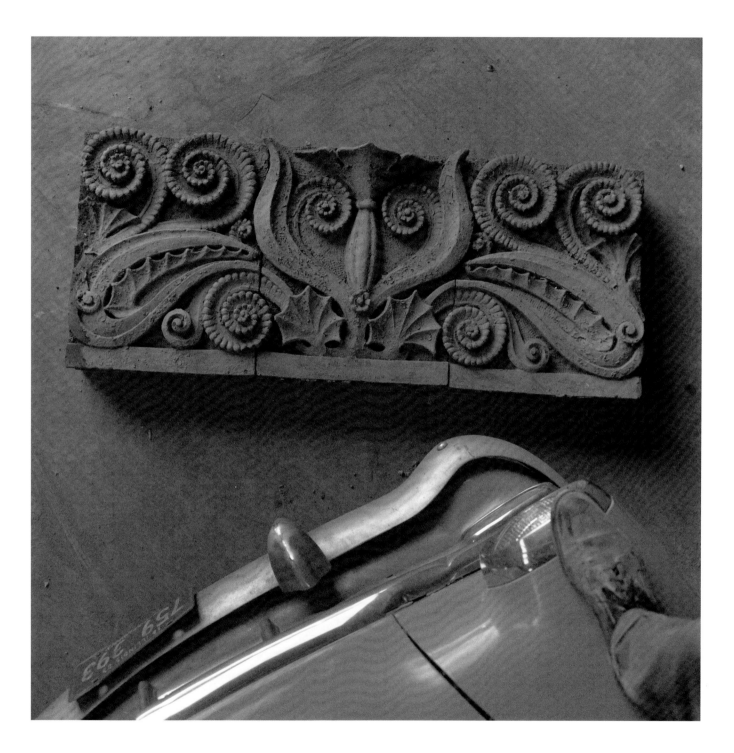

NICKEL PHOTOGRAPHS ORNAMENT FROM THE BARBE RESIDENCE IN HIS GARAGE AT 1508 GROVE AVENUE. HE WROTE OF THE COLLECTION: "I KEPT IT IN MY BACK YARD AT FIRST. IT LOOKED LIKE AN ARCHEOLOGI-CAL FIELD." RIGHT PAGE, CLOCKWISE FROM TOP LEFT: ORNAMENT FROM ADLER AND SULLIVAN'S HENRY STERN RESIDENCE, KNISELY STORE, SEVERAL SOUTH SIDE BUILDINGS, AND THE ROTHSCHILD HOUSES.

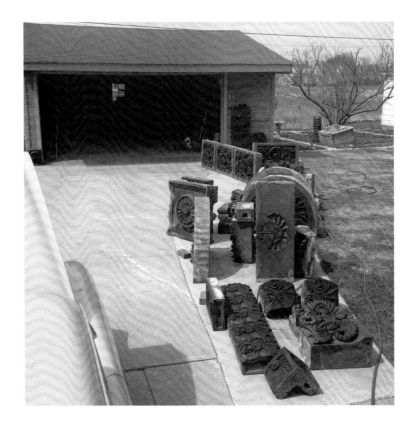

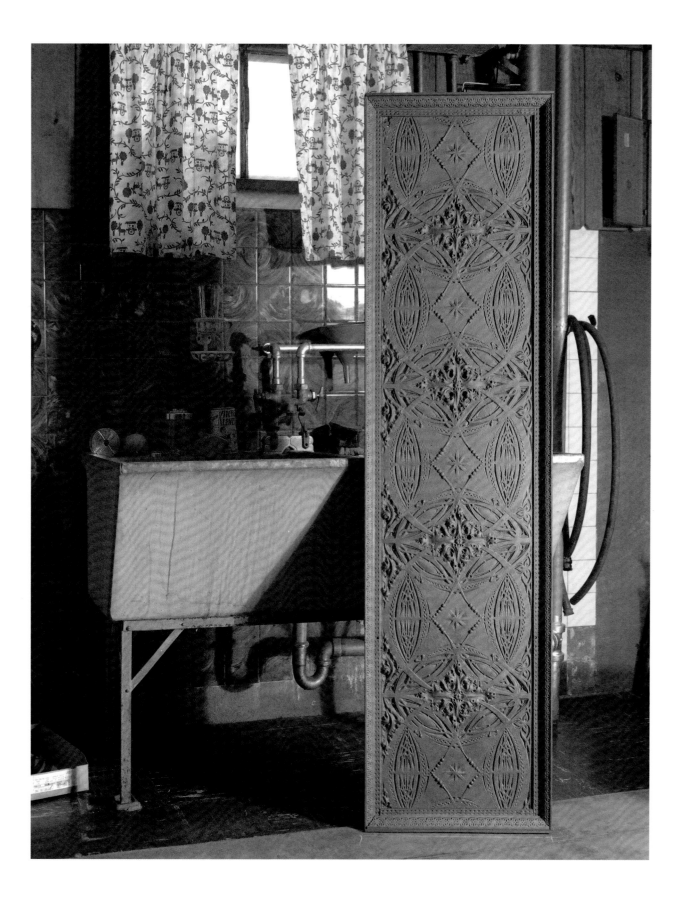

126

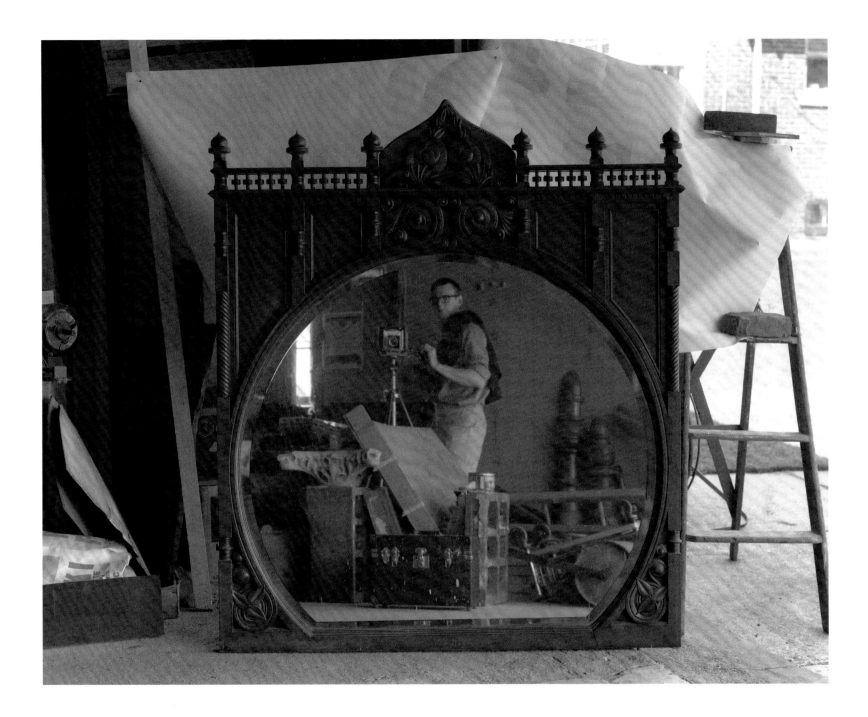

A MIRROR FOUND IN ADLER AND SULLIVAN'S LINDAUER RESIDENCE. LEFT: AN IRON PANEL FROM THE FIRM'S STOCK EXCHANGE BUILDING WHEN THE STRUCTURE WAS REMODELED DURING THE EARLY 1960S. AS NICKEL'S ORNAMENT COLLECTION GREW, HE HOUSED IT IN WAREHOUSES. HE SOLD MOST OF HIS COLLECTION IN 1964 FOR $12,000 TO SOUTHERN ILLINOIS UNIVERSITY.

THE BRICKBUILDER.
VOL. 19, NO. 10. PLATE 129.

HOUSE AT RIVERSIDE, ILL.
Louis H. Sullivan, Architect.

WHILE NICKEL WAS FIGHTING TO SAVE THE GARRICK THEATER, HE LEARNED THAT ONE OF SULLIVAN'S MOST BEAUTIFUL HOUSES, THE 1907 HENRY BABSON RESIDENCE IN SUBURBAN RIVERSIDE, WAS TO BE TORN DOWN TO MAKE WAY FOR A SUBDIVISION. "NOW I AM PULLING OUT OF IT," NICKEL WROTE IN MARCH 1960. "BUILDINGS ARE COMING DOWN ON ALL SIDES."

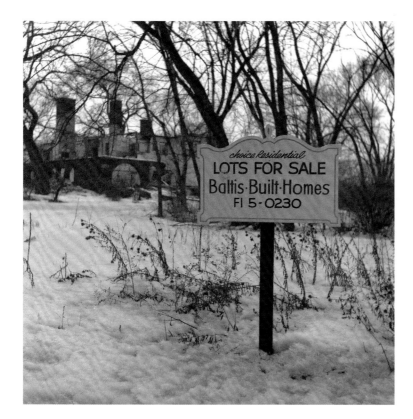
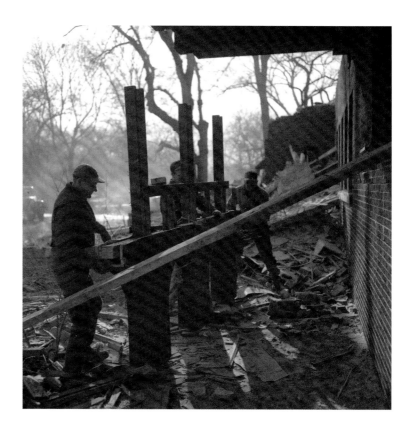
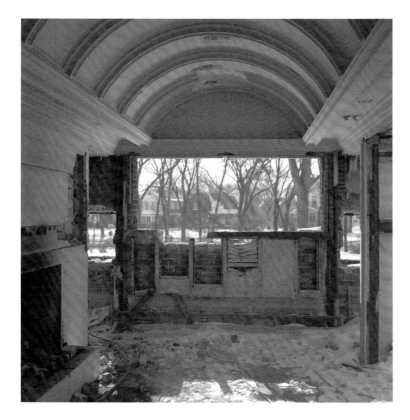

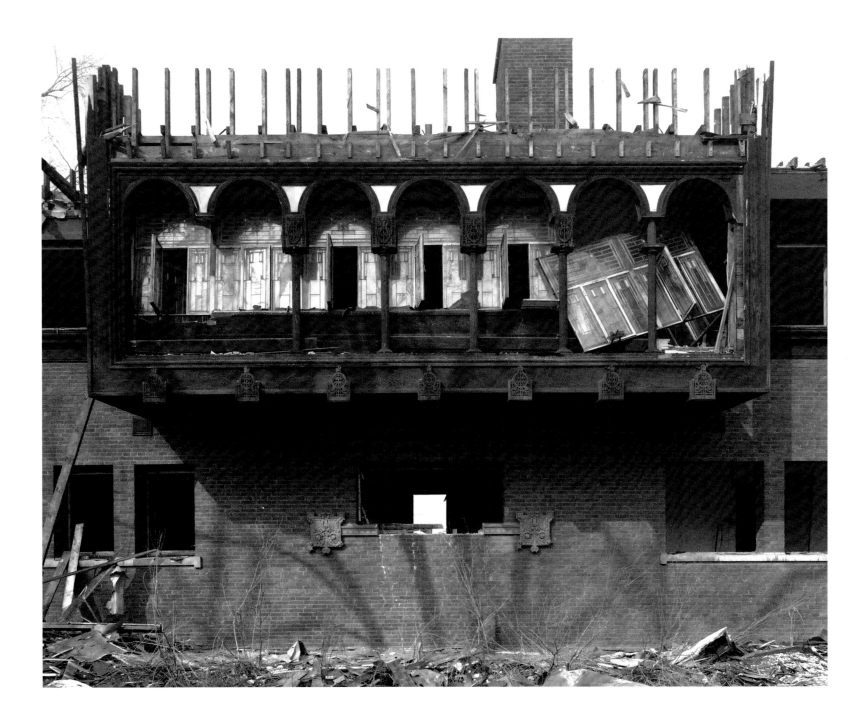

THE BABSON FACADE: "THE PHOTOGRAPHY AND SALVAGING OF ORNAMENT IS A FINAL PRESERVATION MEASURE FOR THE BENEFIT OF HISTORIANS, AND IS IN NO WAY A SUBSTITUTE FOR THE WHOLE BUILDING," NICKEL WROTE. "ARCHITECTURE IS EVALUATED BY FORM, PROPORTION, PLACEMENT OF PARTS, AND SPATIAL QUALITIES. THE ESTHETIC EXPERIENCING OF A WHOLE BUILDING IS NOT POSSIBLE WITH PHOTOS OR PIECES; THEY ARE ONLY SYMBOLS."

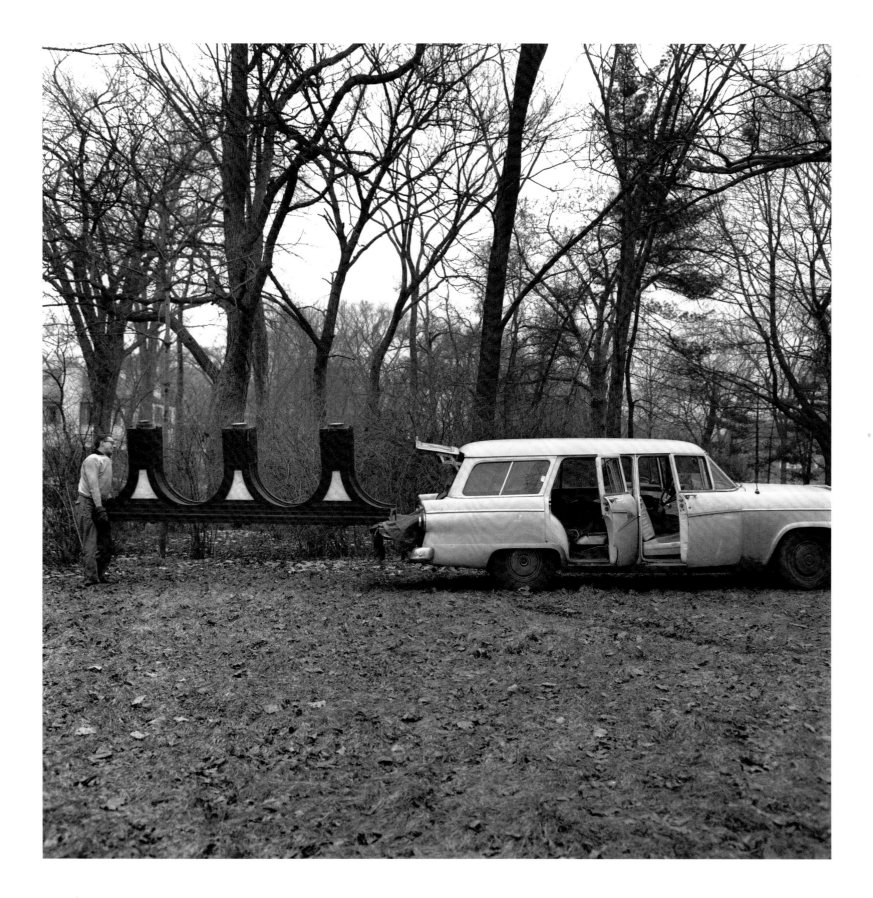

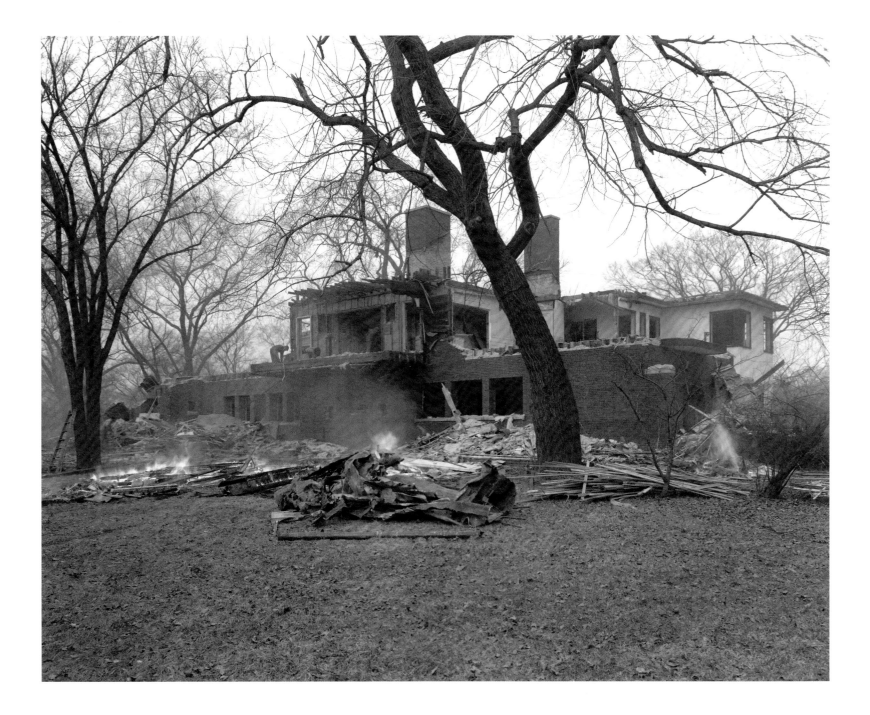

THE FINAL DAYS OF THE BABSON HOUSE. WHEN NICKEL RETURNED IN APRIL 1960, HE NOTED
THAT HE COULD NOT SEE THE HOUSE THROUGH THE TREES ON LONGCOMMON ROAD. THERE WAS
NOTHING LEFT. IT WAS FLAT. "A SHOCK," HE WROTE. RIGHT: HE LATER CAME BACK TO RECORD
CONSTRUCTION OF THE SUBDIVISION ON THE FORMER BABSON ESTATE.

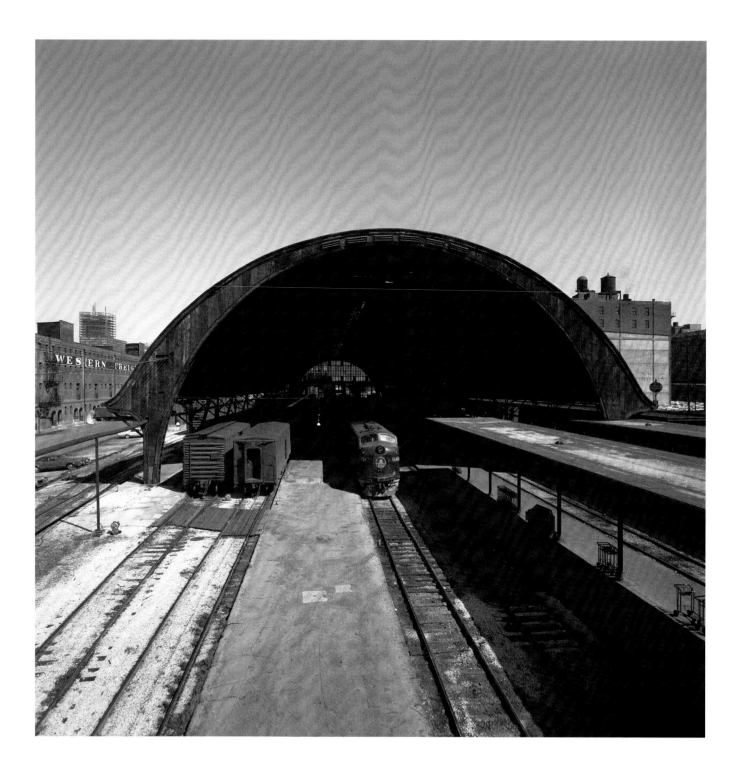

THE TRAIN SHED AT THE GRAND CENTRAL STATION WAS THE SECOND LARGEST IN THE WORLD WHEN IT OPENED IN 1890 AT 201 WEST HARRISON STREET. BY THE EARLY 1960S, ONLY TEN PASSENGER TRAINS A DAY USED THE STATION AS GRAND CENTRAL FELL VICTIM TO THE END OF THE GREAT RAILROAD ERA. THE STATION WAS CLOSED IN 1969, AND WAS TORN DOWN TWO YEARS LATER.

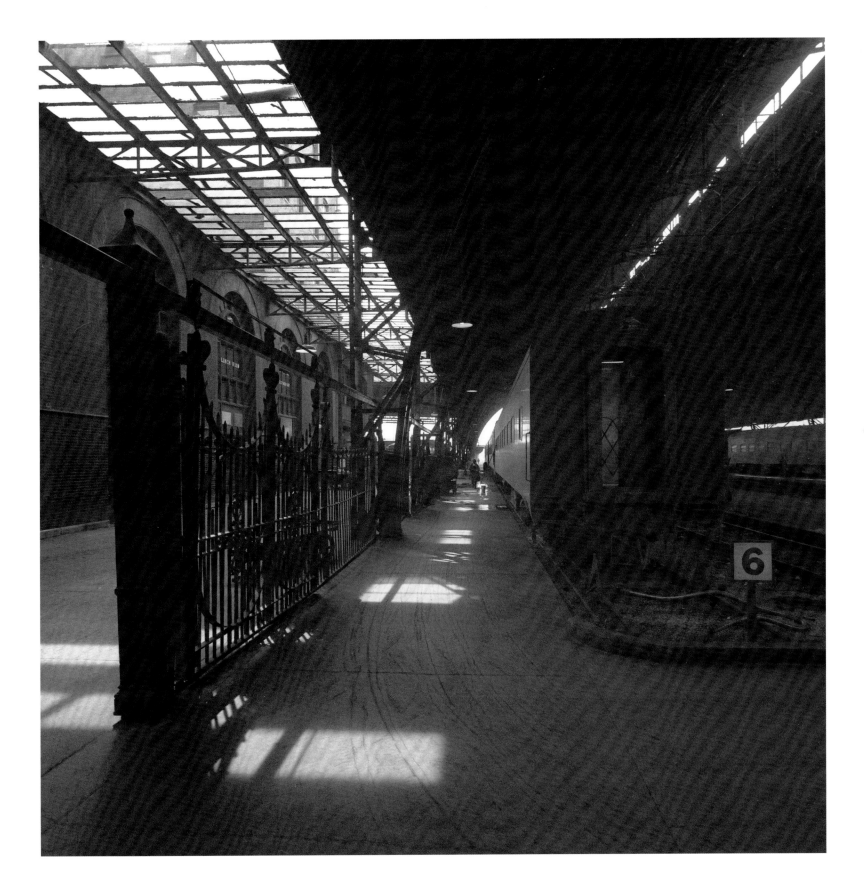

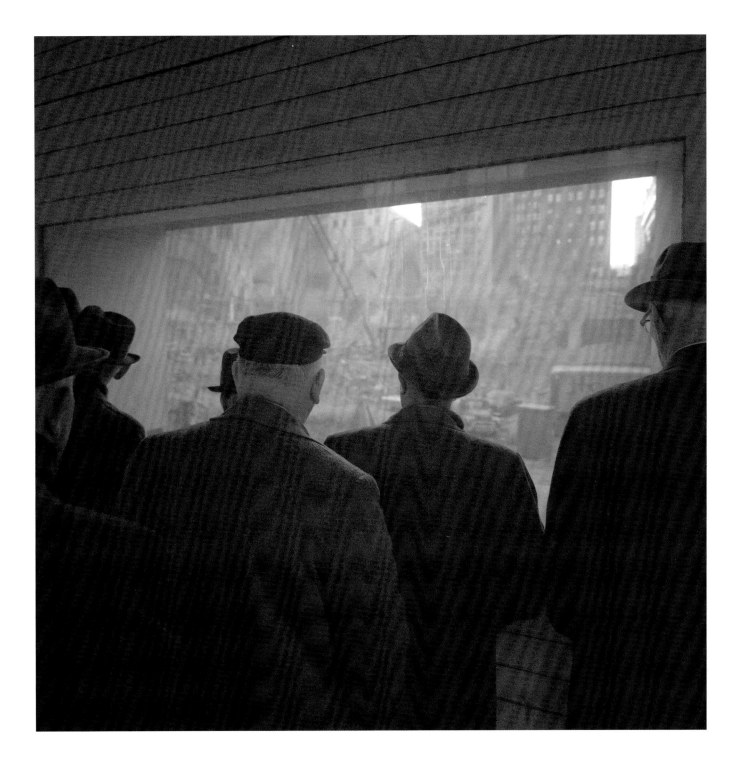

ONLOOKERS WATCH THE DEMOLITION OF THE 45-STORY MORRISON, ONCE THE WORLD'S TALLEST HOTEL,
TO MAKE WAY FOR THE NEW FIRST NATIONAL BANK BUILDING IN 1965. LEFT: WHEN THE CABLE BUILD-
ING WAS DEMOLISHED IN 1960, CITY OFFICIALS HIRED NICKEL TO DOCUMENT THE BUILDING'S LAST
DAYS. THE SKYSCRAPER, DESIGNED BY HOLABIRD AND ROCHE, WAS REPLACED BY THE CNA BUILDING.

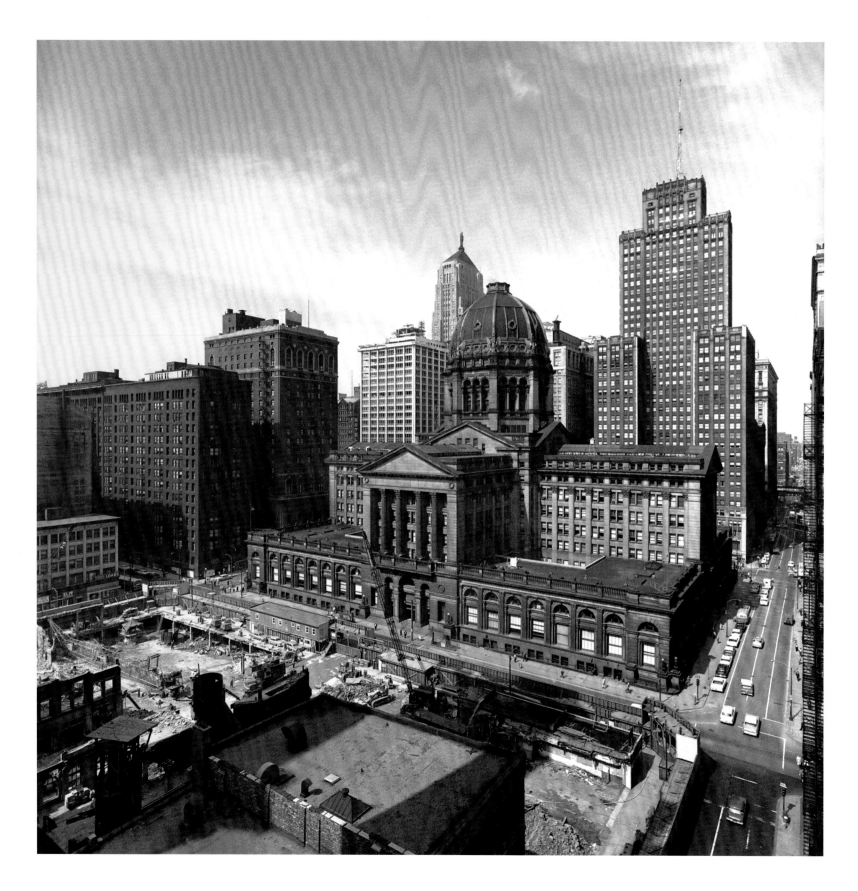

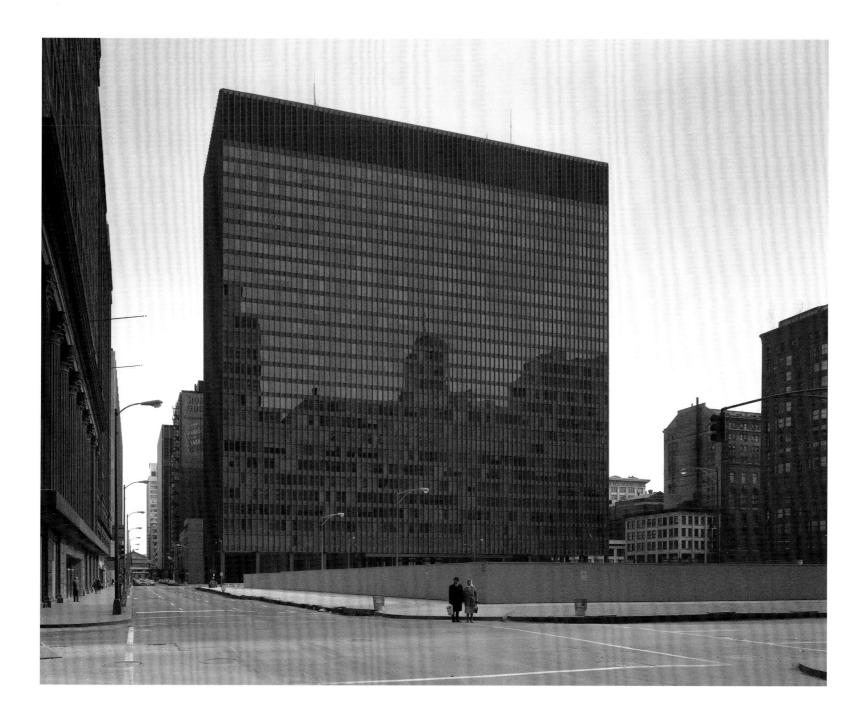

"THE FACE OF CHICAGO IS BEING TRANSFORMED," NICKEL WROTE. "THERE IS NO QUESTIONING IT, AND APPARENTLY NO STOPPING IT." LEFT: THE OLD FEDERAL BUILDING ON DEARBORN STREET BETWEEN ADAMS STREET AND JACKSON BOULEVARD WAS DEMOLISHED IN 1965. ABOVE: MIES VAN DER ROHE'S NEW FEDERAL BUILDING, BUILT ACROSS THE STREET.

ADLER AND SULLIVAN'S CHARLES P. KIMBALL RESIDENCE AT 22 EAST ONTARIO STREET WAS TORN
DOWN IN 1964. THE MANSION HOUSED L'AIGLON RESTAURANT FOR DECADES. AFTER IT CLOSED,
AN INNOVATIVE, SHORT-LIVED NIGHTCLUB AND RESTAURANT CALLED THE BEAR OPENED IN ITS
PLACE. PREMIER PERFORMER WAS YOUNG BOB DYLAN.

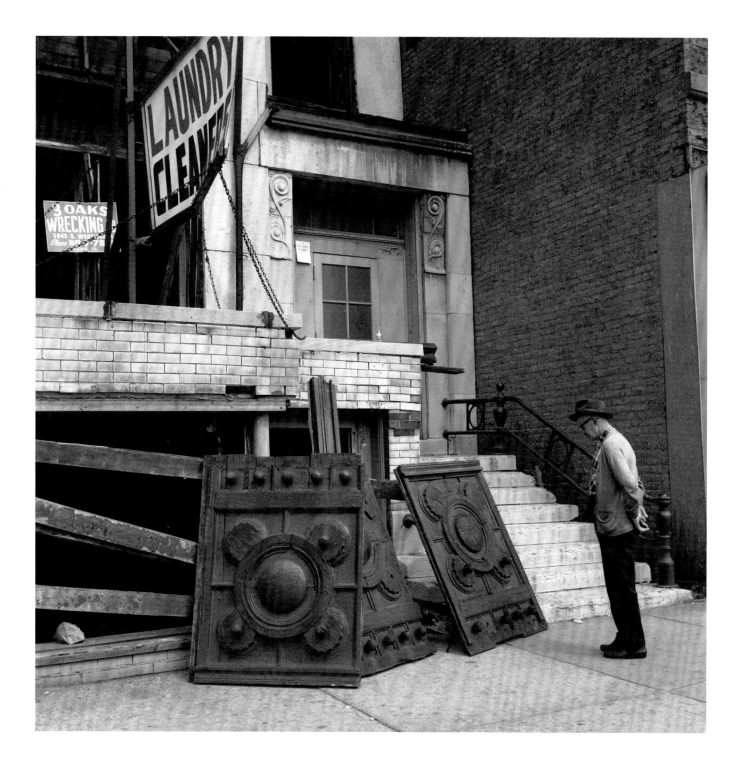

ORNAMENT FROM ADLER AND SULLIVAN'S SOLOMON BLUMENFELD RESIDENCE AT 8 WEST CHI-
CAGO AVENUE WAS DISPLAYED ON THE SIDEWALK DURING DEMOLITION IN 1963. RIGHT: THREE
YEARS LATER, NICKEL WATCHED AS BURNHAM AND ROOT'S 1887 CHURCH OF THE COVENANT,
ON THE SOUTHEAST CORNER OF BELDEN AVENUE AND HALSTED STREET, WAS TORN DOWN.

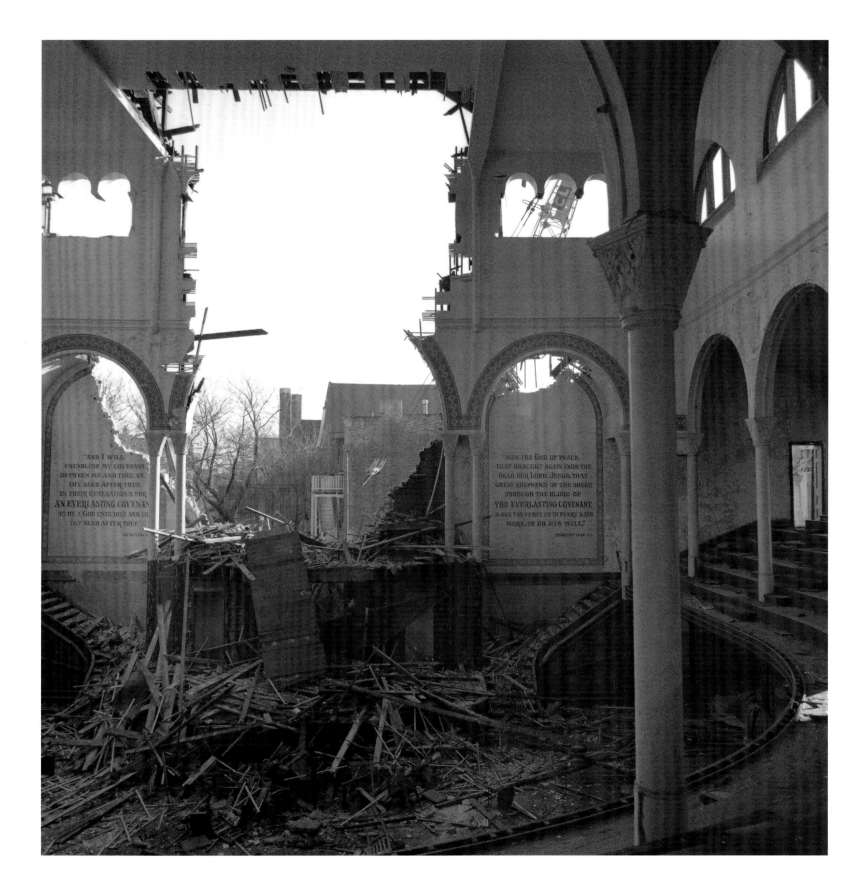

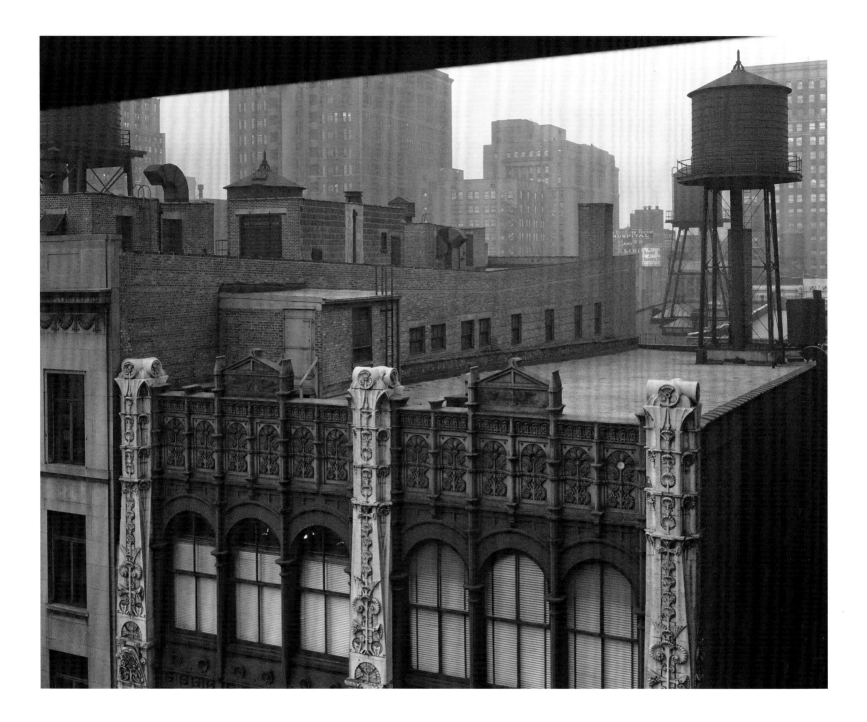

IN EARLY 1972, ADLER AND SULLIVAN'S FIVE-STORY MAX M. ROTHSCHILD BUILDING AT 210
WEST MONROE STREET JOINED THE LIST OF CASUALTIES. NICKEL SUGGESTED THAT THE ENTIRE
STONE AND IRON FACADE BE SAVED, BUT MANAGED TO SALVAGE ONLY FOUR CAST-IRON PANELS
FROM THE TOP OF THE BUILDING. NICKEL BLAMED THE CITY FOR NOT PROTECTING LANDMARKS.
HE WROTE: "ALL THIS IS A RAPE TO MAKE ONE'S BLOOD BOIL."

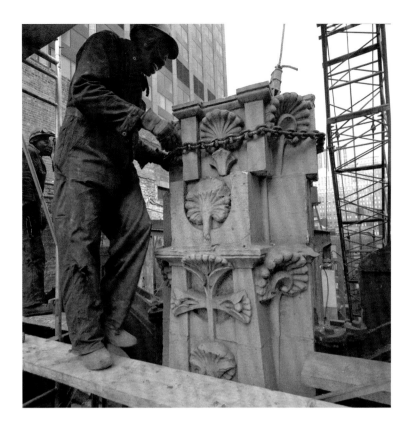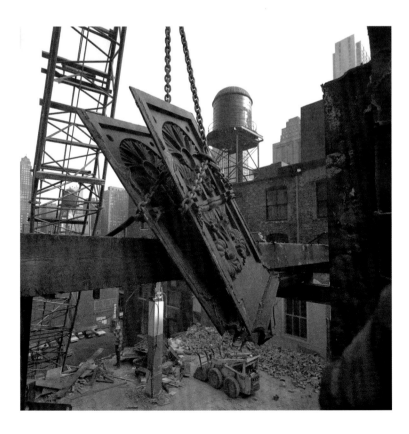

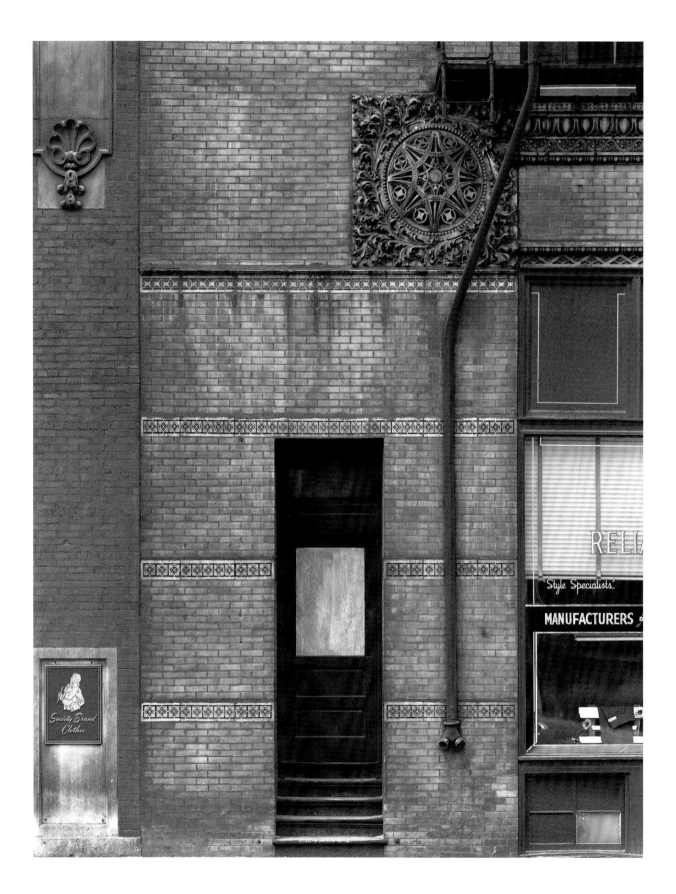

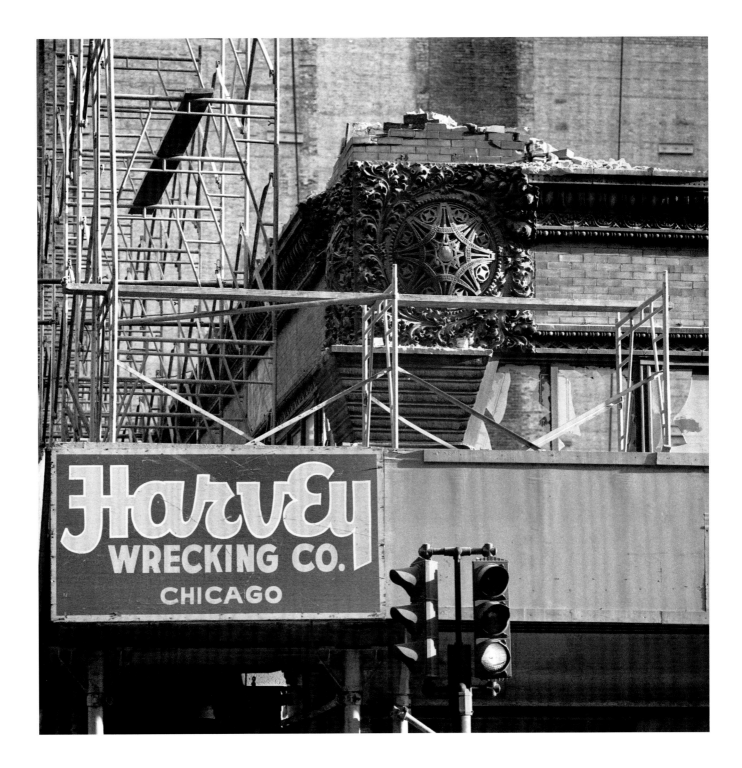

NICKEL CONSIDERED MOUNTING A PROTEST AGAINST THE 1968 DEMOLITION OF THE MEYER BUILD-
ING AT 307 WEST VAN BUREN STREET, BUT HE HESITATED BECAUSE HE WANTED TO ACQUIRE ONE OF
THE BUILDING'S FOUR HUGE TERRA-COTTA MEDALLIONS. "I'M JUST SO TIRED OF SEEING ADLER AND
SULLIVAN WORKS DEFACED, DEMOLISHED," HE WROTE. "I'M AT THE END OF THE ROAD."

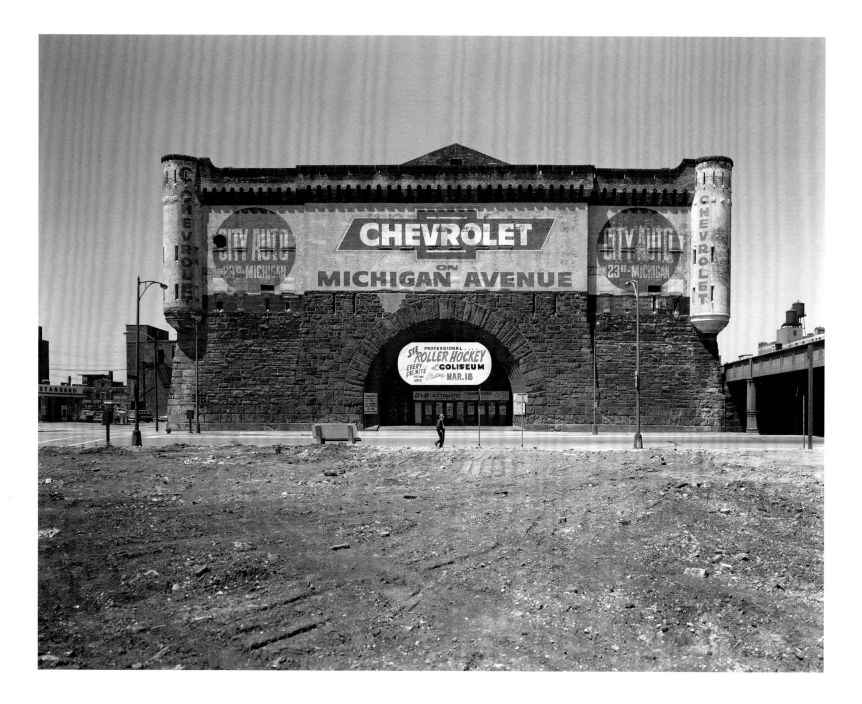

BURNHAM AND ROOT'S FIRST INFANTRY ARMORY STOOD AT MICHIGAN AVENUE AND 16TH STREET FOR SEVENTY-FIVE YEARS—FIRST AS A MILITARY OUTPOST AND LATER AS A COMMERCIAL VENTURE. NICKEL ARRIVED THERE IN 1965. NEXT PAGES: HE RETURNED THE FOLLOWING YEAR AS THE ARMORY WAS TORN DOWN. IT WAS A FAMILIAR SCENE.

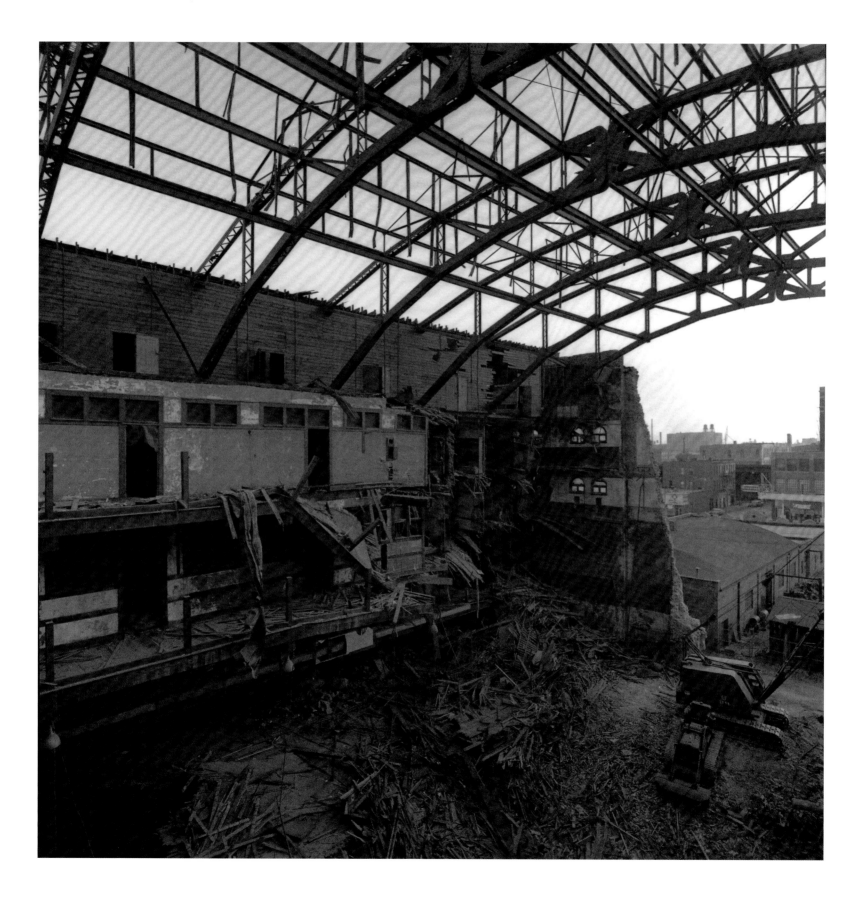

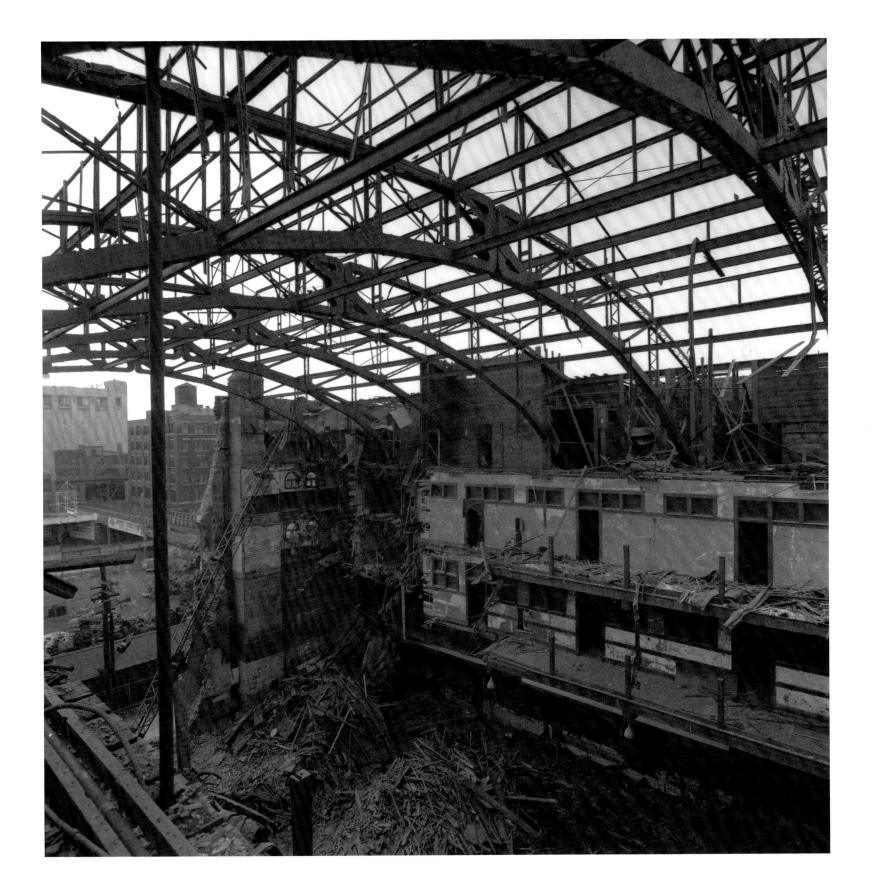

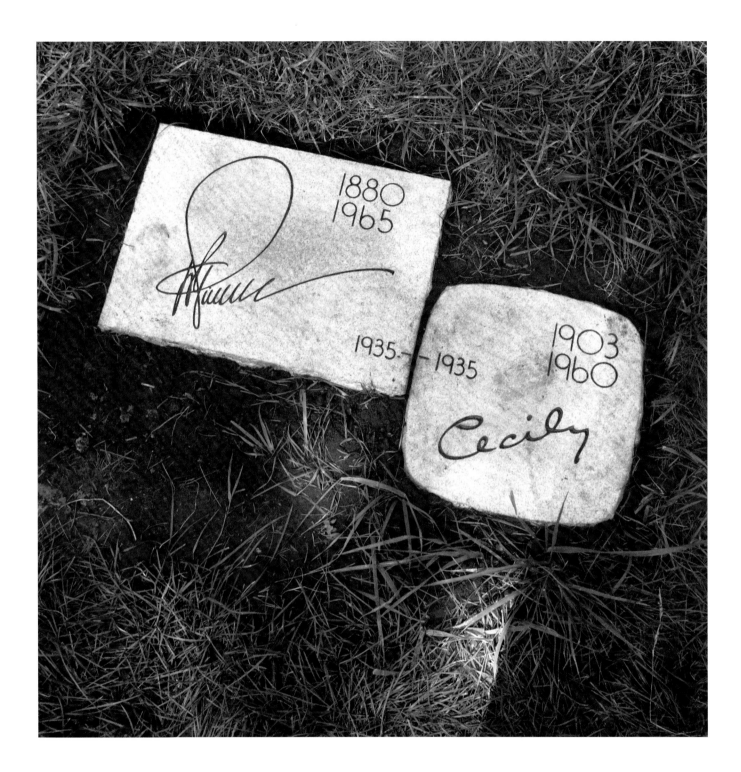

AFTER BEFRIENDING SULLIVAN-COLLEAGUE WILLIAM GRAY PURCELL, NICKEL OVERSAW THE CONSTRUCTION OF GRAVE MARKERS THAT PURCELL DESIGNED FOR HIMSELF AND WIFE CECILY AT FOREST HOME CEMETERY IN FOREST PARK. NICKEL ALSO PHOTOGRAPHED CECILY'S BODY AT THE FUNERAL HOME, AND LATER SNUCK INTO THE CEMETERY JUST AFTER DAWN SO HE COULD PLACE THE MARKERS PERFECTLY.

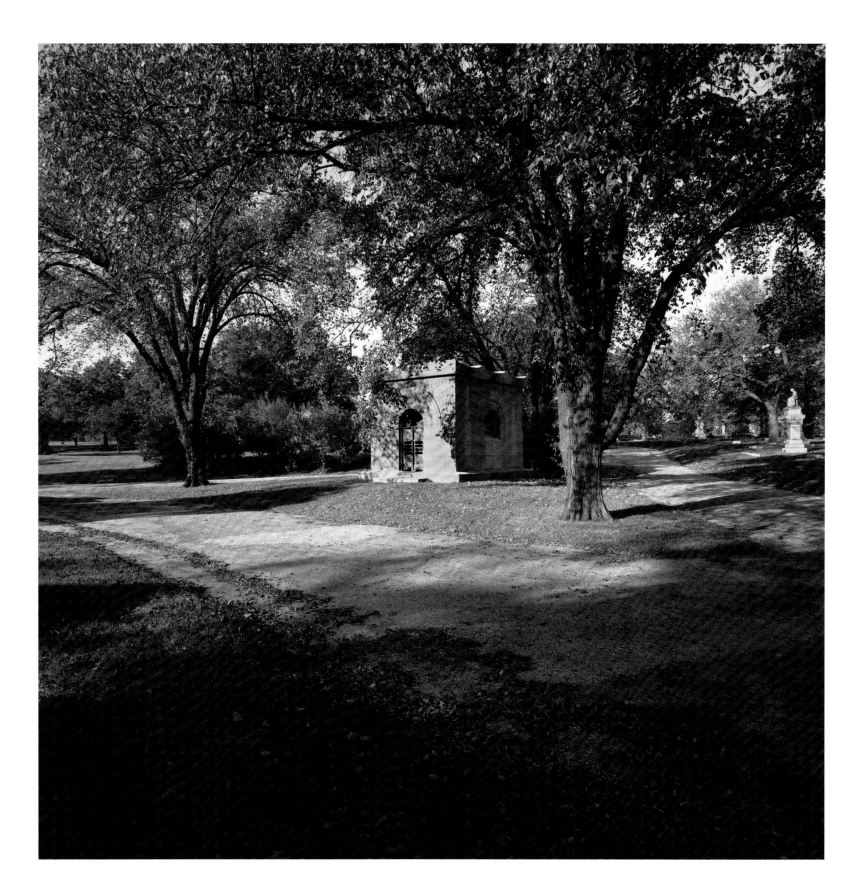

SULLIVAN'S 1889 MARTIN RYERSON TOMB (ABOVE) AND 1891 HENRY HARRISON GETTY TOMB (LEFT) AT GRACELAND CEMETERY ON THE NORTH SIDE. NICKEL WROTE FREQUENTLY ABOUT DEATH AND DYING DURING THE LATE 1960S AND EARLY 1970S. "BETTER TO BE WIPED OUT TOTALLY, INSTANTLY, ALL ALONE, NO ONE KNOWING," WROTE NICKEL, WHO WAS LATER BURIED NEARBY.

CHANGING TIMES

"FROM ONE OF THE MOST DISTINGUISHED CITIES ARCHITECTURALLY WE ARE RAPIDLY MOVING TOWARD ANONYMITY, OR, WHAT IS WORSE, A CITY OF CONTRASTS: THE SUPERFICIAL GLITTER OF THE NEW MIXED WITH THE SLUM OF THE OLD."

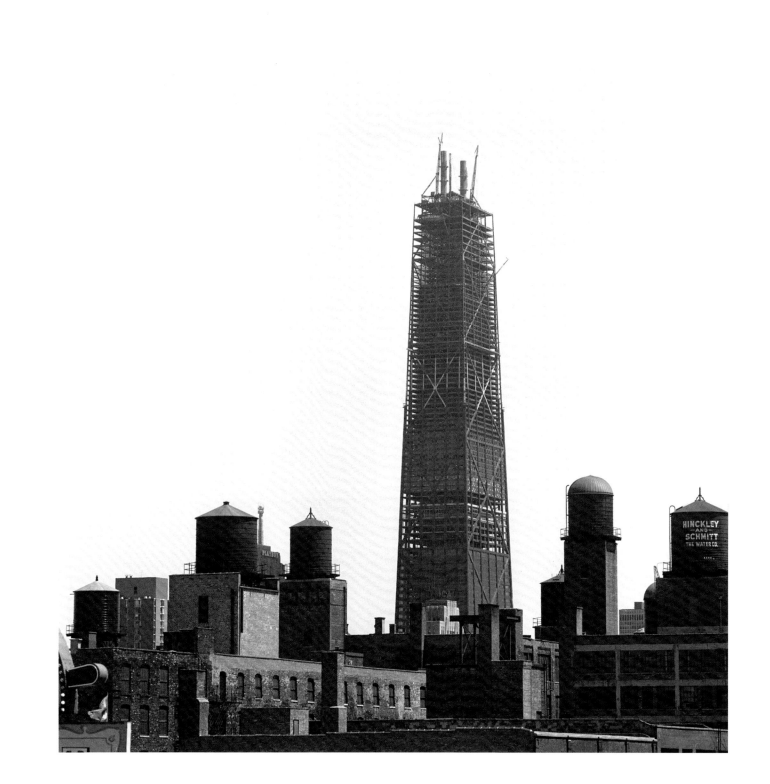

A DOWNTOWN BUILDING BOOM THAT STARTED IN THE LATE 1950S CHANGED THE FACE OF
CHICAGO. THE 100-STORY JOHN HANCOCK CENTER RISES ABOVE NORTH MICHIGAN AVENUE
AND THE CITY IN THE LATE 1960S. THE SCALE OF THE CITY WAS ALTERED FOREVER.

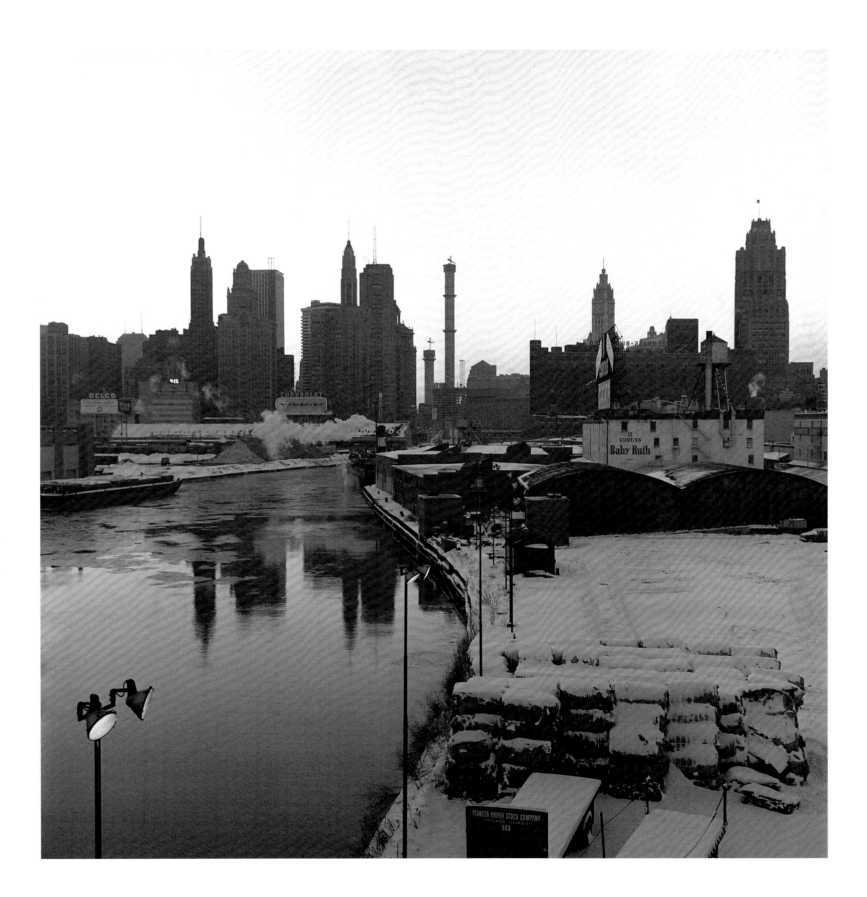

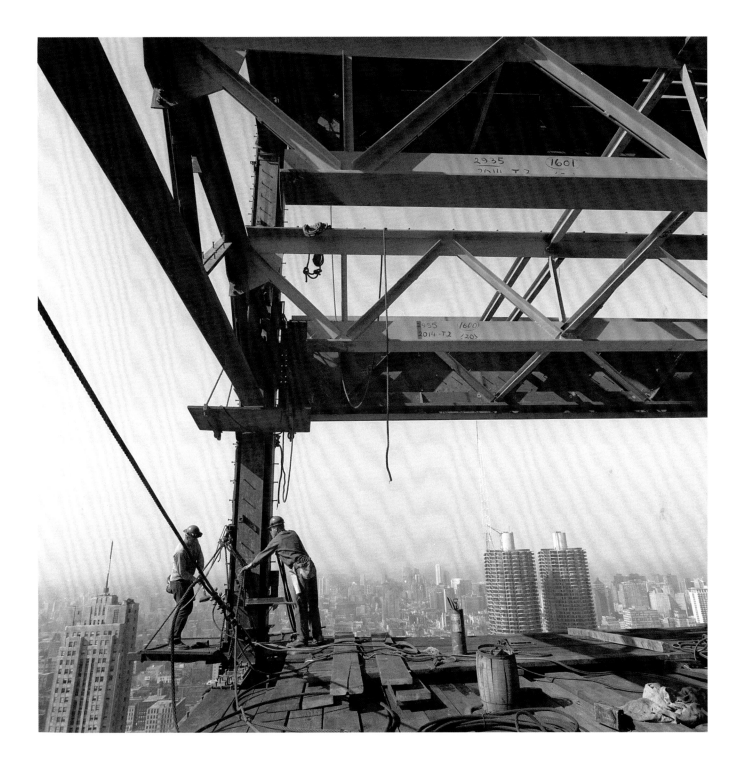

NICKEL DOCUMENTED MANY OF THE CITY'S NEW SKYSCRAPERS, INCLUDING THE 1965 CHICAGO CIVIC CENTER (ABOVE) AND THE 1967 MARINA CITY APARTMENT COMPLEX (LEFT). THIS PHOTO SHOWS THE CONCRETE CORE OF MARINA CITY BEING INSTALLED JUST NORTH OF THE CHICAGO RIVER IN THE EARLY 1960S. NICKEL ADMIRED BOTH PROJECTS.

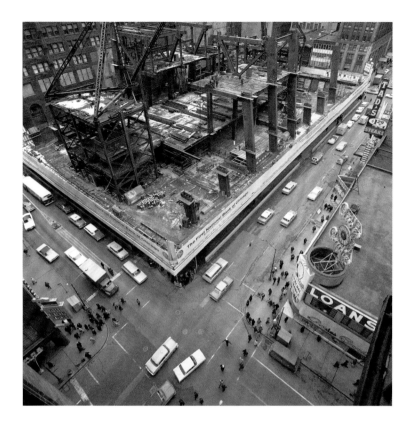

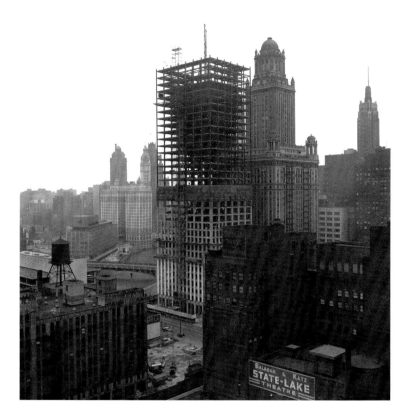

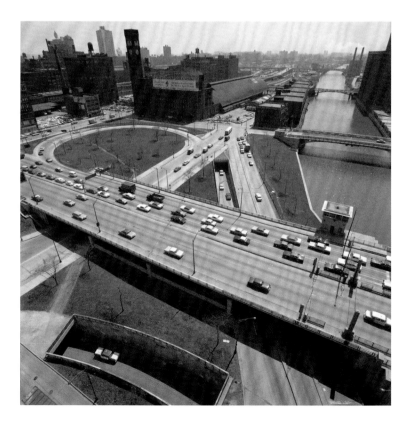

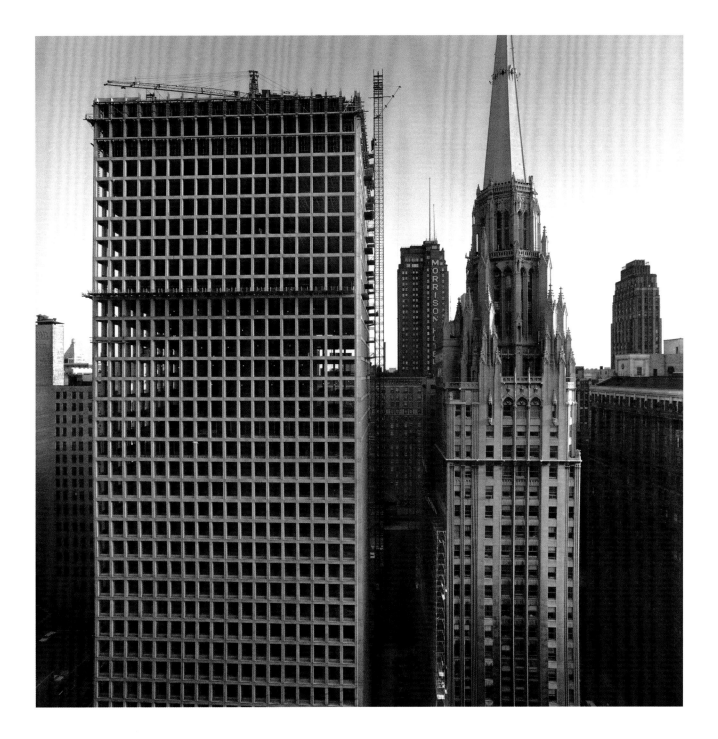

NEW CHICAGO: THE BRUNSWICK BUILDING (FINISHED IN 1965) RISES NEXT TO THE CHICAGO TEMPLE. LEFT PAGE, CLOCKWISE FROM TOP LEFT: THE FIRST NATIONAL BANK BUILDING (1969); UNITED OF AMERICA BUILDING (1962); CONGRESS STREET EXPRESSWAY OVER THE CHICAGO RIVER, AND THE ILLINOIS CENTRAL INBOUND FREIGHT HOUSE, TORN DOWN IN 1970.

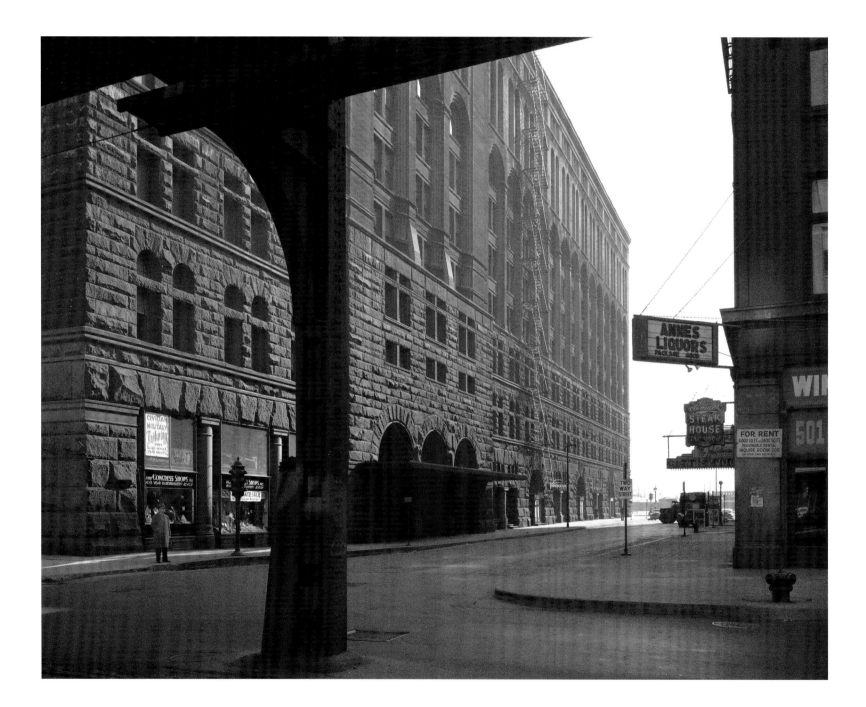

CHANGING CHICAGO: ONE PRESERVATION BATTLE THAT NICKEL DID NOT TAKE PART IN WAS THE EF-
FORT TO RESTORE THE AUDITORIUM THEATRE IN ADLER AND SULLIVAN'S AUDITORIUM BUILDING. NICKEL
STARTED PHOTOGRAPHING THE BUILDING DURING THE EARLY 1950S, BEFORE CONGRESS STREET WAS
WIDENED AND STOREFRONTS WERE TORN OUT FOR AN ENCLOSED SIDEWALK.

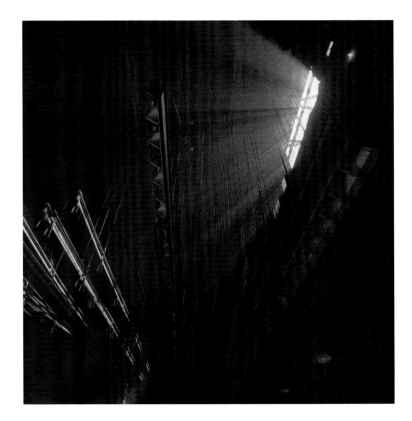

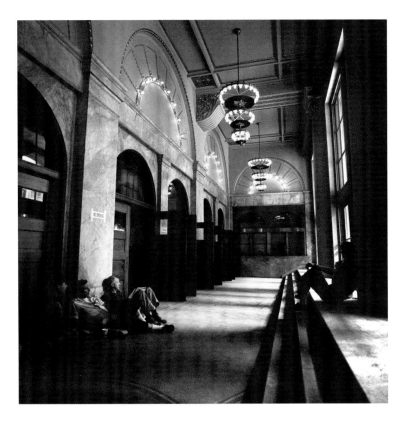

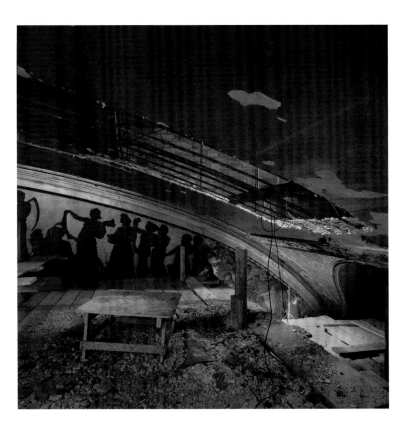

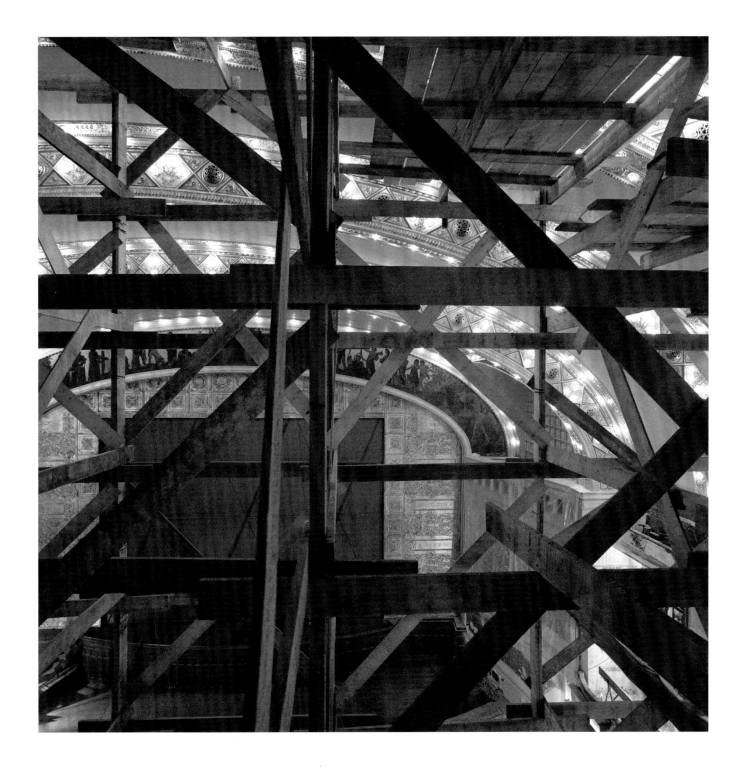

"A BRILLIANT EXAMPLE OF THE POSSIBILITIES WHERE THERE IS A LITTLE LOVE AND FAITH AND TRUTH," NICKEL WROTE OF THE AUDITORIUM RESTORATION.

A NINE-YEAR CAMPAIGN TO RAISE $2.25 MILLION TO BRING BACK THE AUDITORIUM CAME TO A GRAND CONCLUSION ON OCTOBER 31, 1967, WHEN THE THEATER REOPENED WITH NEW YORK CITY BALLET'S "A MIDSUMMER NIGHT'S DREAM." NICKEL'S SALVAGING COLLEAGUE DAVID NORRIS, WHO HELPED IN THE RESTORATION, ATTENDED THE PREMIERE WITH HIS SISTER CORAL (RIGHT) AND FRIEND ROSE WALTON.

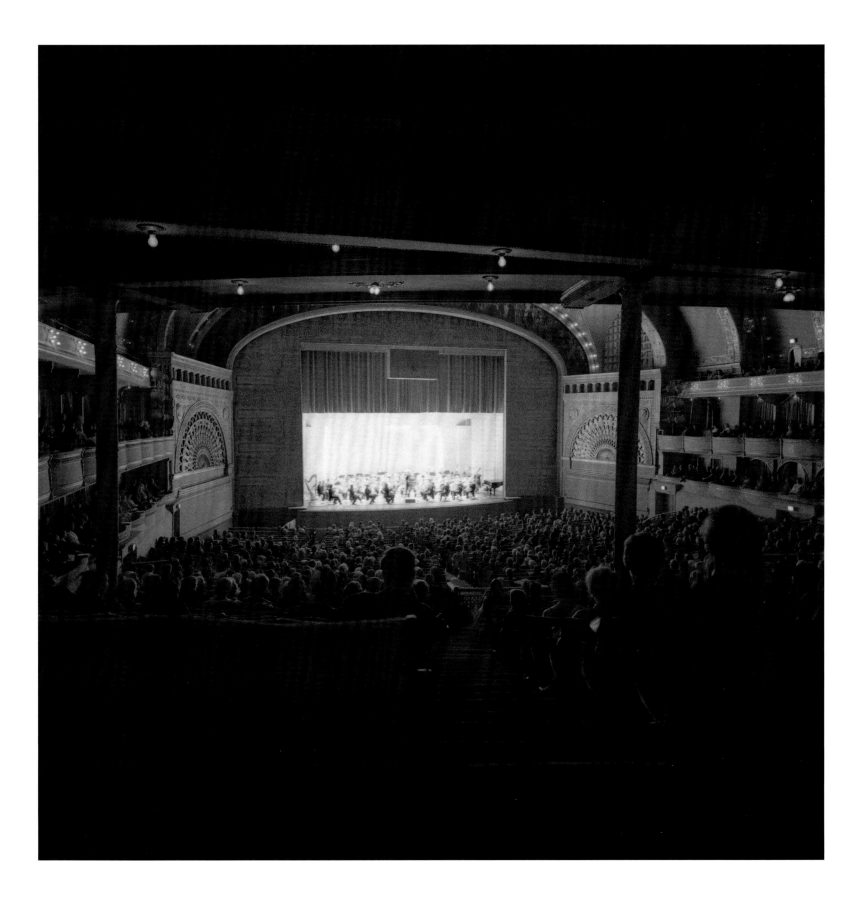

CHICAGO PROTESTS TURNED MORE POLITICAL DURING THE LATE 1960S. HERE, DEMONSTRATORS AGAINST THE VIETNAM WAR GATHERED AROUND THE LOGAN STATUE IN GRANT PARK DURING THE DEMOCRATIC NATIONAL CONVENTION IN AUGUST 1968.

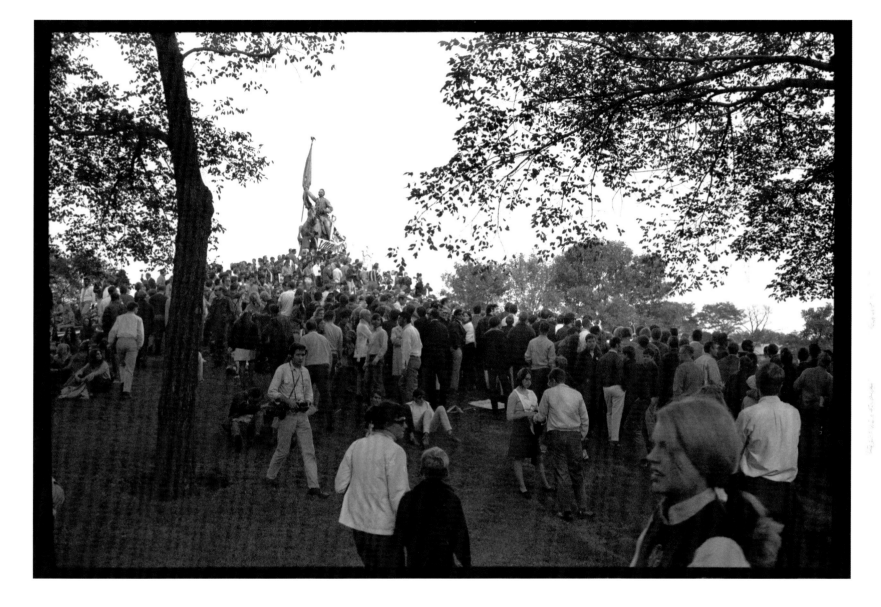

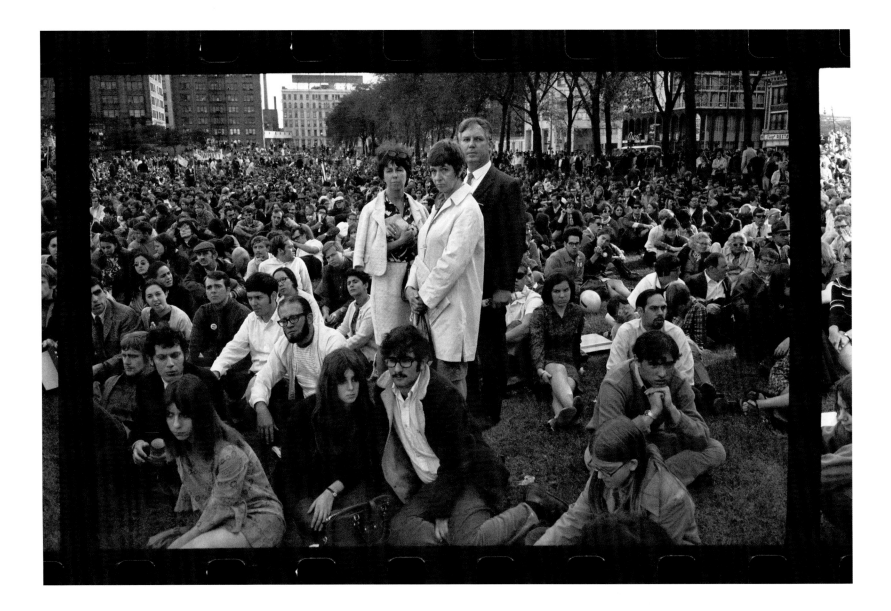

"I REALLY SENSE THAT THE OLD USA IS TURNING INTO RAPISTS AND IMPERIALISTS," NICKEL WROTE IN 1968. "THANK GOD THERE ARE YOUNG PEOPLE WHO HAVE THE GUTS TO BURN THEIR DRAFT CARDS." NICKEL SYMPATHIZED WITH THE NEW MOVEMENT, BUT NOT WITH ALL OF ITS TACTICS.

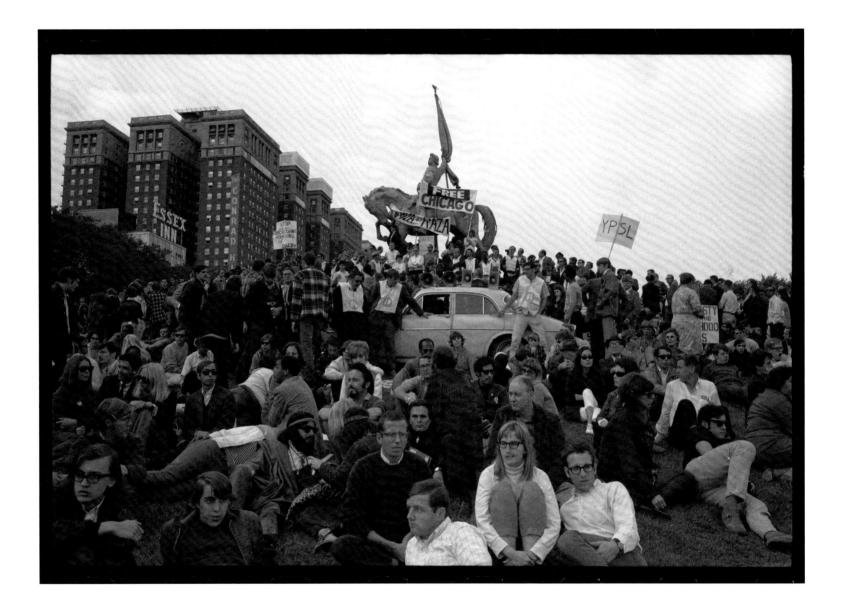

HOMES OF THE HEART

"IT'S NOT A PLACE TO LIVE SO MUCH AS AN ESTHETIC EXPERIENCE."

NICKEL PURCHASED "A MODEST BUILDING IN A BOURGEOIS NEIGHBORHOOD" AT 1810 WEST CORTLAND STREET ON THE NORTHWEST SIDE IN 1969. HIS PLAN WAS TO SLOWLY CHANGE THE FIRST-FLOOR BAKERY INTO LIVING SPACE AND THE UPSTAIRS INTO A BEDROOM AND MANUSCRIPT ROOM, WHERE HE HOPED HE WOULD FINALLY FINISH "THE COMPLETE ARCHITECTURE OF ADLER AND SULLIVAN."

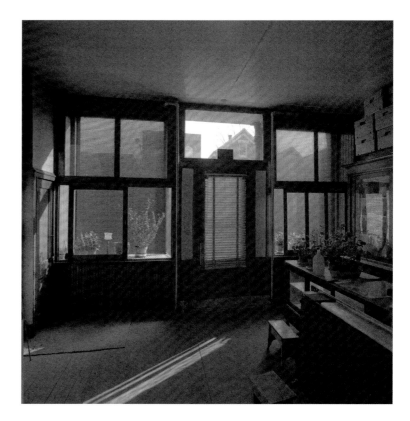

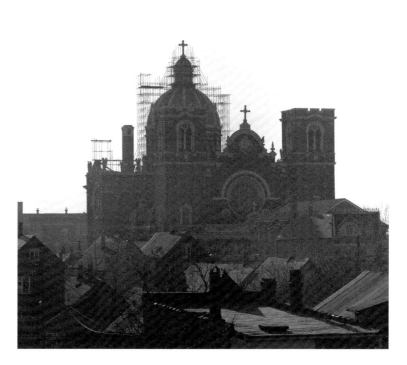

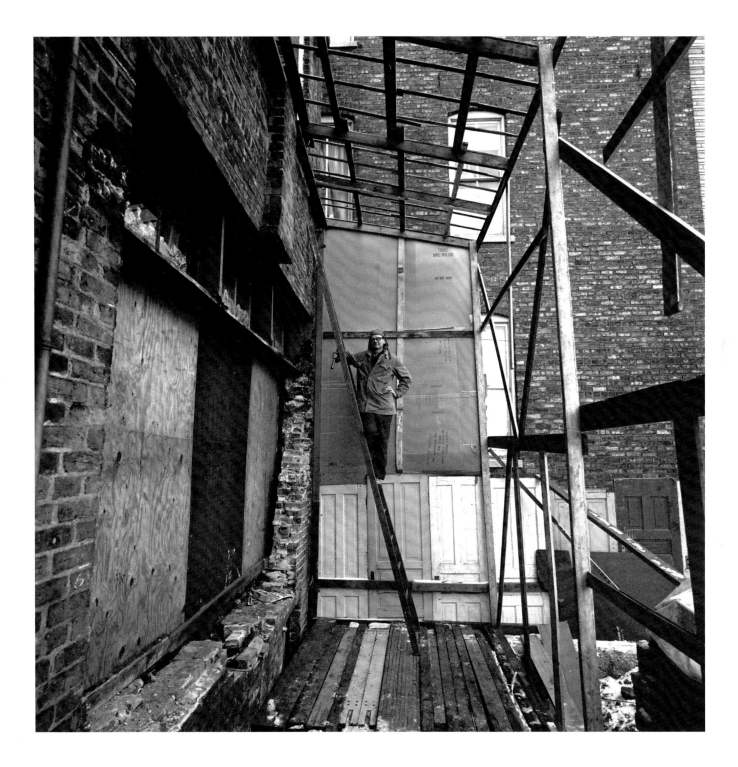

NICKEL REHABBED THE BACK WALL OF THE 80-YEAR-OLD BUILDING, ADDING WINDOWS. HE LOVED THE ELEGANT ELEVATION OF HIS STOREFRONT HOUSE, ITS BEAUTIFUL FLOOR PLAN AND THE VIEW OF ST. MARY OF THE ANGELS ROMAN CATHOLIC CHURCH. "I SHOULD HAVE OWNED A BUILDING SEVERAL YEARS AGO," HE WROTE. "I ENJOY ALL THE STEPS I AM GOING THROUGH, BUT I WORRY IF I WILL EVER MAKE IT."

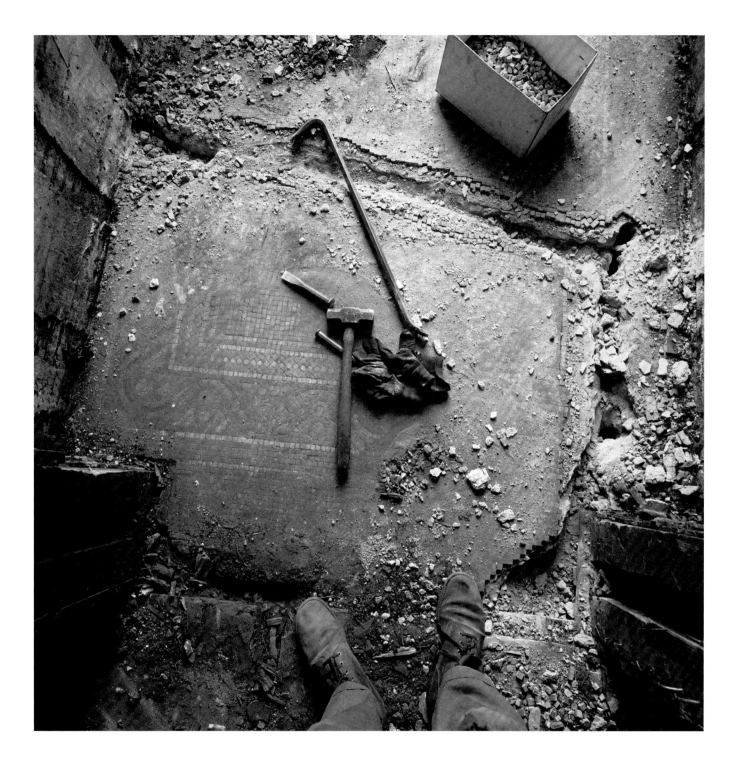

NICKEL'S MOST BELOVED HOUSE IN CHICAGO WAS A TWO-STORY RESIDENCE (CENTER IN THE UPPER LEFT PHOTO ON NEXT PAGE) THAT SULLIVAN DESIGNED FOR HIMSELF IN 1891. NICKEL CONSIDERED BUYING THE HOUSE, KNOWN AS THE ALBERT SULLIVAN RESIDENCE, FOR HIMSELF IN 1963. SEVEN YEARS LATER, AFTER THE HOUSE WAS ABANDONED, NICKEL ARRIVED WITH HIS WRECKING TOOLS.

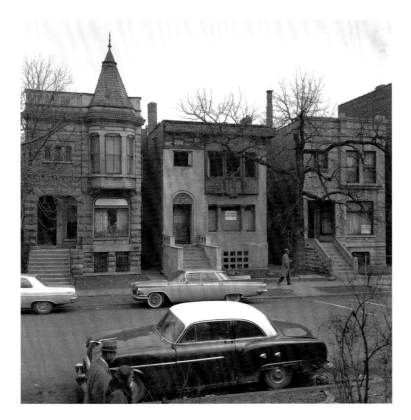
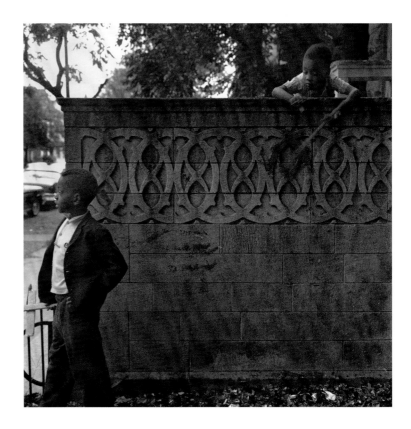

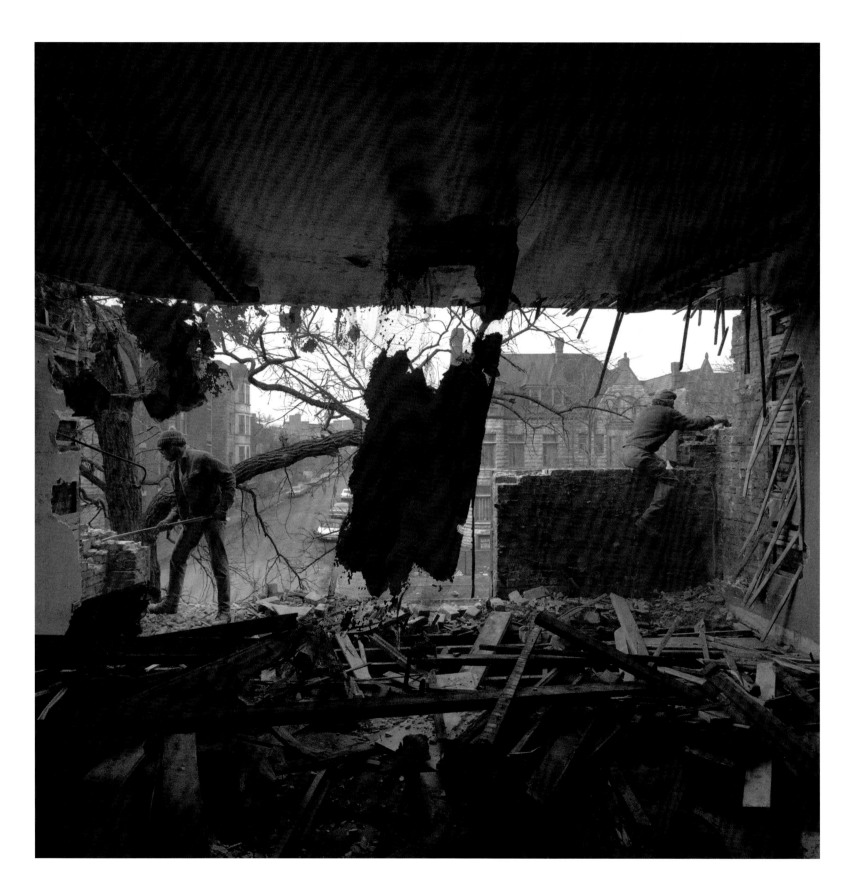

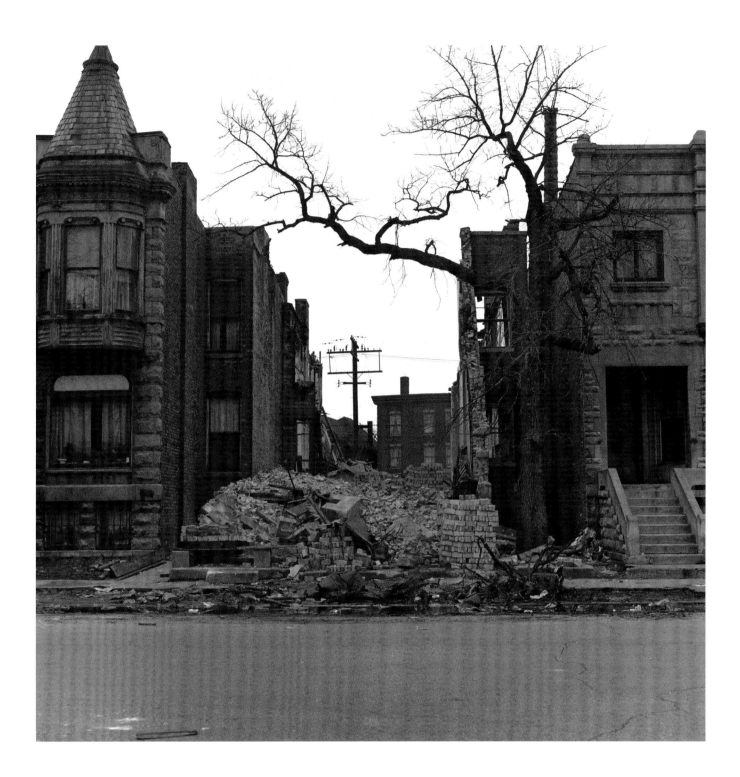

LEFT: SALVAGERS, UNDER NICKEL'S DIRECTION, DISMANTLE THE FRONT OF THE SULLIVAN HOUSE
BRICK BY BRICK. MUCH OF THE FACADE IS STILL IN STORAGE AT SOUTHERN ILLINOIS UNIVERSITY,
WHERE IT MAY BE REBUILT IN A MUSEUM. ABOVE: THE VACANT LOT AT 4575 SOUTH LAKE PARK
AVENUE. "WHAT HAS HAPPENED TO THAT HOUSE IS A DISGRACE," NICKEL WROTE IN 1970.

THE FINAL ACT

"I CHARGE THE CULTURAL ELITE OF CHICAGO WITH THE DOOM OF THE CHICAGO SCHOOL BUILDINGS. THEY RAPE THE CITY FOR PRIVATE FORTUNES IN ORDER TO ENJOY PRIVATE ART IN THE SUBURBS. IT'S SICKENING! WORST OF ALL, IN AN AGE OF REALITY AND ENLIGHTENMENT, IT'S SO UNCULTURED, SO IGNORANT. IN PARTICULAR, HOW CAN THE ARCHITECTURAL PROFESSION STAY AWAY FROM THIS? IN A CITY OF SLUMS, WHY MUST THE QUALITY BUILDINGS BE DOOMED . . . YOU CAN'T CONVINCE ME THERE ARE NO ALTERNATIVES."

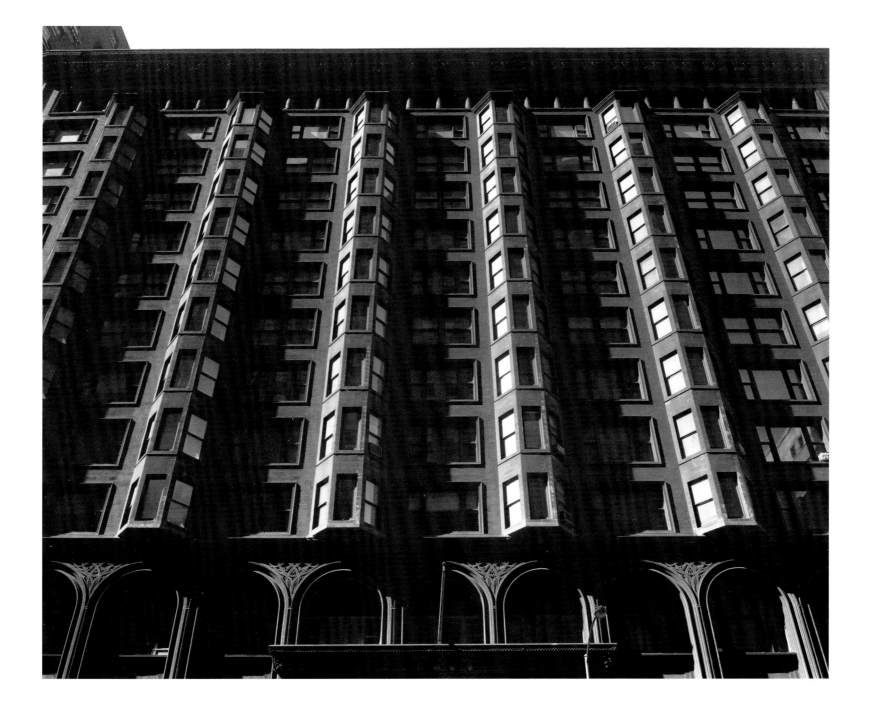

ADLER AND SULLIVAN'S 1893 STOCK EXCHANGE BUILDING AT 30 NORTH LASALLE STREET.

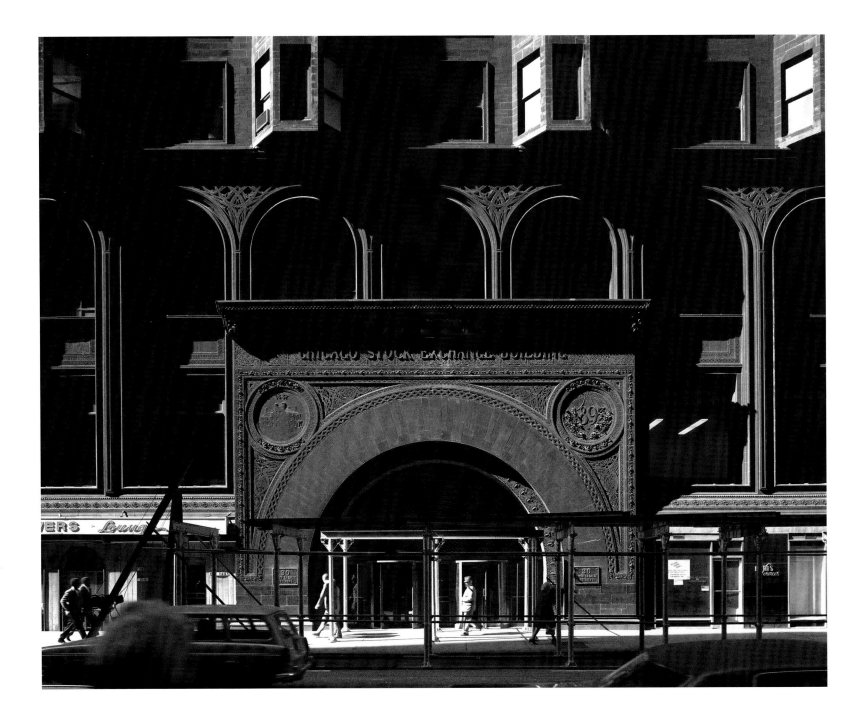

SCAFFOLDING BEGAN IN OCTOBER 1971.

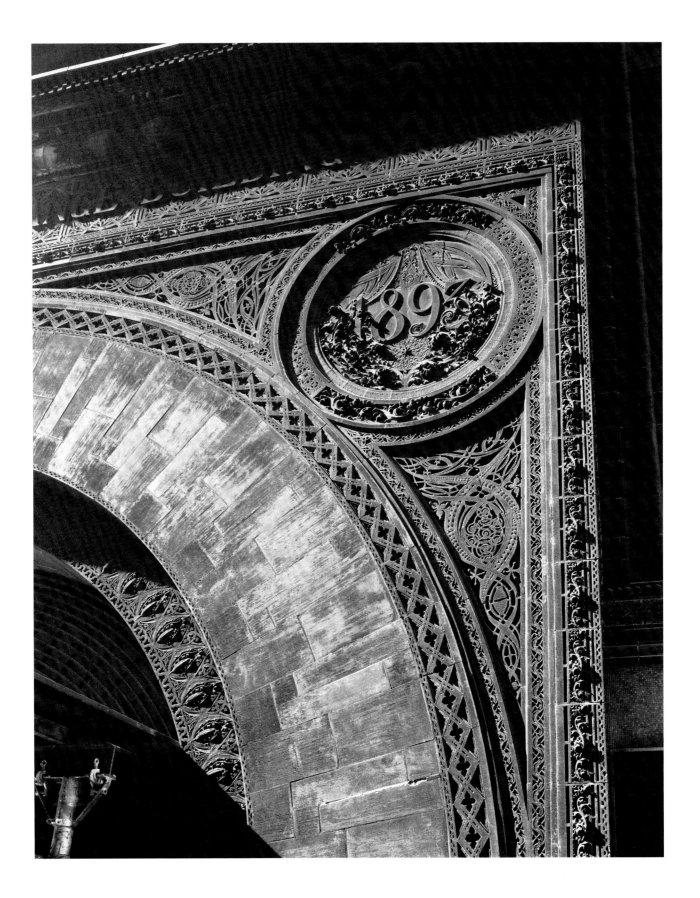

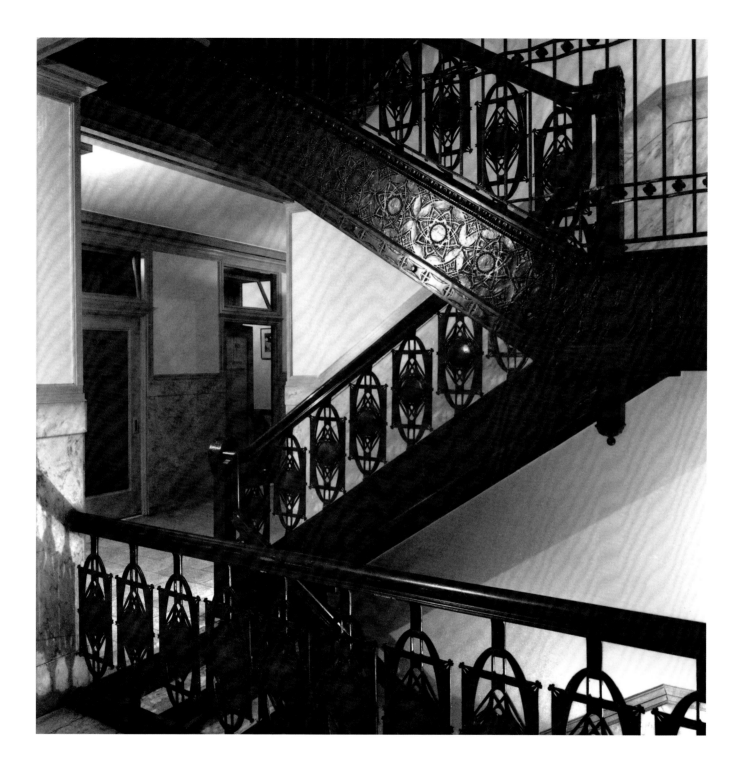

THE THIRTEEN-STORY STOCK EXCHANGE WAS LAYERED IN SULLIVAN'S ORNATE ORNAMENT. NICKEL SUPERVISED THE DE-INSTALLATION OF FOUR FLIGHTS OF STAIRS, WHICH WERE REASSEMBLED IN THE AMERICAN WING OF THE METROPOLITAN MUSEUM OF ART IN NEW YORK CITY.

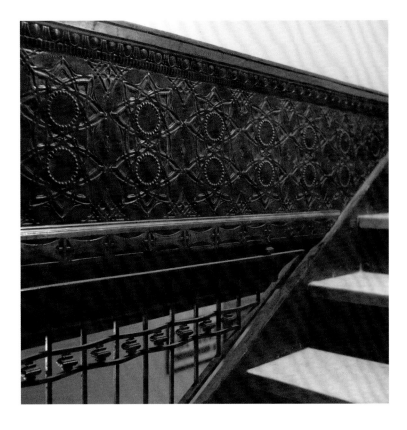

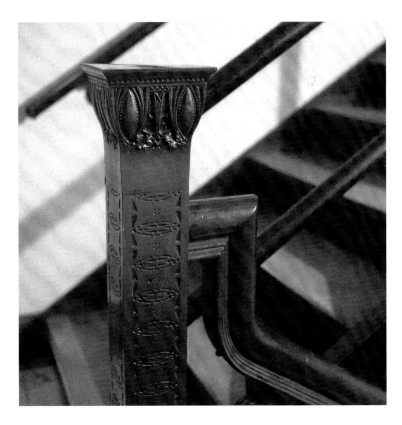

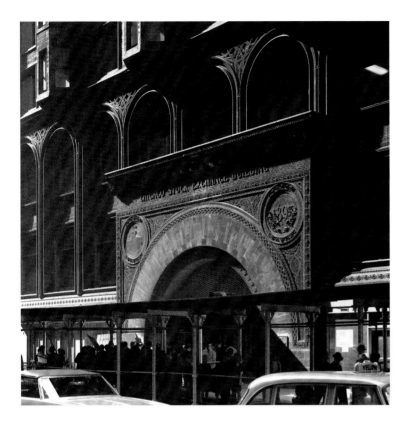 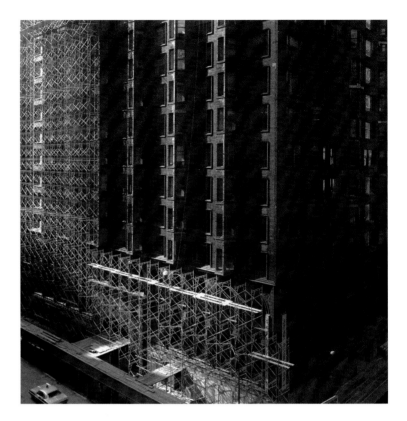

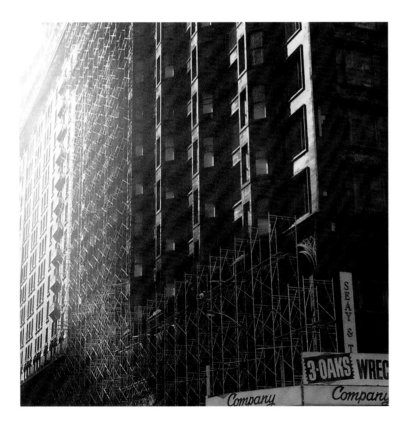 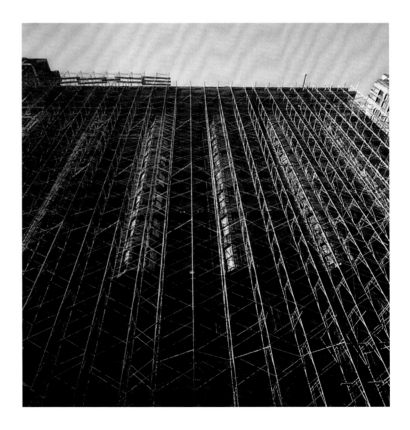

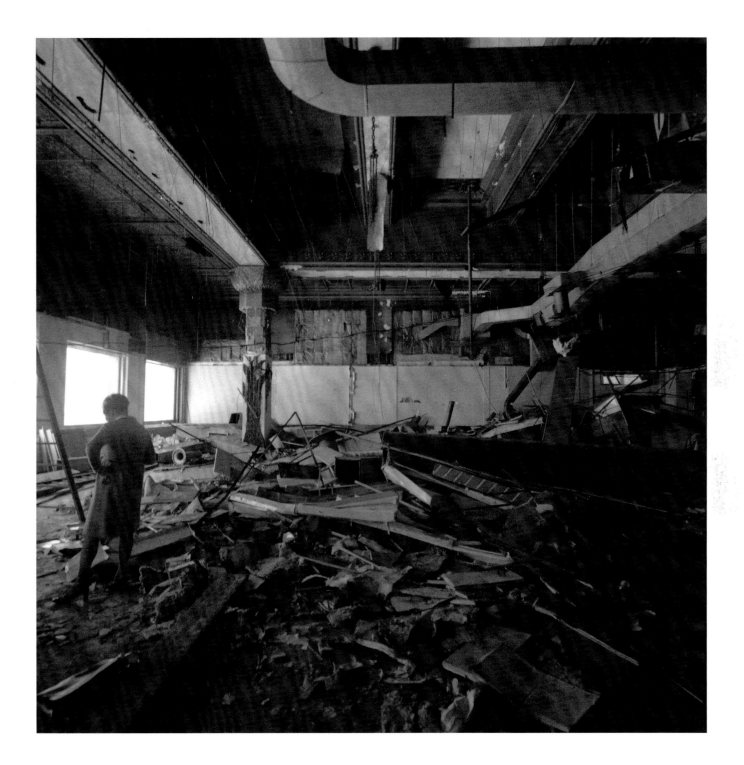

LEFT: DUTCH ARCHITECTS AND CITY PLANNERS CALL OUT THE WORD "SCHANDE," WHICH MEANS
SHAME, AS THEY VIEW THE BUILDING. ABOVE: A FALSE CEILING IS REMOVED FROM THE STOCK
EXCHANGE'S TRADING ROOM. NEXT PAGES: NICKEL METICULOUSLY PHOTOGRAPHED THE NEWLY
EXPOSED CEILING OF THE ROOM SO IT COULD BE RESTORED AT THE ART INSTITUTE.

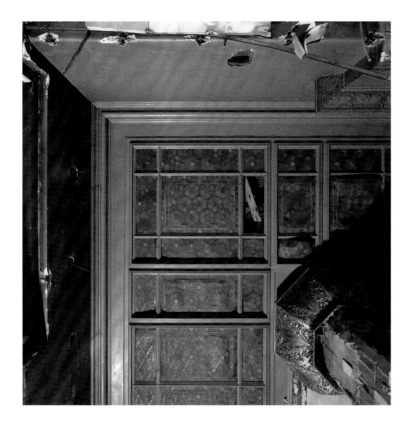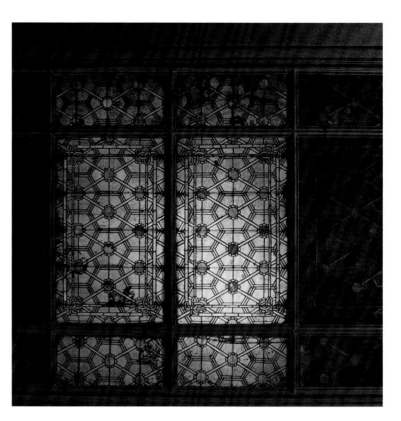
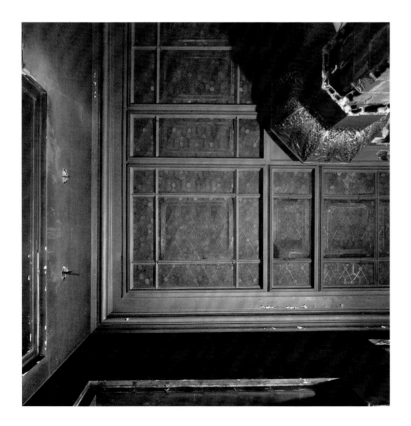

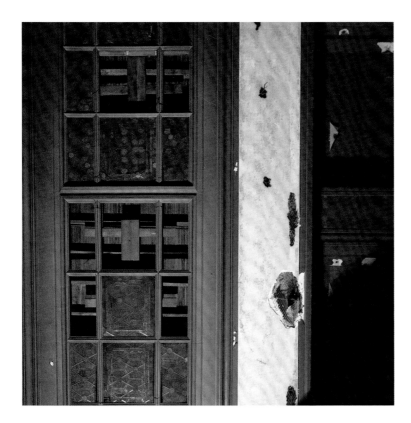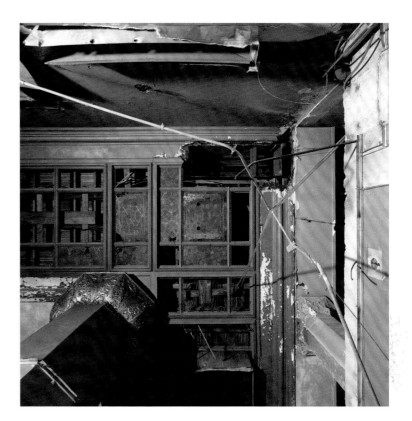

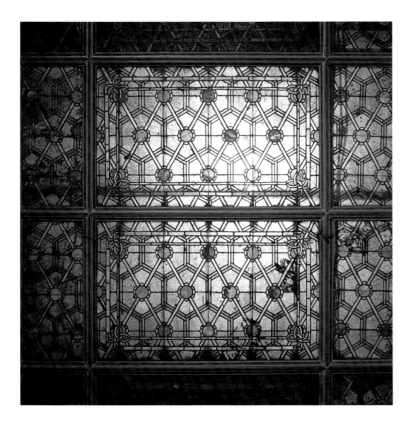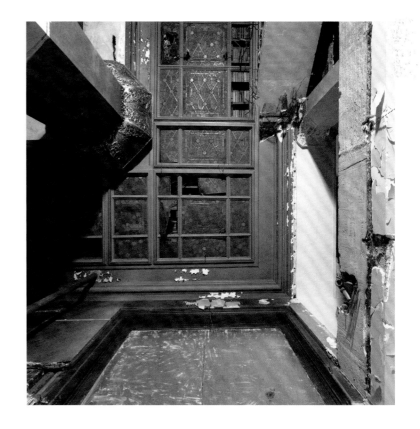

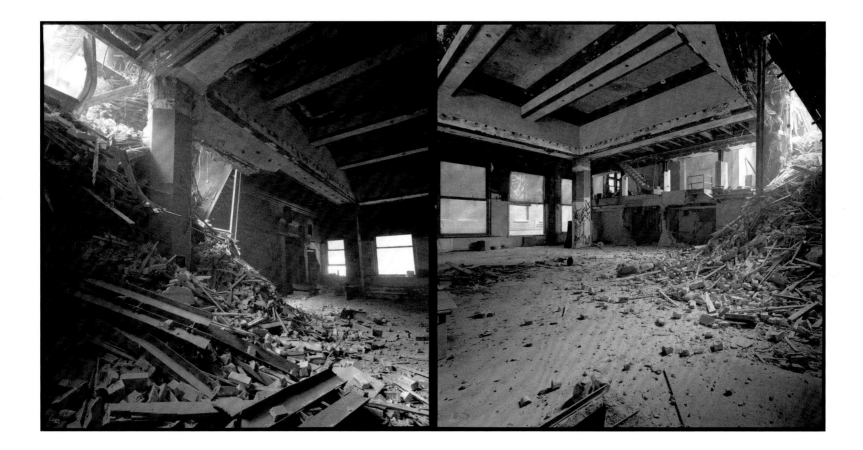

THE END: NICKEL WAS KILLED IN THE STOCK EXCHANGE TRADING ROOM OR IN A BASEMENT BE-
NEATH THE ROOM AS DEBRIS PILED UP, WEAKENED THE FLOOR, AND CAUSED IT TO COLLAPSE ON
APRIL 13, 1972. WRECKERS SPENT TWENTY-EIGHT DAYS SEARCHING THROUGH THE RUBBLE BEFORE
THEY FOUND HIS BODY. NICKEL NEVER FINISHED "THE COMPLETE ARCHITECTURE OF ADLER AND
SULLIVAN." HE WAS BURIED AT GRACELAND CEMETERY, NOT FAR FROM THE GRAVE OF LOUIS SULLIVAN.
NICKEL DID NOT HAVE A CAMERA THE DAY HE DIED. THESE PHOTOGRAPHS OF THE TRADING ROOM
ARE THE LAST HE TOOK INSIDE THE BUILDING.

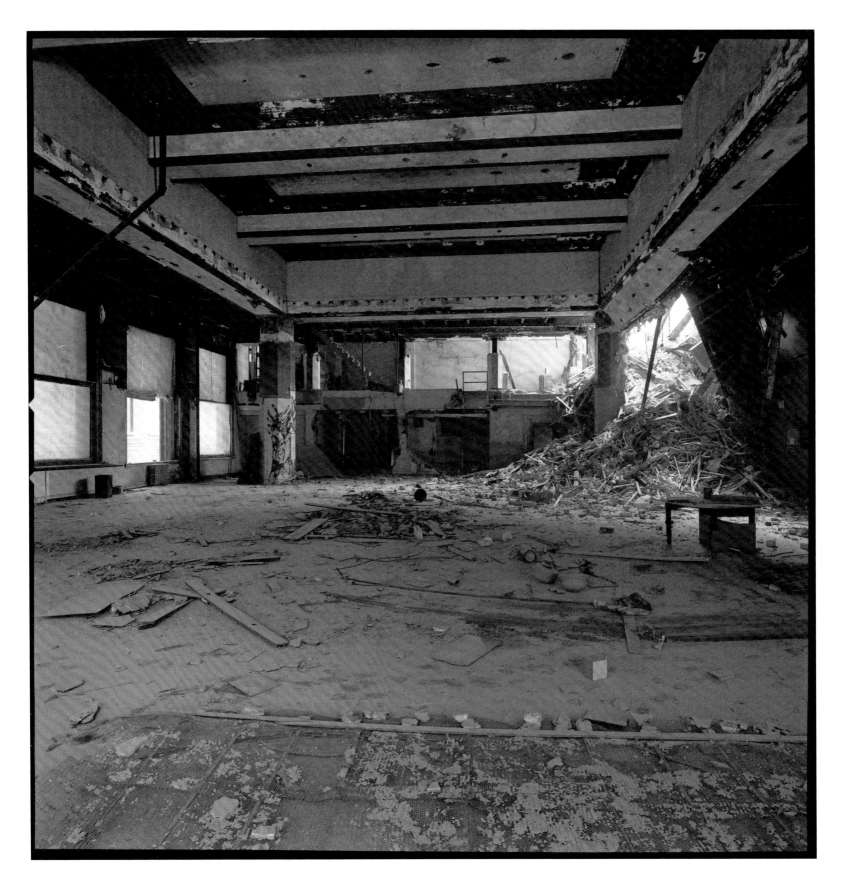

Photo Index of Major Buildings